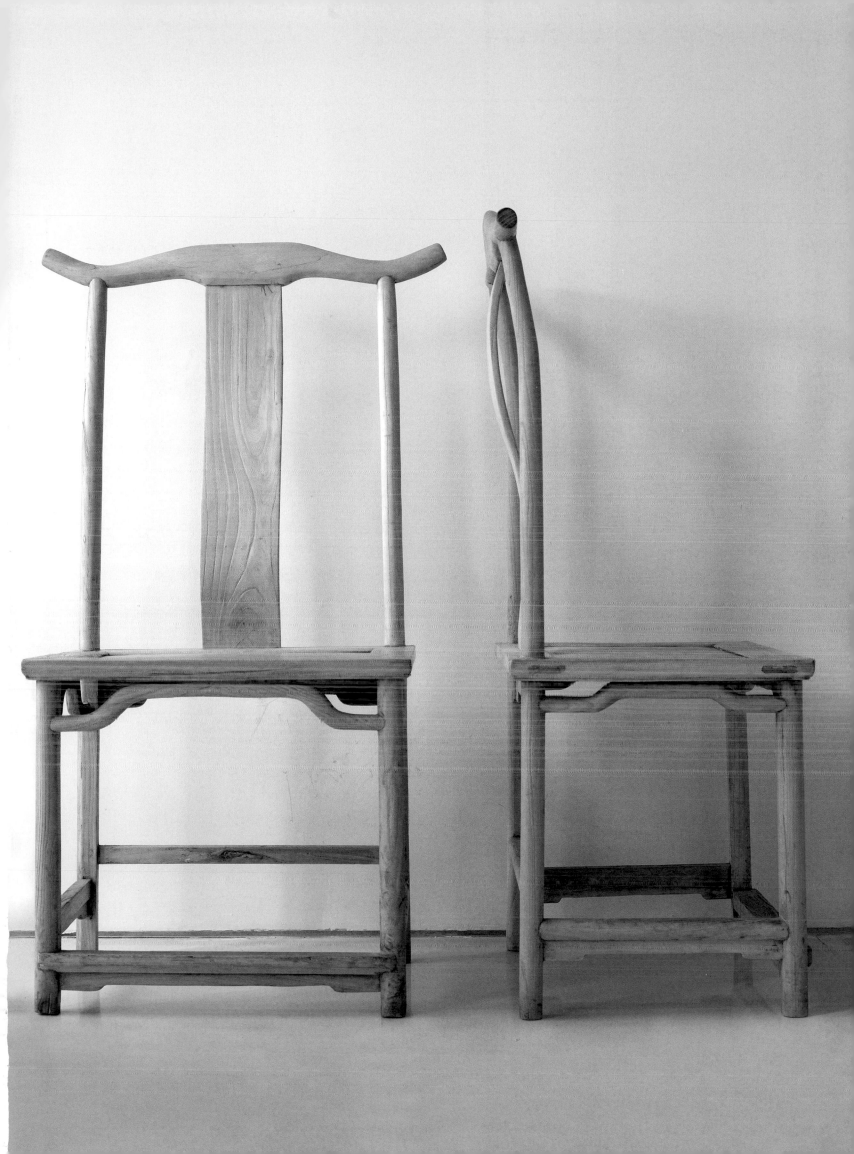

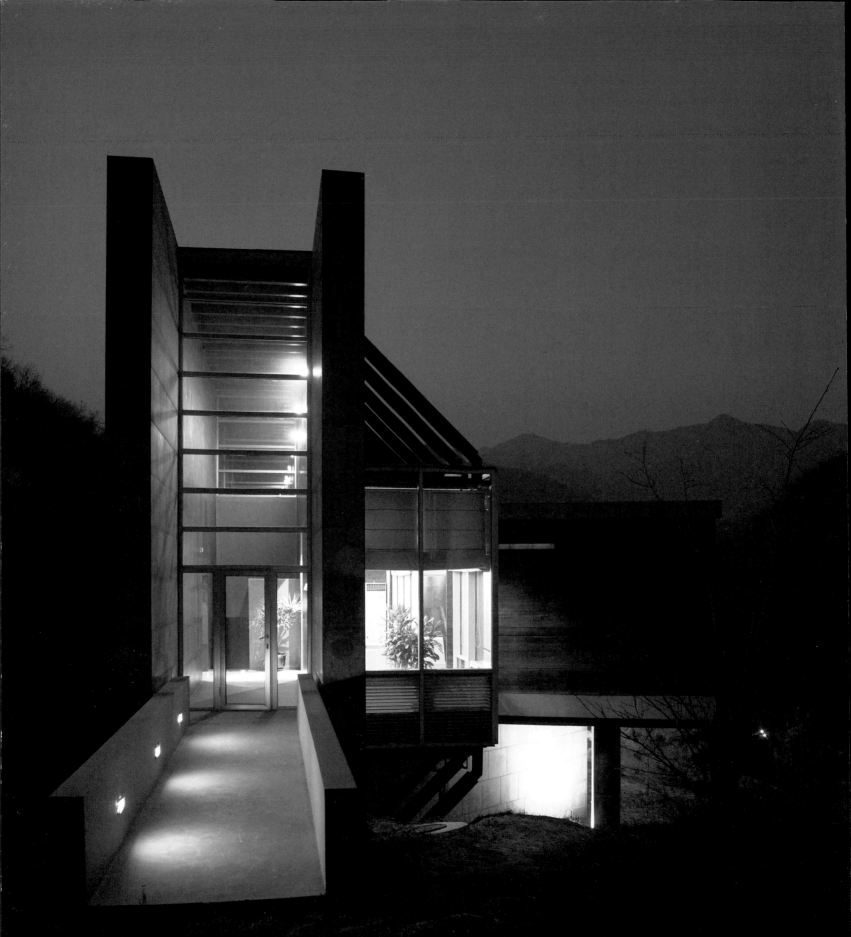

china LIVING

BY SHARON LEECE ▪ PHOTOGRAPHY BY A. CHESTER ONG

PERIPLUS EDITIONS
Singapore • Hong Kong • Indonesia

Published by Periplus Editions (HK) Ltd, with editorial offices at 130 Joo Seng Road #06-01, Singapore 368357.

ISBN-13: 978 0 7946 0435 6
ISBN-10: 0 7946 0435 8

Distributed by

North America, Latin America and Europe
Tuttle Publishing, 364 Innovation Drive, North Clarendon, VT 05759-9436 U.S.A.
Tel: 1 (802) 773-8930; Fax: 1 (802) 773-6993
info@tuttlepublishing.com
www.tuttlepublishing.com

Japan
Tuttle Publishing, Yaekari Building, 3rd Floor, 5-4-12 Osaki; Shinagawa-ku; Tokyo 141 0032
Tel: (81) 3 5437-0171; Fax: (81) 3 5437-0755
tuttle-sales@gol.com

Asia Pacific
Berkeley Books Pte Ltd, 130 Joo Seng Road #06-01, Singapore 368357
Tel: (65) 6280 1330; Fax: (65) 6280 6290
inquiries@periplus.com.sg
www.periplus.com

First edition
10 09 08 07
5 4 3 2 1

Printed in Singapore

Front endpaper Carved white screens at the Green T House, Beijing.

Back endpaper A Tang dynasty-inspired carved stone wall designed by Robarts Interiors and Architecture, Beijing.

Page 1 Variations on the traditional yoke back armchair in unvarnished wood, Green T House, Beijing.

Page 2 Side view of the Airport House designed by Chien Hsueh-Yi at the Commune by the Great Wall near Beijing.

Right A series of three stark white walls mark the entrance to Green T House Living, Beijing.

Overleaf A vaulted ceiling soars high over the dining room of the Garden of Delights, Beijing, designed by Antonio Ochoa-Piccardo. The painted panel was inspired by a work by Dutch painter Hieronymus Bosch.

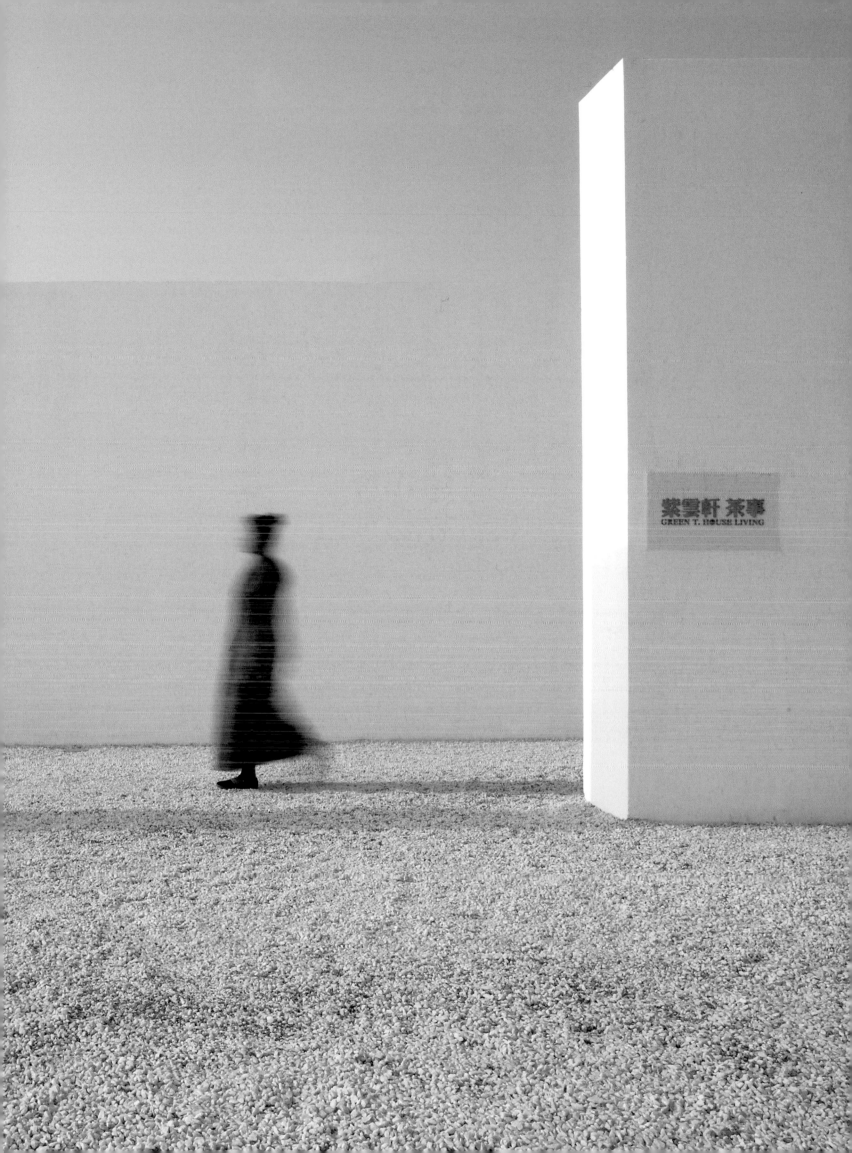

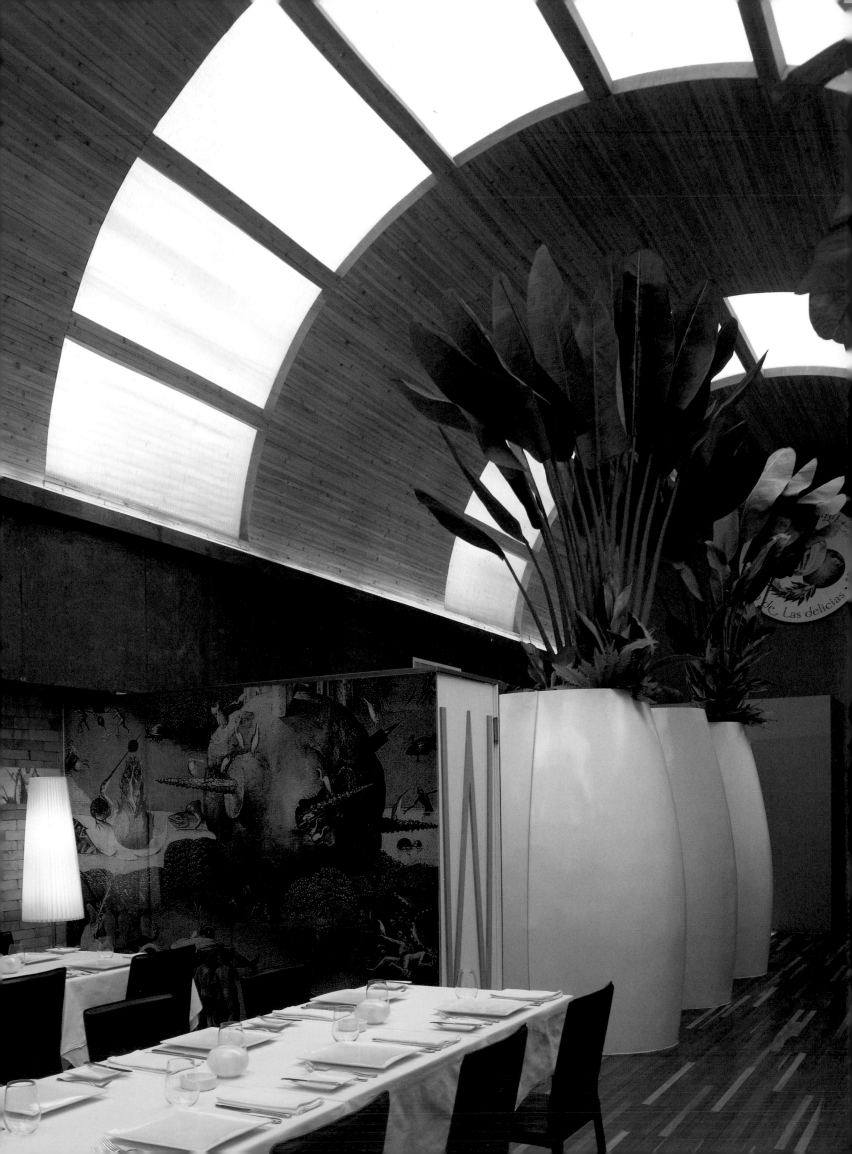

contents

back to the future

These are exciting times in the new China. Since the opening up of post-cultural Revolution China in the late 1970s, followed by the building boom of the 1990s and early 21st century, the country has changed immeasurably as huge economic and social transformations have swept through every aspect of life. In this rapidly developing nation, the pioneering spirit of a buoyant economy and a desire to embrace new opportunities is manifesting itself in innovative interior design and architecture projects.

A seemingly insatiable appetite for the new is leading architects and designers to take a forward-thinking and often visionary approach to their work. Almost overnight, gleaming skyscrapers are transforming the skylines of major cities with high-rise apartment blocks and office towers replacing traditional structures. One need only look at the statement-making architecture that is being constructed in Beijing for the Olympic games in 2008 to appreciate the desire of the country and its citizens to create a world-class environment presenting the face of modern China to the world.

One thing is for sure—in the midst of such great change, the only thing that is predictable is change itself. A lack of inhibitions means that in design terms almost anything goes. Whilst this may cause more conservative types to shudder, it allows room for fresh inspiration and creativity. With China's first generation of private architectural firms starting up as recently as the early 1990s, it comes as no surprise to see how this new change of pace is driving the desire for design to reinvent itself in this country.

Of course, in the race to build quicker, better, bigger, the results are not always positive. Sometimes the sensitive and the discerning are eschewed in favor of poorly planned and built developments. Critics also say the country's heritage is being lost in the race to embrace the future; although advocates say they are building a better life for the county and its citizens. But what is becoming clear in the midst of all this rhetoric is that a small but increasingly high-profile group of architects and designers is carving a path which focuses on quality design. And their bold statements about the future of Chinese design are now unfolding across the nation to increasing critical acclaim.

By infusing their work with a fresh vision that is totally Chinese in its essence and yet thoroughly international in its outlook, these architects and designers are busy creating a body of work that is global in its appeal even though it is rooted in local conditions. This work is often highly personal in nature, valuing the environment

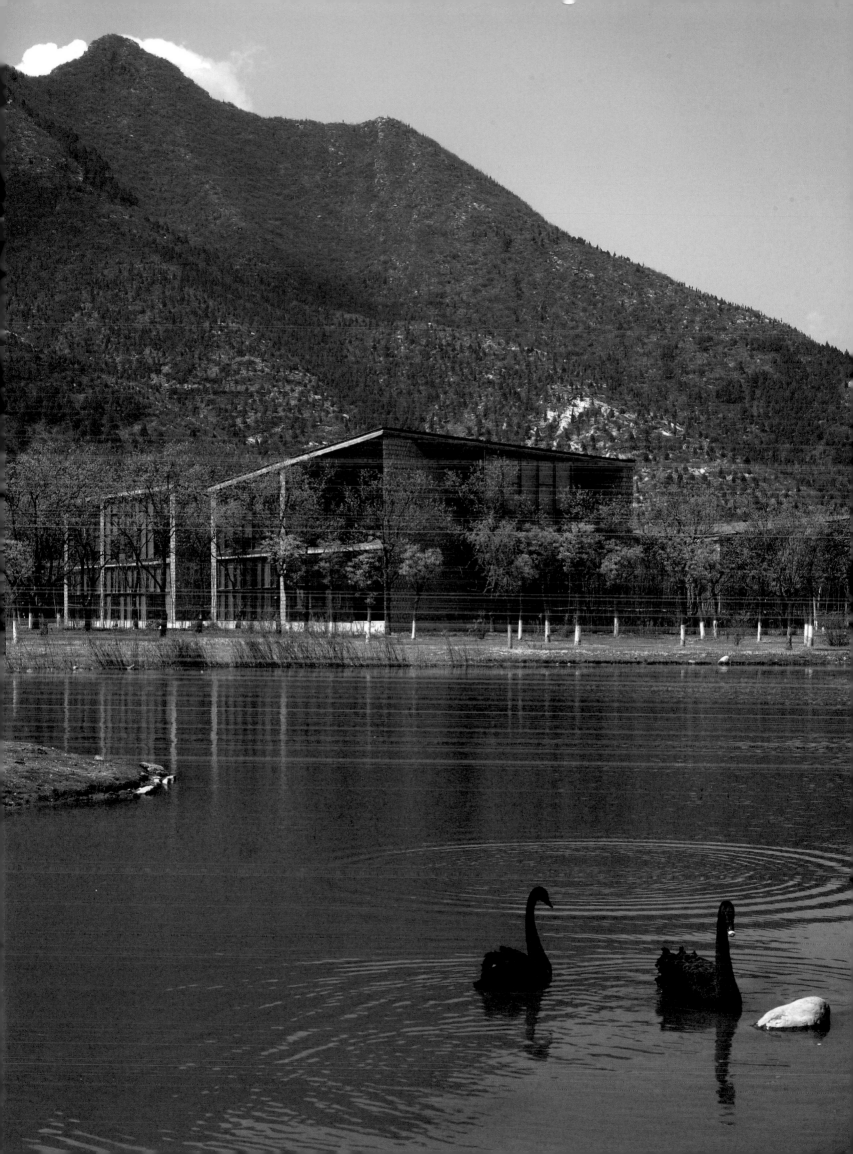

and incorporating local construction techniques and materials. It respects the past while looking to the future to create a new design aesthetic. This book presents the diverse landscape that is China today and in so doing explores a wide range of innovative new projects. From modernist mountainside villas to high-rise city apartments and artistic retreats in refurbished industrial zones—the array of modern living options in China is as diverse as the country itself.

One of the distinguishing characteristics of contemporary Chinese design is its thoroughly global outlook. Globalism is fast permeating all aspects of modern Chinese life, and designers such as Beijing-based Wang Hui feel that good design comes out of this cosmopolitan approach. "It's a kind of exchange," he explains. "If you only think about things in one way it is kind of limited; fresh information gives you new points of view from which to think about design."

With Chinese architects now having access to the world's top architecture schools and big-name foreign architects opening practices in the country, incredible new synergies are playing themselves out. It is the new generation of Chinese architects who are able to see their own culture from both within and without and are

thus able to reconnect with their roots in an international context. No longer is "Chinese design" traditional; on the contrary, the parameters of the genre have been intentionally blurred in a bid to meet the needs of modern clients. Traditional influences are low-key, rather than overt. Says Wang Hui: "The culture is already in my heart. Through design, I prefer to use it in subtle ways."

Experimentation is now at the forefront—with traditional materials and techniques being radically adapted to modern purposes. Structures such as the villas by Yung Ho Chang and Chien Hsueh-Yi at the Commune by the Great Wall and the award-winning Villa Shizilin by Yung Ho Chang and Wang Hui near Beijing, take a natural approach—using timber, compressed earth and local stone—and in so doing respect the history of the land to blend in seamlessly with the environment.

Such villas weave in many outside influences (designer and antique furnishings, space-making technologies and modern global comforts) yet remain rooted in their Chinese locality and sensitive to their surroundings. Today's Chinese architecture is modernist and minimalist, yet the materials used lend rawness and texture, reflecting a sometimes contradictory dialogue between

austerity and luxury which has come to define many new designs, especially in and around Beijing.

Such a dialogue says as much about the Chinese psyche—especially within the thriving artistic community—as it does about new design influences. What can be seen today is not just people's desire to push traditional boundaries and enjoy an enhanced standard of living but also a pent-up need to express creative aspirations through design. In Beijing, many of the architects, artists and creative types who are making news are self-taught practitioners who take quirky, non-conformist approaches to their work. A new, self-styled struggle is evident with few rules or restrictions holding them back. To be too comfortable would perhaps blunt the edge of innovation and hinder the quest for the new.

It is not just in Beijing—with its modernist, creative tension and aura of austerity—that boundaries are being pushed. In Shanghai, where the pace has been hard and fast and energy levels extraordinarily high, a tentative balance between heritage architecture and modern skyscrapers is still being struck. Design in this cosmopolitan, forward-thinking city is both heady and glamorous, emphasizing style and opulence, in contrast to the northern capital. Design directions in Shanghai are rooted in the city's multi-cultural history and delivered through its global commercial outlook.

Shanghai, like many of China's other major cities, is experiencing a building boom which has created new suburban centers, with villa developments ringing the city. Whilst styles vary, the most successful developments take inspiration from traditional architecture, with designs that renew the age-old Chinese dialogue between interior and exterior space. The classic Chinese courtyard house, the *siheyuan*, is a prime

Below James Law's Hong Kong home (see pages 124–131) is intelligent enough to interact with its user. Flexible animatronic walls and partitions, digital wallpaper, a cyber butler and video conferencing capabilities allow real space and cyberspace to merge.

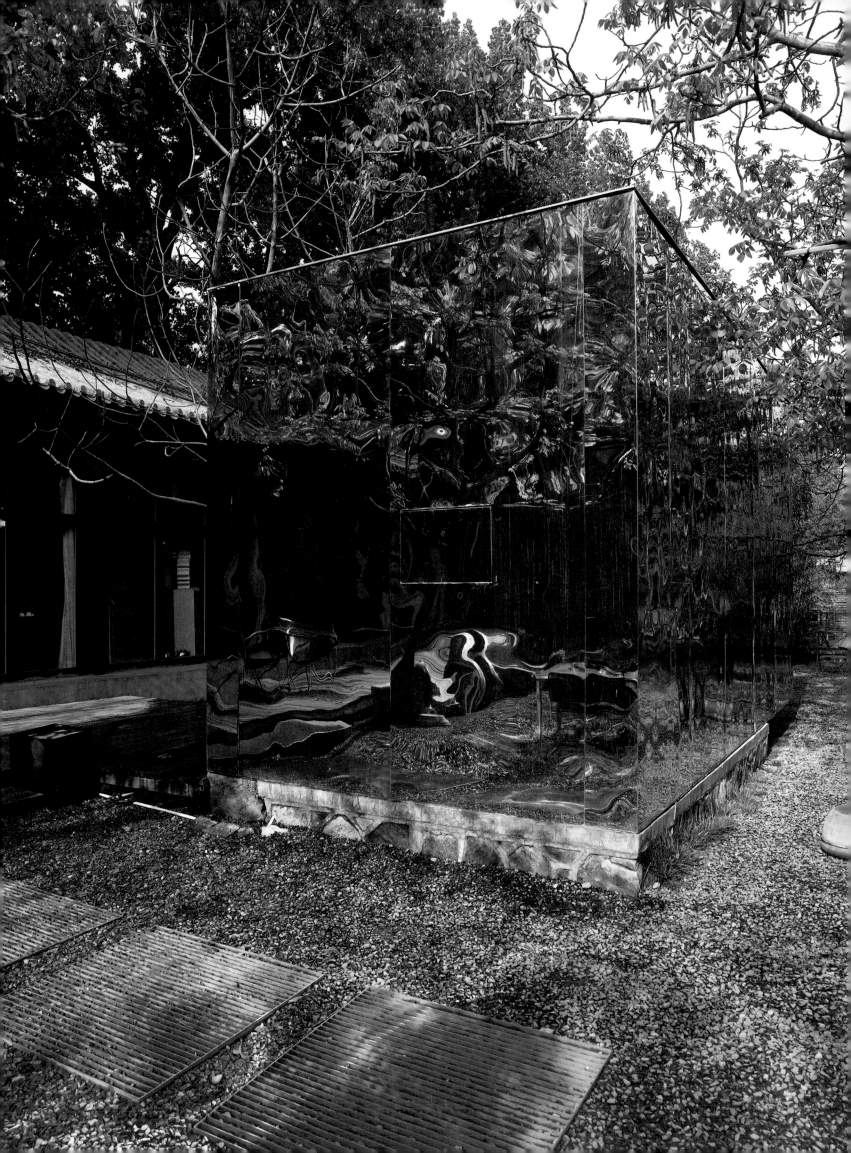

example of a traditional residential model that is being reinterpreted in novel ways.

Respect for history and the traditional family living arrangements is being increasingly recognized in this new architectural movement as thoughts turn from *chai* (demolition) to *bao* (preservation). There is a realization that new is not always better when it comes to redevel-opment. "We want to remind people how to bring older elements into a contemporary environment," says Daker Tsoi of The Lifestyle Centre, the developer behind The Bridge 8 complex in Shanghai—a former automotive plant that has been reconfigured as a creative retail and working space. "We always keep in mind that developing so-called Chinese culture is not just about taking an old drawing or just putting two Qing chairs in your living room. Rather it's about how people live, the size of the streets, the spatial rhythms and what they feel comfortable with. These are inter-esting elements that can be brought into contemporary architecture to represent China."

In Hong Kong—one of the most exciting and vibrant cities in the world—residential design continues to push new boundaries. Leading designers here are creat-ing homes with global appeal, applying new technologies and design concepts like nowhere else on the planet. Especially popular are homes providing new solutions for urban living in compact spaces. As befits a multi-cultural and international city, the people behind the projects come from varied backgrounds and are producing design directions that draw on their own indi-vidual experiences and world vision. Style and sophistication are the key, with inspirations from the classical Chinese attributes of balance, order and harmony being reinterpreted with a modern twist.

For the purposes of this book, contemporary Chinese design and architecture have been divided into four sections or "schools"—each revealing a different approach. "New Creativity" explores the work of designers who are revisiting classic Chinese motifs and architectural forms to produce elegant new spaces that are minimalist yet imaginative. Each project takes its inspiration from Chinese culture and art, reworked in a sophisticated manner to be compatible with modern living require-ments. Highlights include a stark white stone pavilion by Beijing-based designer, master chef and musician JinR; a clean-lined villa by Clarence Chiang and Hannah Lee; and a garden courtyard house by Rocco Yim.

Right Gary Chang's Suitcase
House at the Commune by the
Great Wall (see pages 176–179)
soars over the sloping terrain.
The 40-meter (130-foot) rectan-
gular box structure is a steel
frame clad with teakwood from
Western China.

"Urban Innovation" focuses on forward thinking, cutting-edge urban interiors. Energetic, inspirational and progressive, these projects subtly hint at cultural origins yet look firmly towards the future. City apartments such as those designed by Darryl W. Goveas, Ed Ng, Gary Chang and James Law reveal how innovative materials, flexible spatial transformations and the latest in cyber technologies can produce new and exciting residential interiors.

Experimental designs take precedence in "Elemental Appeal", which reveals how architects, designers and creative thinkers are pushing beyond established boundaries to create residences that favor function over luxury, innovation over tradition. Such unconventional approaches to design embody a respect for the past—simplicity of form, sense of craftsmanship—but they juxtapose the traditional and the modern in an un-inhibited way that often borders on the austere. The modernist influence is strong and homes featured include art collector Guan Yi's residence containing his

huge collection of contemporary installation art and Ai Wei Wei's austere grey brick duplex, now home to photographer couple RongRong and inri.

By contrast, "City Glamour" focuses on cosmopolitan inner city residences full of vision and flair. Here, Chinese and global elements combine with panache, infusing classic inspirations with contemporary textures, colors and patterning. Examples include Kenneth Grant Jenkins' geometric art deco duplex; Kent Lui's inside-out apartment and Andre Fu's Peak apartment full of lacquer finishes, wood veneers and Chinoiserie-style fabrics.

Such breath of vision, in all its permutations, reveals a single truth about Chinese design today: that the pace of change is every increasing. Freed from rules and restrictions, designers are now able to absorb influences from every quarter and chart their own path. The groundwork for the future of Chinese design is being laid today.

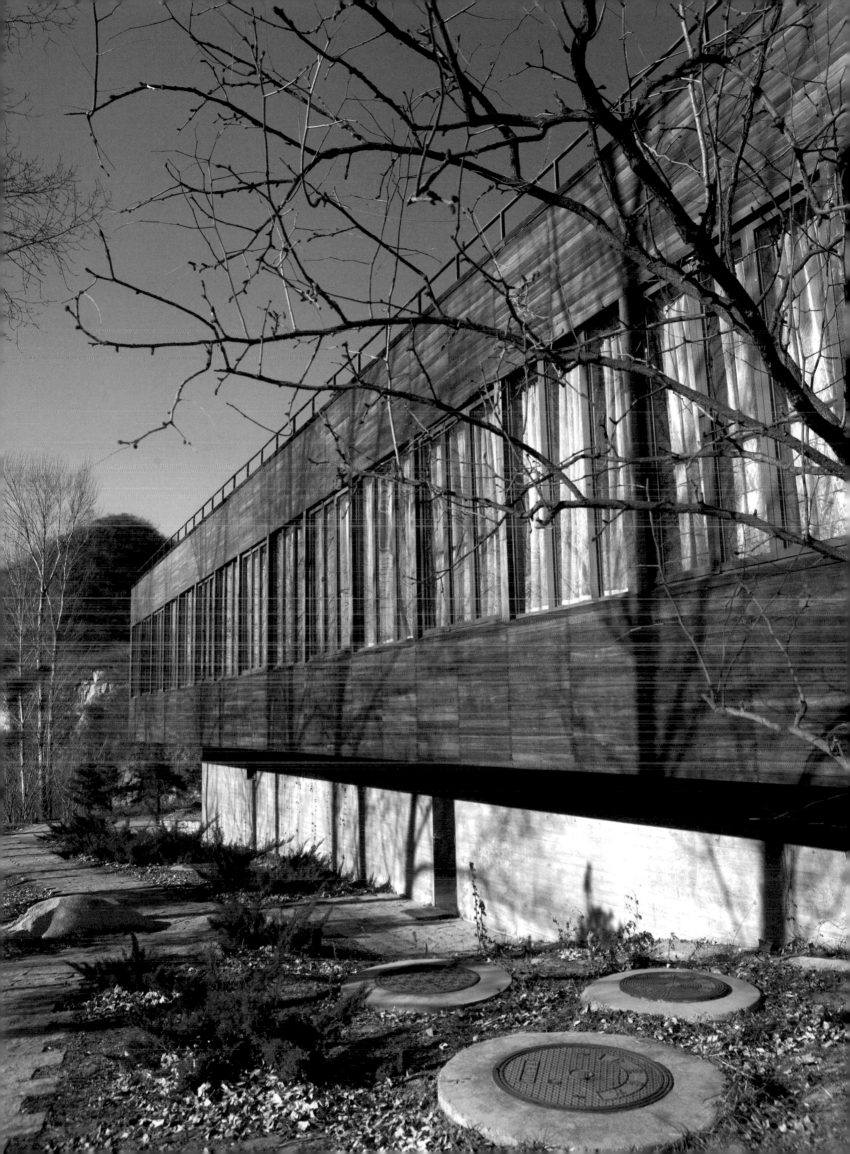

new creativity

By reworking traditional elements, a completely new Chinese aesthetic is emerging which respects the past but looks to the future. Demonstrating high style and cutting-edge sophistication, contemporary Chinese designers are transforming classic ideas in ways that make them not only relevant—but integral to modern living. Modern residences conceived along age-old design patterns—think Zhanguo period architecture, Tang dynasty motifs and Ming courtyard houses—affirm the validity of traditional ideas in a modern environment.

suzhou river duplex a cool zen-like space

Designer JIANG QIONG ER | Suzhou River SHANGHAI

THE SHANGHAI RESIDENCE of French architect Jean-Marie Charpentier is an exercise in Zen elegance—with pure sweeping lines and a minimalist approach. Based primarily in Paris, Charpentier, who founded Arte-Charpentier et Associes in 1969, has contributed to a number of key architectural projects in China, including the innovative Shanghai Grand Theatre.

A firm believer in nurturing Chinese design talent, Charpentier is also a partner in Shanghai-based Vep Design, alongside creative talent Jiang Qiong Er (see page 102). To create a home for his frequent visits to the city, Charpentier chose a 350-square-meter (3767-square-foot) duplex apartment on the edge of the Suzhou River and asked Jiang to redesign the space for him.

"He preferred to make something simple and pure," explains Jiang, who completely reworked the structure, opened up the space and installed a sweeping circular staircase in the middle to link the two levels. The curves of the staircase allow good energy flow and provide a sense of visual and sensual harmony. On the ground floor is a huge, double-height living room featuring a wall of windows which enable maximum light to enter the space. "Previously the proportions were not good so I installed the double windows to make the space work," says Jiang.

The upper level, which comprises a balconied area that wraps over the living room below and has bedrooms leading off to the sides, provides space for a study and to display Charpentier's collection of old musical instruments. Along the edge of the space is a long, wooden seating structure with a sloping back, based on the traditional Chinese *mei ren kao* bench, a kind of reclining garden chair.

In keeping with the minimalist, balanced proportions of the space, the furnishings are low key: antique, clean-lined blackwood Chinese chairs, an elegant altar table and cabinet and modern European designer pieces. The palette consists of muted tones of off-white, grey and stone. It is a serene space, perfect for contemplation and the ideal counterfoil to the dynamic, fast pace of the city outside.

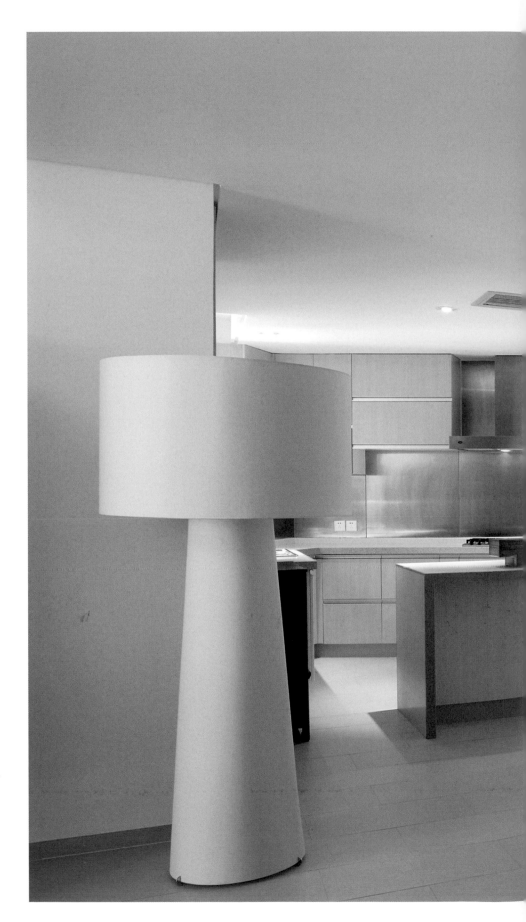

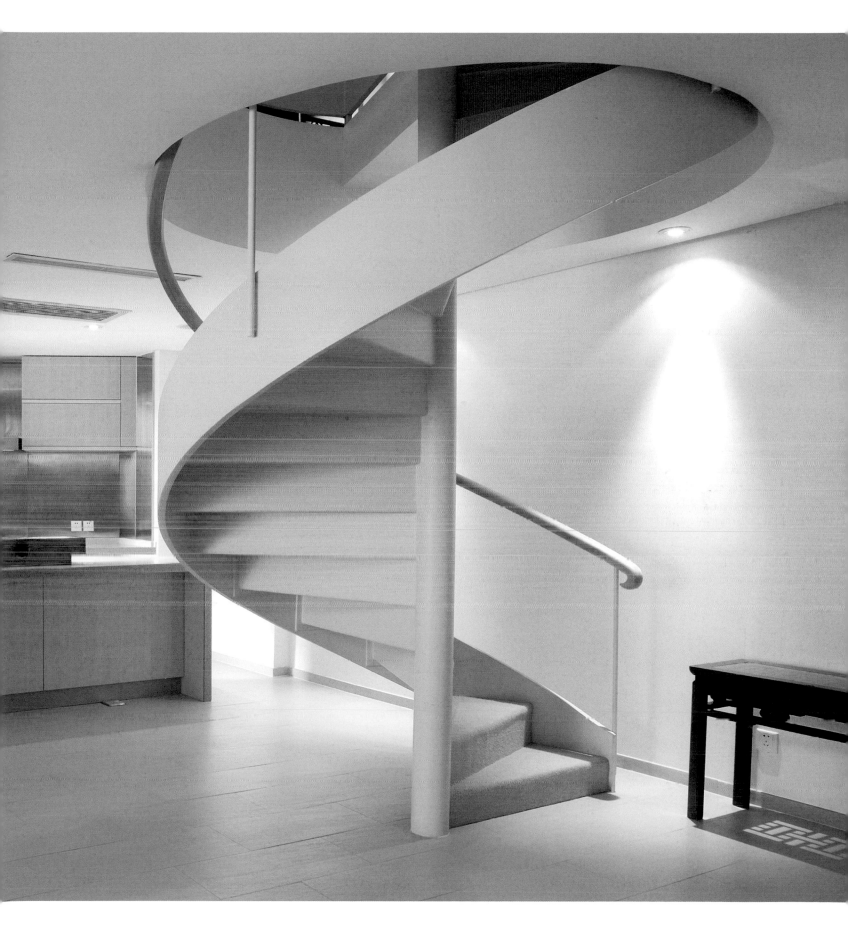

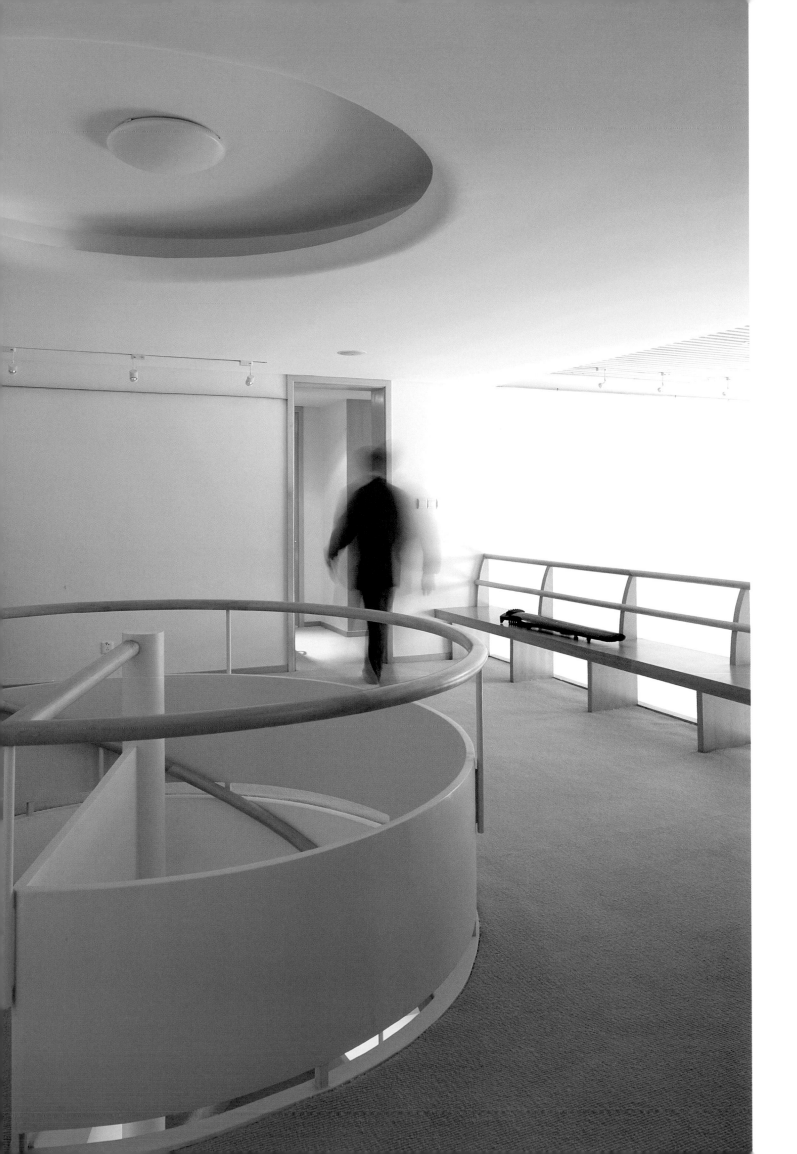

Left On the upper level, a bench inspired by the traditional Chinese *mei ren kao* bench found in Anhui's classical gardens functions as both a seating area and as a balcony railing. A guest bedroom can be glimpsed through an internal glass window beyond.

Below The ground floor salon benefits from double height windows installed to enable maximum light flow. The room is furnished with a combination of design classics, contemporary pieces and antique Chinese furniture.

Opposite The curvaceous lines of the staircase are echoed by a circular depression in the ceiling designed to showcase the light source. Pale carpeting echoes the neutral palette and adds warmth to the space.

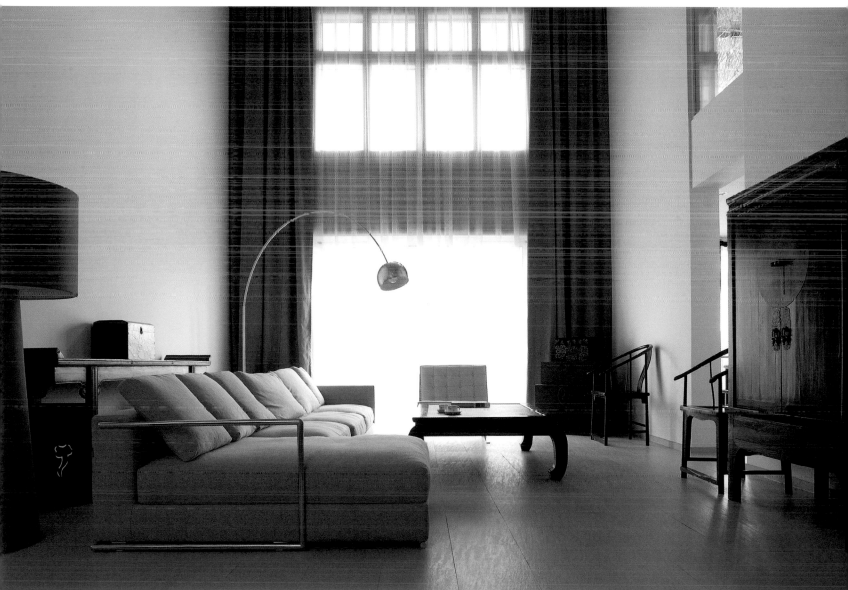

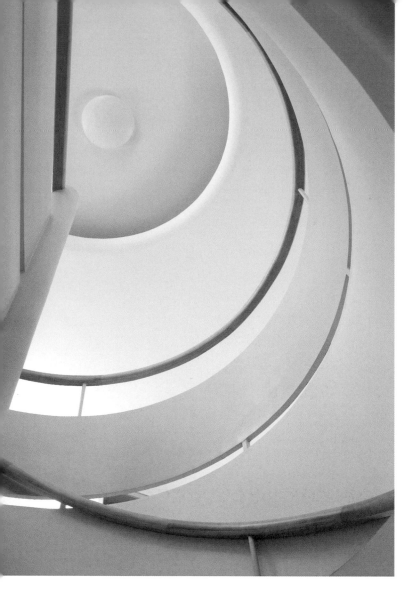

Left top A kaleidoscope of curves viewed looking upwards from the base of the staircase.

Left Elegant black and silver furniture pieces are juxtaposed with plain white walls. An antique blackwood horseshoe armchair contrasts effectively with a modern, Chinese-style stainless steel chair.

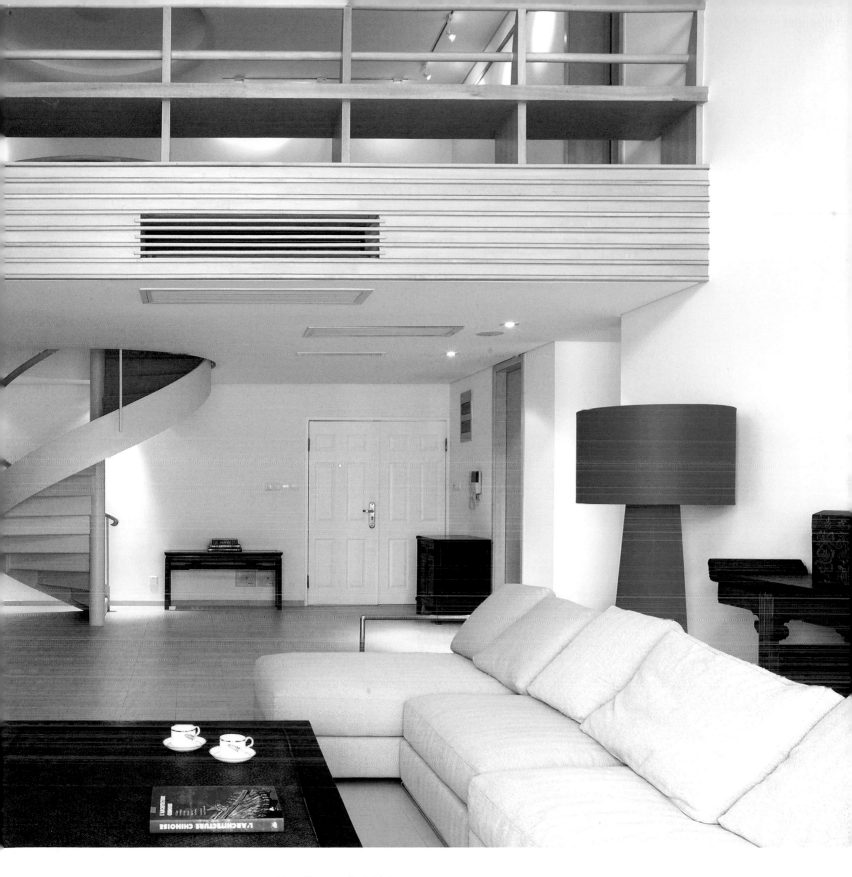

Above The use of pale timber on the upper level helps emphasize the sense of space and light. The collection of clean-lined antique Chinese furniture was sourced from No D Gallery.

green t house
fusion central

Designer JinR | Chaoyang BEIJING

WITH ITS MINIMALIST yet imaginative décor, rich atmosphere
and creative fusion food, Beijing's Green T House has set a
benchmark for modern design in the capital. Created by JinR
(Zhang Jin Jie)—her skills include musician, designer and
masterchef—the Green T House is a distinctive blend of
teahouse, restaurant and gallery.

Feted in the media as Beijing's "Queen of Style," JinR is known
for her desire to push boundaries and redefine conventions.
Her love of the traditional Chinese teahouse as a place to relax,
reflect and converse prompted her to create a space filled with
unique and beautiful objects of her own design. In 1997 she
had a tiny location with just three tables; next came a Tang
Dynasty-inspired interior with an intimate atmosphere akin to
a "mysterious old house." Today, the Green T House occupies
a light and airy space near the west gate of the Workers'
Stadium in the Chaoyang District of Beijing. With its clean
lines and distinctive Chinese aesthetic, it is "modern without
being foreign."

The restaurant's interior is an iconic blend of Alice in
Wonderland meets new China chic. A huge velvet curtain
pushes aside to reveal a dramatic interior furnished with white
latticework Chinese screens, slim white branches weaving
across the ceiling, sculptural high-backed chairs and hand-
painted silk lanterns. In addition, the culinary creations are so
beautifully presented that they are artworks in themselves.
Here, JinR has created a sense of theater in which anything
seems possible. "I want to create the best moment for people…
an experience they will always remember."

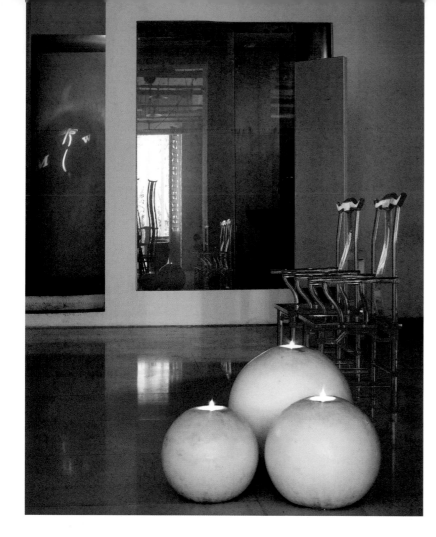

Left Oversized globe candles and two clear perspex yokeback armchairs designed by JinR glow under red overhead lighting which adds a sense of theater and drama to the space.

Below left A calming influence: in the study, a Zen-like bronze hand sculpture sits atop a pile of books.

Below In the office, a painting by artist Liu Fei is propped up in the corner behind a curtain of clear perspex disks. The white staircase leads up to a mezzanine level which houses a library of reference books.

Right The windows have been imprinted with red bamboo stencils. White soft furnishings, sheer curtains and a clear perspex tray and accessories ensure that the tea experience is as rewarding to the eye as it is to the tastebuds.

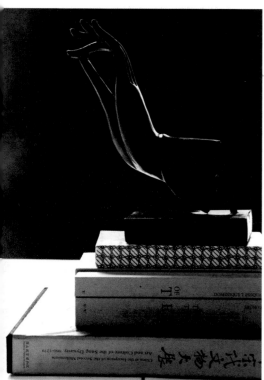

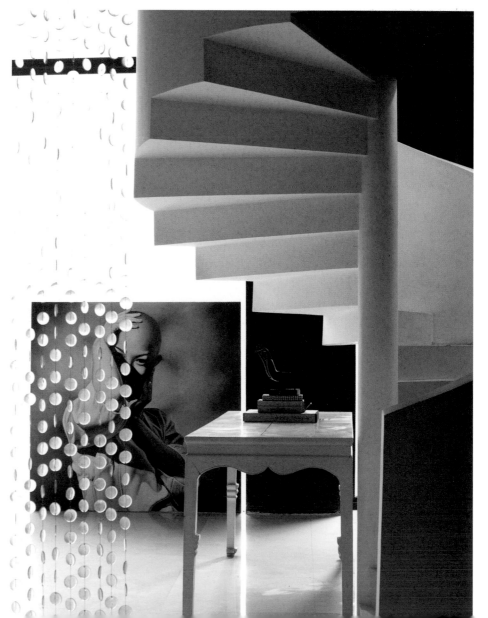

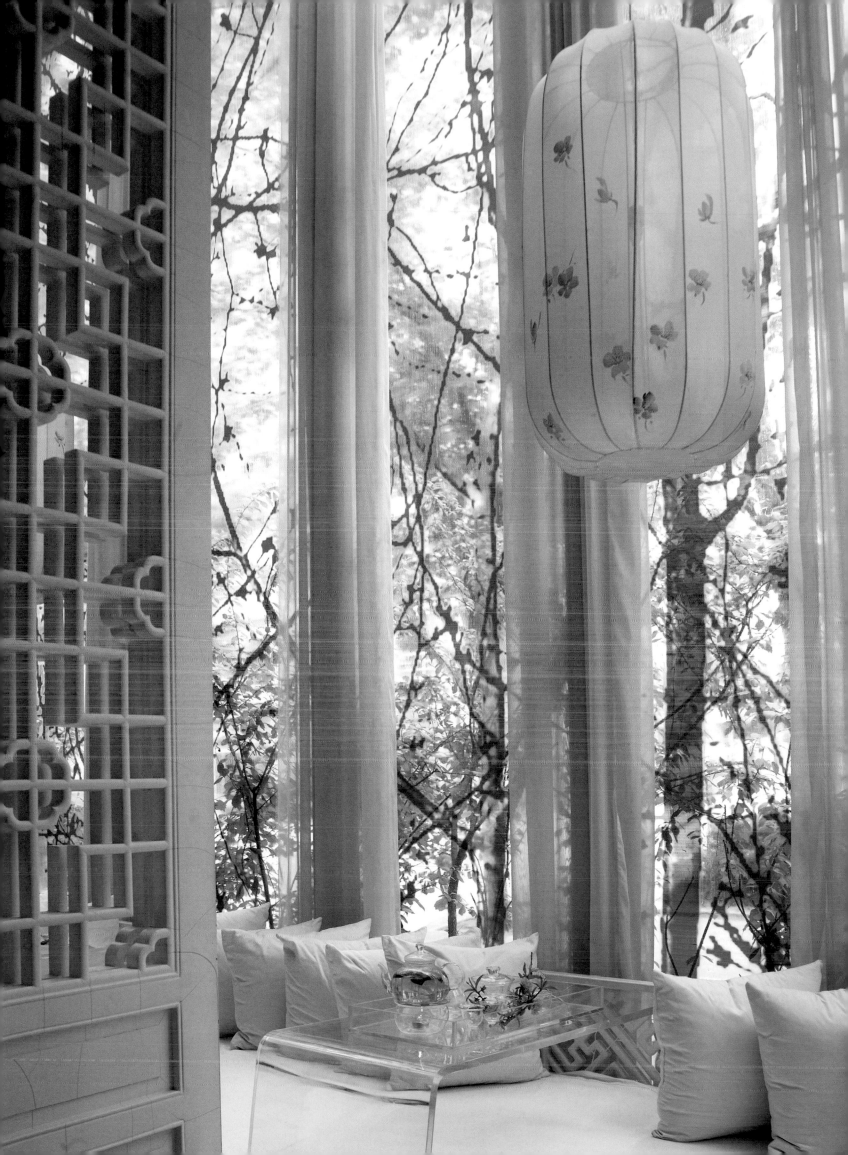

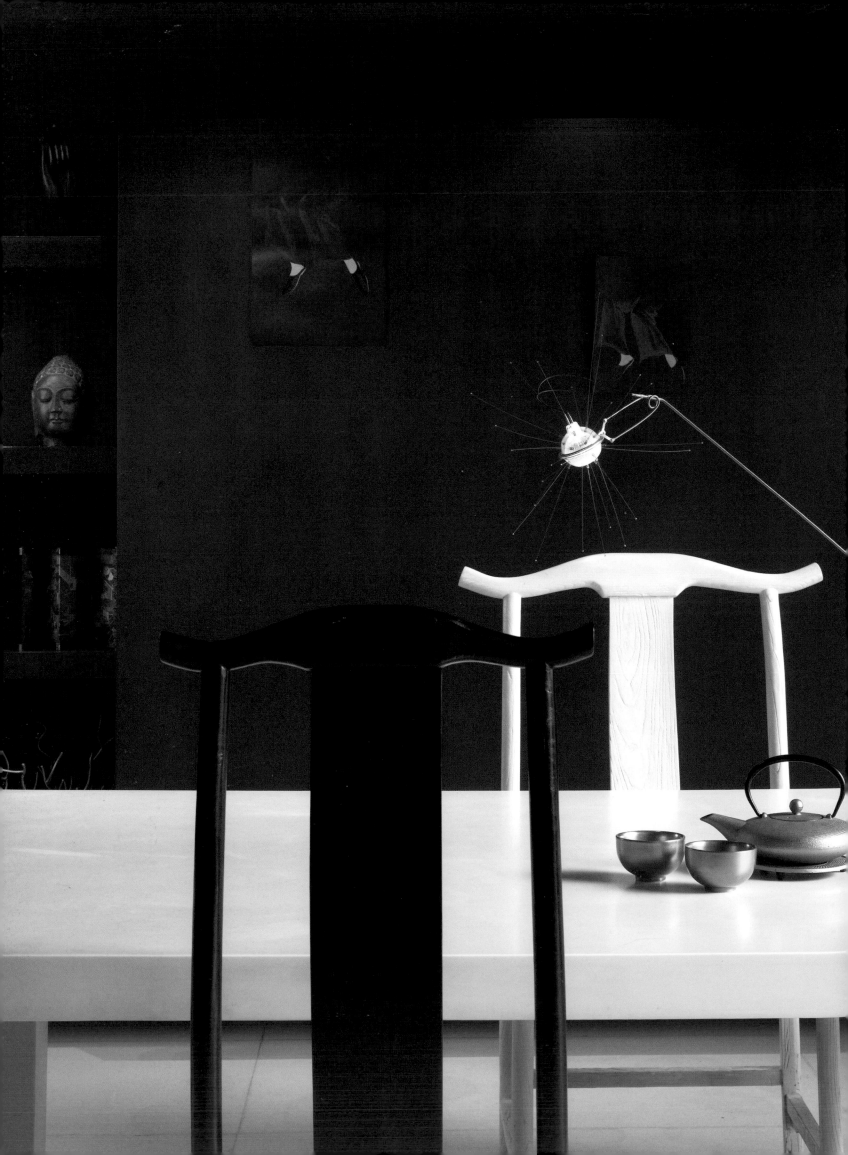

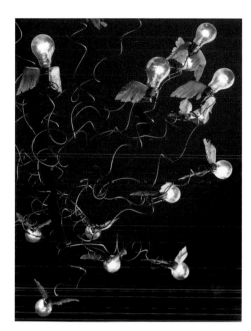

Above From the ceiling hangs the exuberant Birdie Chandelier by Ingo Maurer, comprising a series of low-voltage light bulbs with goose feather wings.

Right A private table in a corner of the restaurant is accessorized by high-backed chairs designed by JinR. Above the table hangs a Zettelz chandelier by Ingo Maurer consisting of sheets of Japanese notepaper clipped onto stainless steel wire cables.

Right top The restaurant is filled with sculptural chairs with 3-meter-high (10-foot-high) backs designed by JinR. Each chair is a whimsical reinter pretation of a classic Chinese design.

Left In contrast to the restaurant, the office features bold red walls to offset a series of black and white yokeback-style armchairs. Paintings, bronze artifacts and lacquerware tea sets accessorize the space.

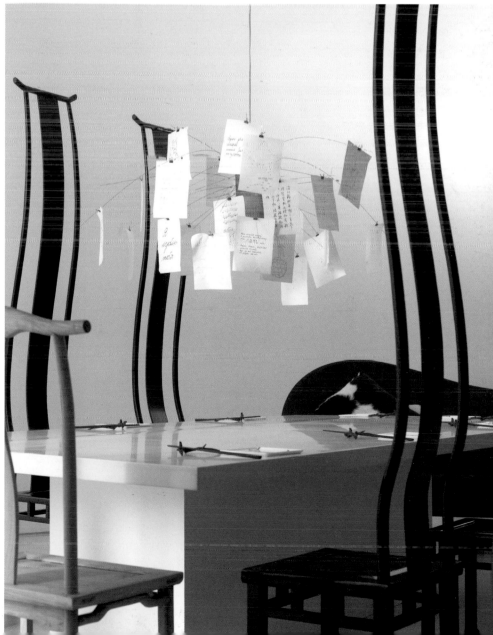

the white house
modern glamour by the sea

Designer DEBORAH OPPENHEIMER | Chung Hom Kok HONG KONG

WITH ITS SCULPTURAL WHITE STAIRCASE, polished white lacquer flooring and sophisti-cated color scheme, the spacious, light-filled home of Jung Ho and Helen Park is an exercise in pared-down glamour. Located on Hong Kong Island's Southside, the 400-square-meter (4306-square-foot) home benefits from both sea and mountain views and is filled with that very special quality of light inherent to this part of Hong Kong.

Interior designer Deborah Oppenheimer of Deborah Oppenheimer Interior Design Ltd created a clean shell which has a liquid quality and which is at the same time serene, calming and comfortable. "We all had a vision of a white house, with white lacquered floors and Statuario marble, everything very simple and very white," she explains.

The focal point of the house is the large molded staircase that sweeps upwards, developed in collaboration with architect Michael Chan. "We felt that by having a white core with a sculptural element in the middle, we would be getting away from a cookie cutter environment," says Oppenheimer. To balance the white palette, soft auxiliary colors such as mouse grey, taupe, duck egg blue and charcoal have been woven in to form a neutral but luxurious backdrop to the Parks' collection of contemporary Chinese art, sculpture and photography.

The use of high quality materials which coordinate perfectly adds elegance to the interior. The high gloss lacquer floorboards needed seven coats each to create such a high gloss finish; oversized lime-stone slabs "float" in the entrance hall; finely woven dark taupe vinyl lines the stairs and glazed linen drapes edged with velvet hang from the windows.

Oppenheimer has cleverly blended elements from around the world, including her native South Africa, to achieve an environment that both reflects different cultures and at the same time works as a cohesive whole. "We enjoyed the meeting point of different cultures and ethnic influences. There was a great harmony achieved by using elements such as Chinese ceramics, art and sculpture alongside African ceramics and landscape photography—in terms of color and texture as well as content."

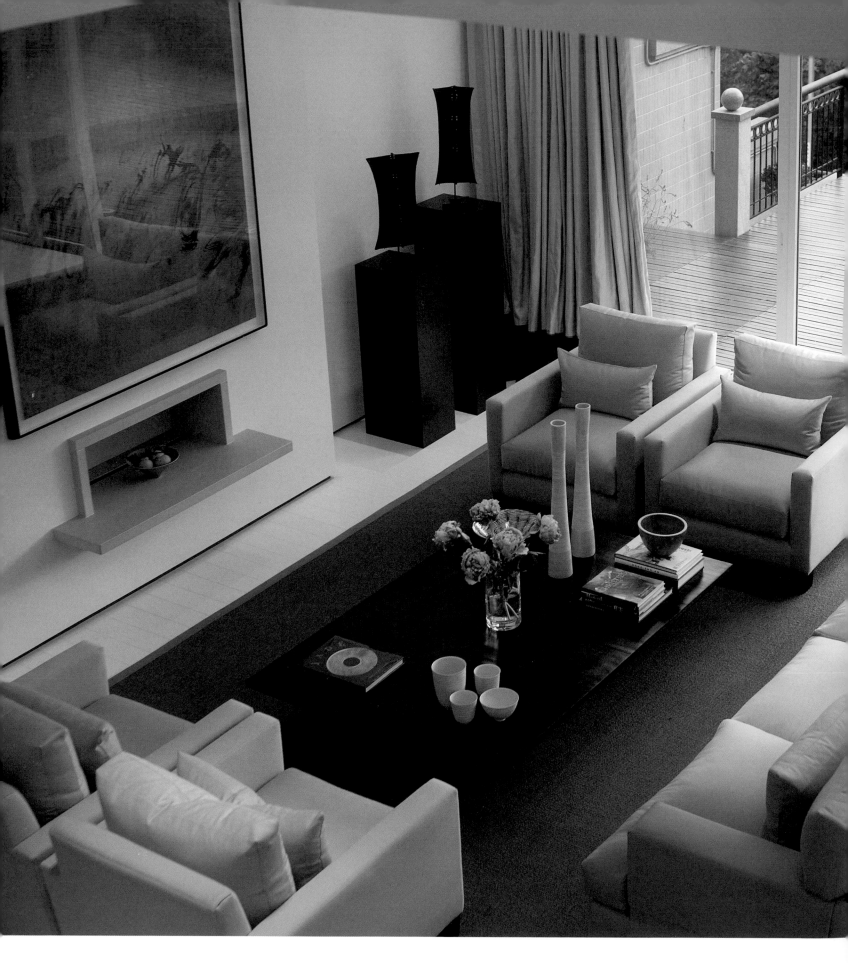

Above The living room is an exercise in luxury and pared-down elegance. Serene shades of taupe and charcoal offset the pure white palette. In the center of the room is a coffee table made of compressed bamboo.

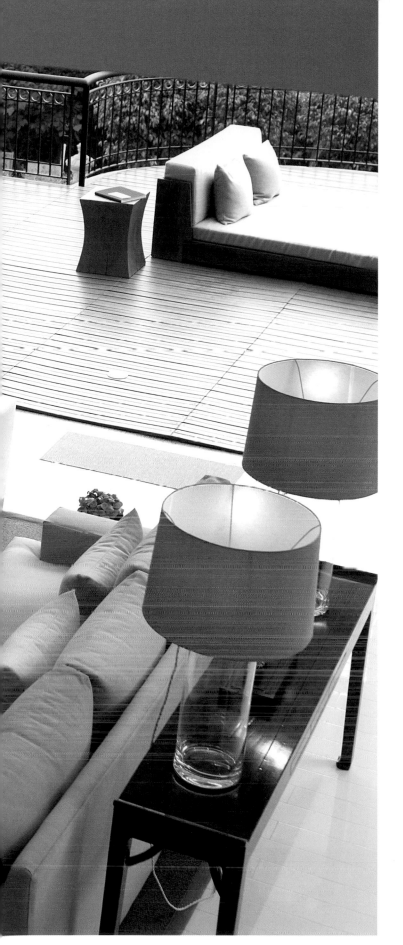

Above top A molded handrail is recessed into the side of the sculptural staircase; lights are positioned at skirting level.

Above Elegant dark taupe vinyl matting has been used for the floor of the staircase. It has a fine weave yet is very practical.

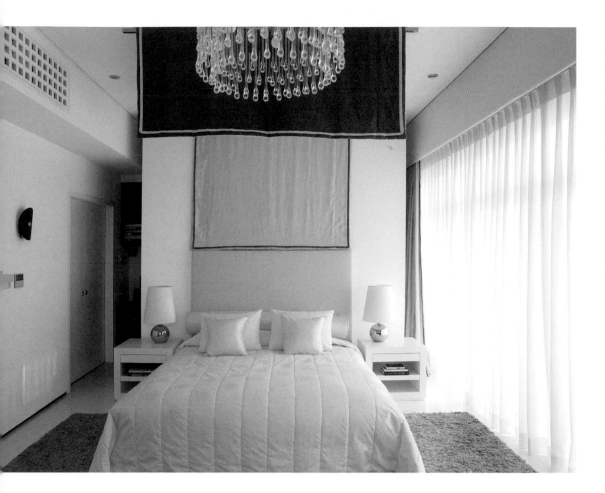

Left The master bedroom is a symphony in white, cream, taupe and ivory. Adding extra glamour is a crystal drop chandelier, ivory glazed linens by Rubelli and a tri toned loose pile linen rug.

Below The son's light-filled bedroom has been accessorized with a pale blue and charcoal color scheme. In the corner is a miniature horseshoe armchair; above the bed is a large pinboard.

Right The family room is both cosy and stylish featuring tailor-made white shelf units to display sculptures and photographs. Above a faux lizard ottoman hangs a pleated lampshade by Santa and Cole.

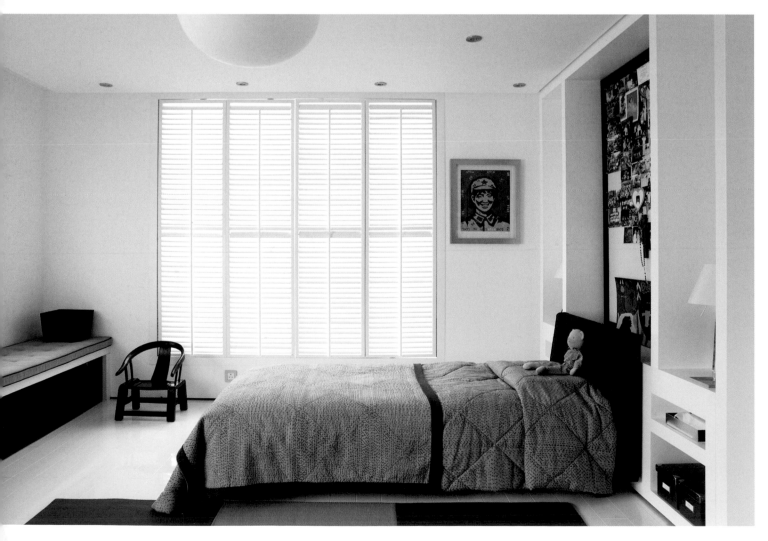

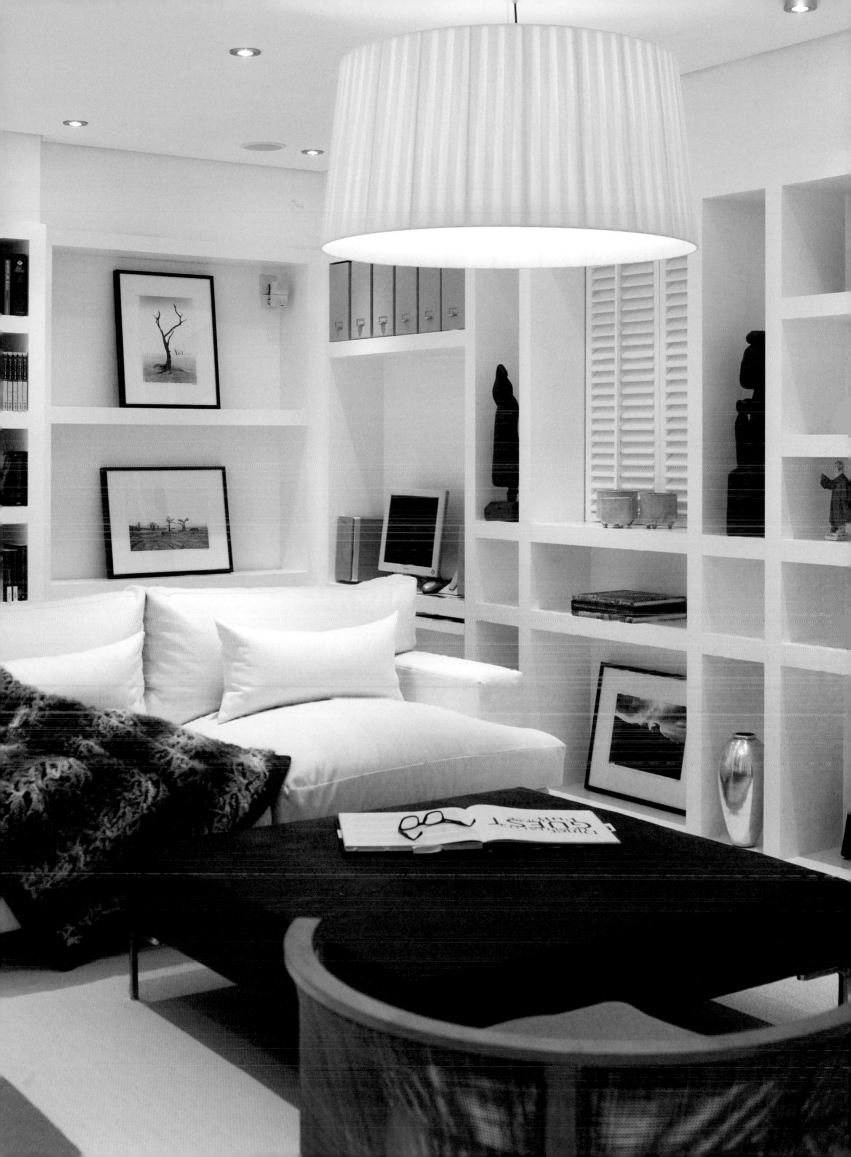

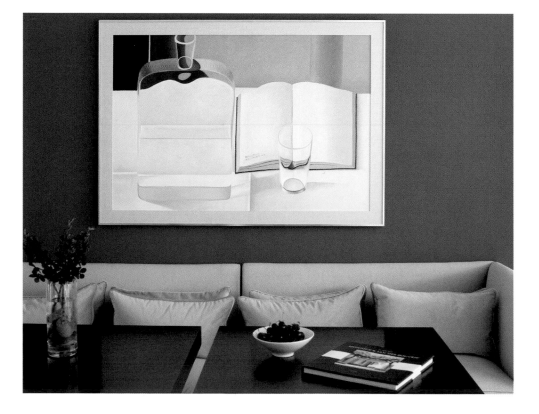

Above left Blanket-stitched blue and charcoal felt rug by Roger Oats.

Above center Glass mosaic tiles in the bathroom continue the taupe and pale blue color scheme.

Above right Close-up of Zhu Wei sculpture.

Left The dining room features a dark charcoal taupe wall as a backdrop to the pale, duck egg upholstery. On the wall hangs a painting by Natalie du Pasquier.

Opposite top With its picture windows, the living room offers picturesque views of the surrounding hillside. Rubelli linen curtains trimmed with dark taupe velvet contrast with the white lacquer flooring.

Opposite left Molded chairs flank a kitchen island which is topped with Statuario marble.

Opposite right A painting by Hong Zhu An hangs in a corner of the living room. The pair of rectangular sculpture stands to the right were designed by Oppenheimer.

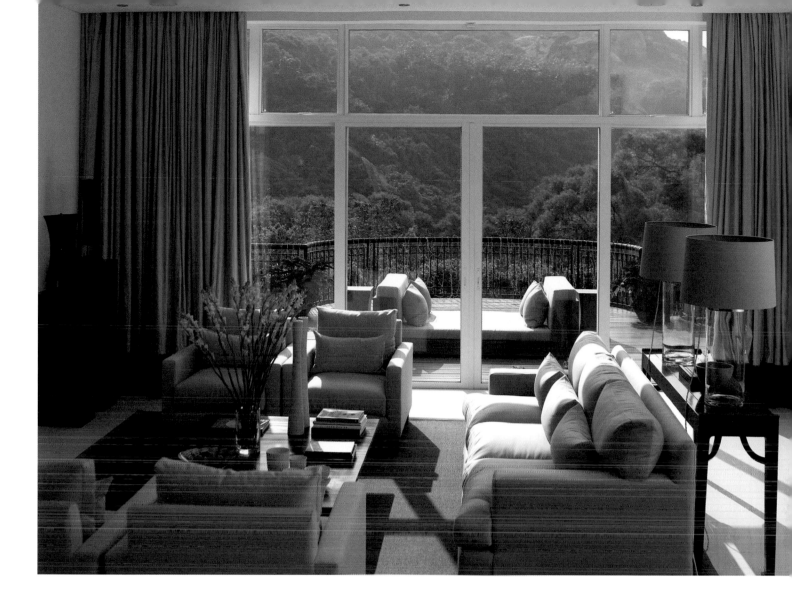

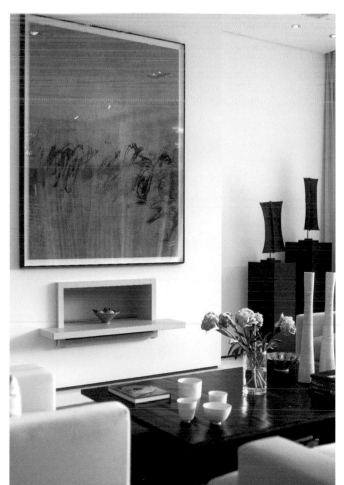

tang villa
new courtyard house

Designer ROCCO YIM and WILLIAM LIM | Pudong SHANGHAI

THE SPRAWLING DISTRICT of Pudong, located on the east bank of Shanghai's Huangpu River, is becoming the city's financial and commercial hub. Just over a decade ago, Pudong was mainly farmland; today the area is a glittering mass of futuristic skyscrapers which face across the river towards the classical art deco buildings of The Bund.

With its wide boulevards, sculpted parks and ordered sense of space, Pudong is home to growing numbers of high end villa developments. One of the most noteworthy is the Mandarin Palace or Jiu Jian Tang, a collection of modern Chinese garden houses designed by architects from China, Hong Kong, Taiwan and Japan. Since classical times, gardens have been an important element in the homes of China's elite, demonstrating the status of their owners.

The largest villa here is the Tang Villa by Hong Kong-based architect Rocco Yim of Rocco Design for developer Shanghai Zendai Delta Property. The interior design is by William Lim of CL3. Designed as a contemporary take on the Chinese courtyard house, the villa—which measures 900 square meters (9500 square feet) and is on a 2,000-square-meter (21,000-square-foot) plot of land—combines traditional Chinese architectural and cultural concepts with modern living requirements.

The expansive space is divided into several distinct areas—an impressive glass-walled formal reception hall and dining room with visible system of supporting pillars is on the ground floor with the guest and family quarters to the side. On the upper level is a master suite with bedroom, bathroom and study; in the basement is a gallery space, games room and bar.

Nature is highlighted at every opportunity. As water is an integral element in the Chinese garden, one enters the villa across a stone walkway flanked by fish-filled ponds. Beyond is the glass-walled reception hall, with soaring 8-meter-high (26-foot-high) ceilings and an angled roofing structure inspired by traditional cylindrical roof tiles. Inside, an oversized wooden screen in the living area echoes the zigzag shapes of mountains in traditional Chinese painting. Wooden lattice screens and internal glass walls allow maximum sunlight and views into the gardens; and a pendant lamp in the dining area follows the form of the traditional Chinese stylised cloud motif. Bamboo groves, planted throughout the property, both in the courtyards and in the gardens, bring nature further inside.

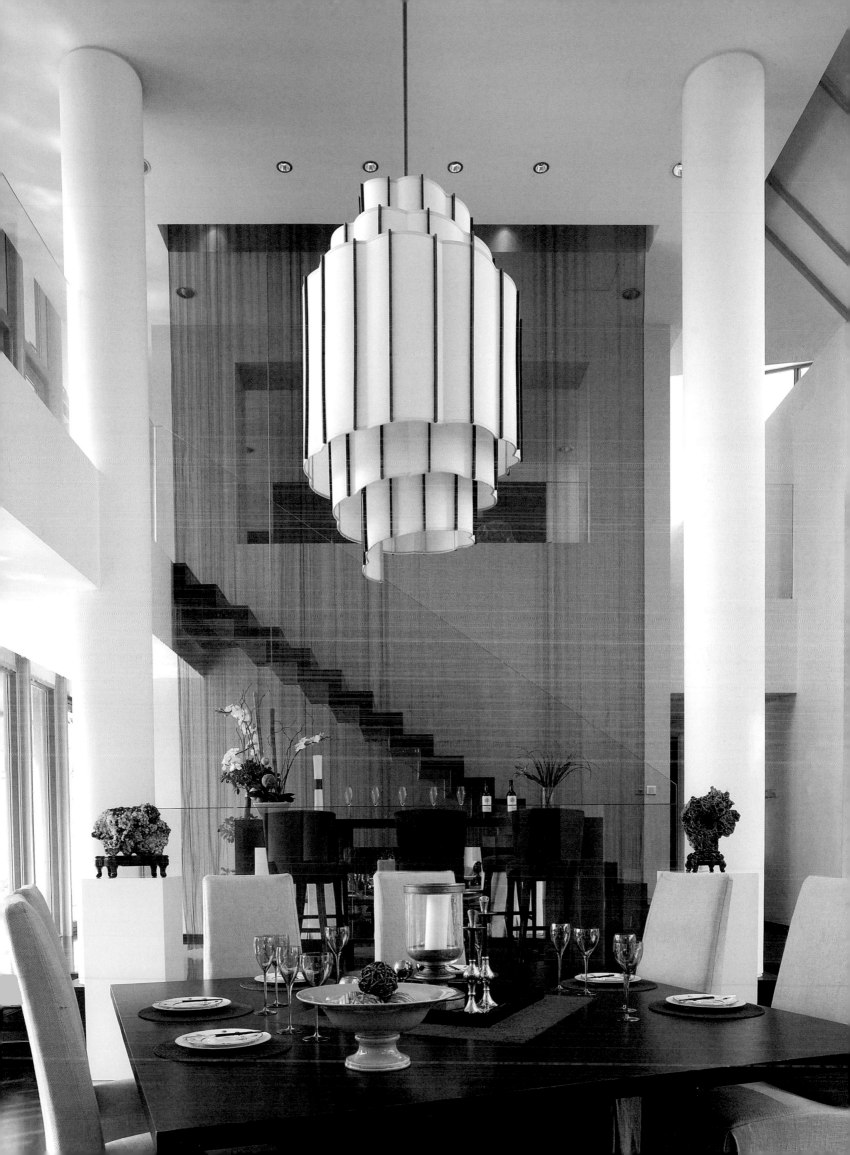

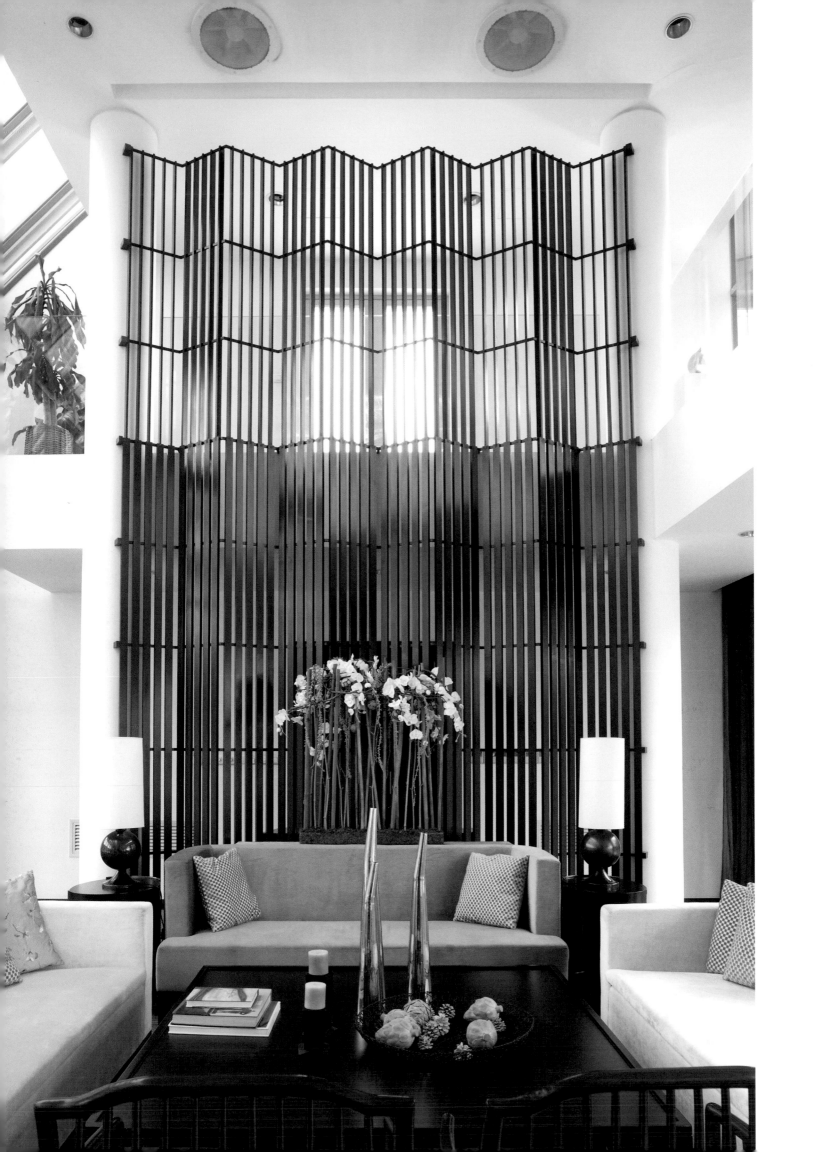

Right The glass-walled reception hall offers views of the pond-filled courtyard outside. The angled roofline is graceful and elegant.

Far right Upstairs, warm wood paneling works with neutral furnishings to promote a cool, calm atmosphere.

Below A brown palette informs the master bedroom which features a large four-poster bed and luxurious linens and throws.

Left An oversized wooden screen in the living area echoes the zig-zag shapes of mountains in traditional Chinese paintings.

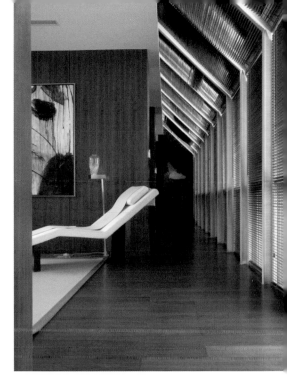

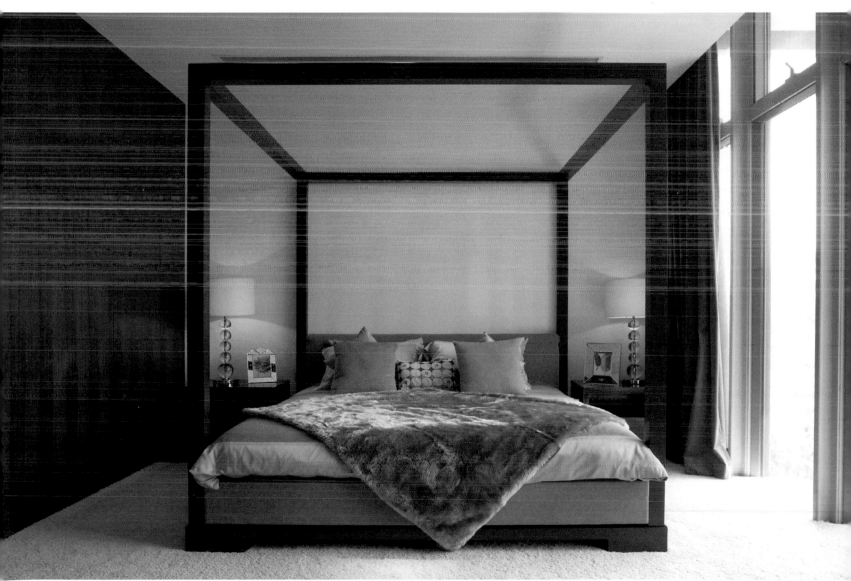

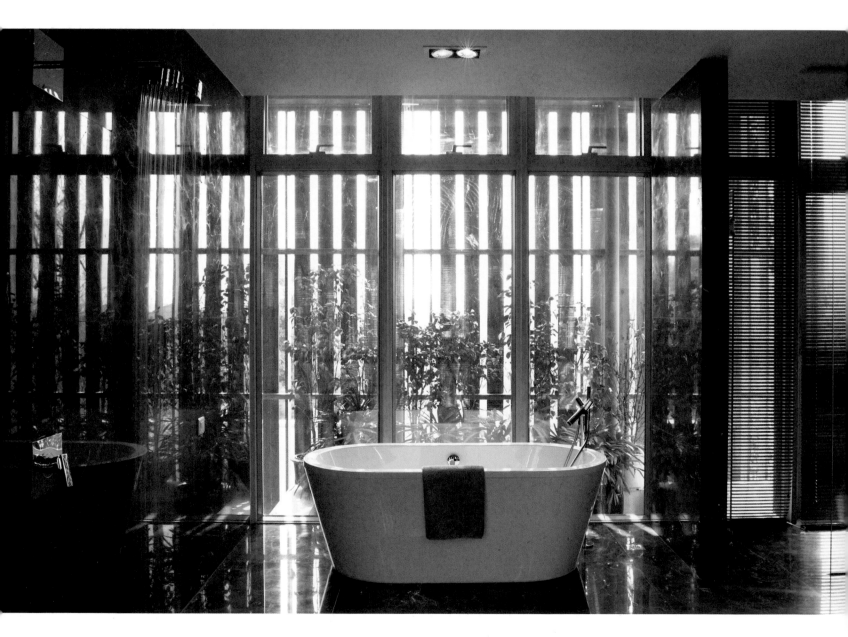

Above top Bamboo groves bring nature inside at every opportunity.

Above The black marble master bathroom has a Philippe Starck tub. Floor to ceiling glass windows offer green vistas outside.

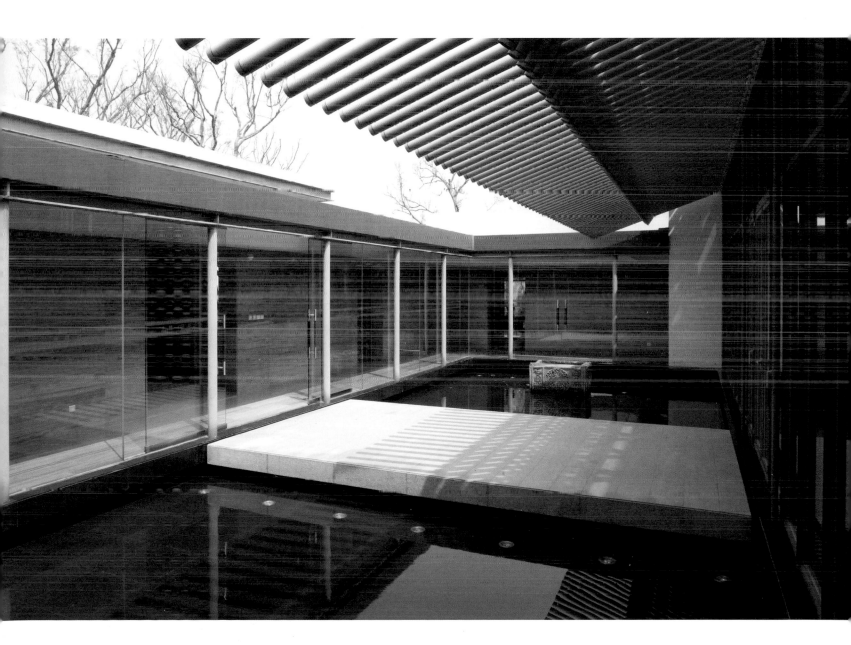

Above top A wall in the entrance corridor is composed of stones piled behind a wire mesh grid.

Above This contemporary reinvention of the traditional Chinese mansion features a pond-filled courtyard inside the front entrance.

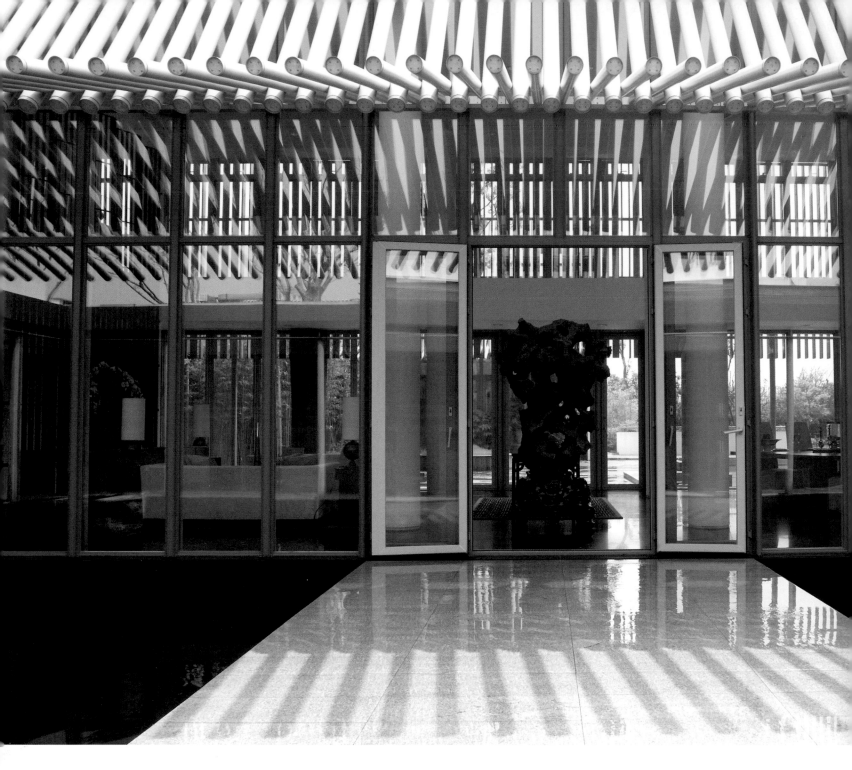

Above A stone bridge leads into the glass-walled living areas. The roof was inspired by traditional cylindrical roof tiles. A huge rock sculpture stands at the entranceway; rocks such as these traditionally signify bringing the mountains into an urban setting.

Right Looking back to the entrance. The design affords maximum privacy and complies with the classic Chinese concept of the home being a refuge from the outside world.

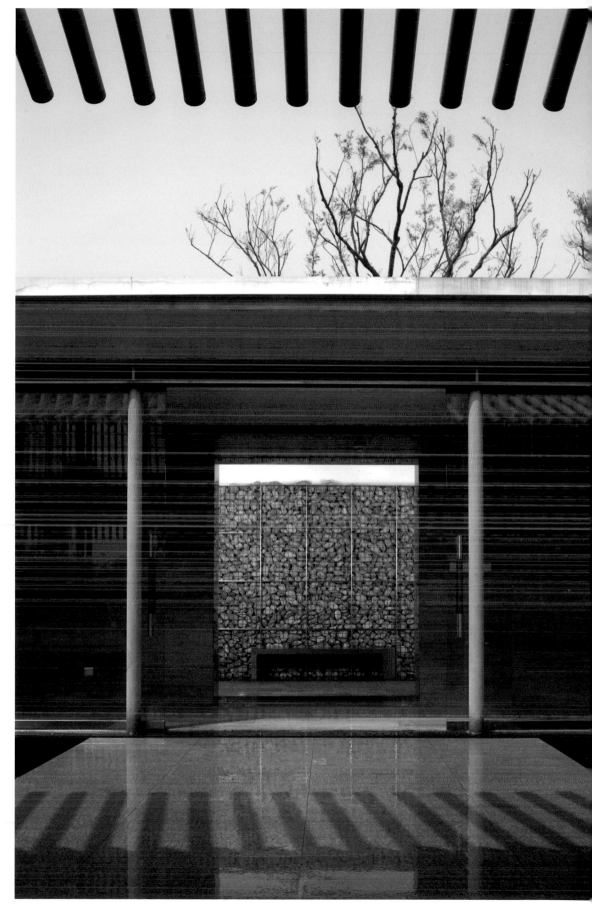

Left Light floods into a serene guestroom though angled glass panels in the ceiling. Furnishings are a mix of classic Chinese and contemporary designs.

Below In the basement, an informal living room, bar and games room with a modernist palette of black, white and grey. Windows offer views of a bamboo-filled courtyard.

Right top and bottom Garden design has long been considered an art form in China. Here, a gracefully landscaped courtyard blends nature and culture, both ancient and modern.

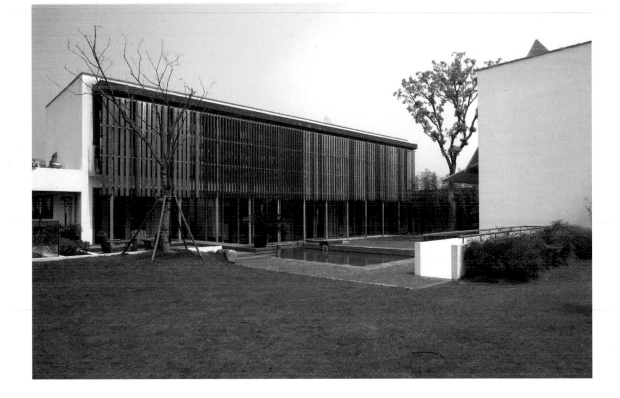

tian an villa
back to nature

Designer TEAM HC | Songjian SHANGHAI

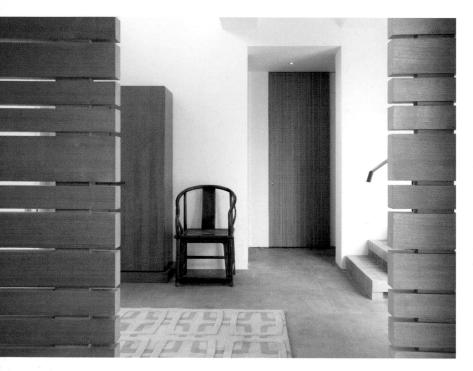

As CHINA'S CITIES GROW, a new trend in residential housing is emerging. In an effort to relieve inner city congestion, gated villa developments now stand on the outskirts of major cities where rural farmland used to be. The Tian An Villa complex, in Shanghai's Songjian district about 40 minutes' drive from the city, is located near She Shan Mountain and enjoys a landscape of winding streams, green lawns and bamboo groves.

Whilst each villa is uniform in external appearance, the interiors offer ample opportunity for creativity. Architect Clarence Chiang Jr and interior designer Hannah Lee of Hong Kong-based Team HC used principles of simplicity, harmony and balance to convert a 500-square-meter (5382-square-foot) villa into a luxurious holiday retreat for the owner and her family. The expansive space now comprises an open living and dining area on the ground floor; a guest wing to the right and a glamorous upstairs master bedroom suite with double-height ceilings, glass walls and closets. An upper floor sundeck and balcony plus a huge, ground floor terrace offer ample outside space.

The design duo has produced a clean-lined, flexible interior, relying on natural materials and harmonious shapes to define the minimalist space. "There are lots of layerings in this house," says Chiang. "Simple materials have been strung together to create particular forms." For example, an open staircase made of 15 x 30-cm (6 by 12-inch) ashwood planks connects the two levels whilst sliding screens in the entryway are composed of wood panels of differing widths. "At the time of construction we were developing a lot of screen ideas for our furniture line in the United States so we were really into screens and finishings that were crafted manually," Chiang explains. "We wanted to bring these ideas into the house as well."

Utilizing local craftsmanship was the key: "Due to the low cost of craftsmanship we were able to explore ideas here which would have been impossible elsewhere in the world," says Chiang. The huge, 2.7-meter-high (8.8-foot-high) pivot hung doors, for example, are made of solid ash with a sawcut finish, a technique previously used only for smaller furniture pieces. Such subtle detailing adds a richness to the pared-down space.

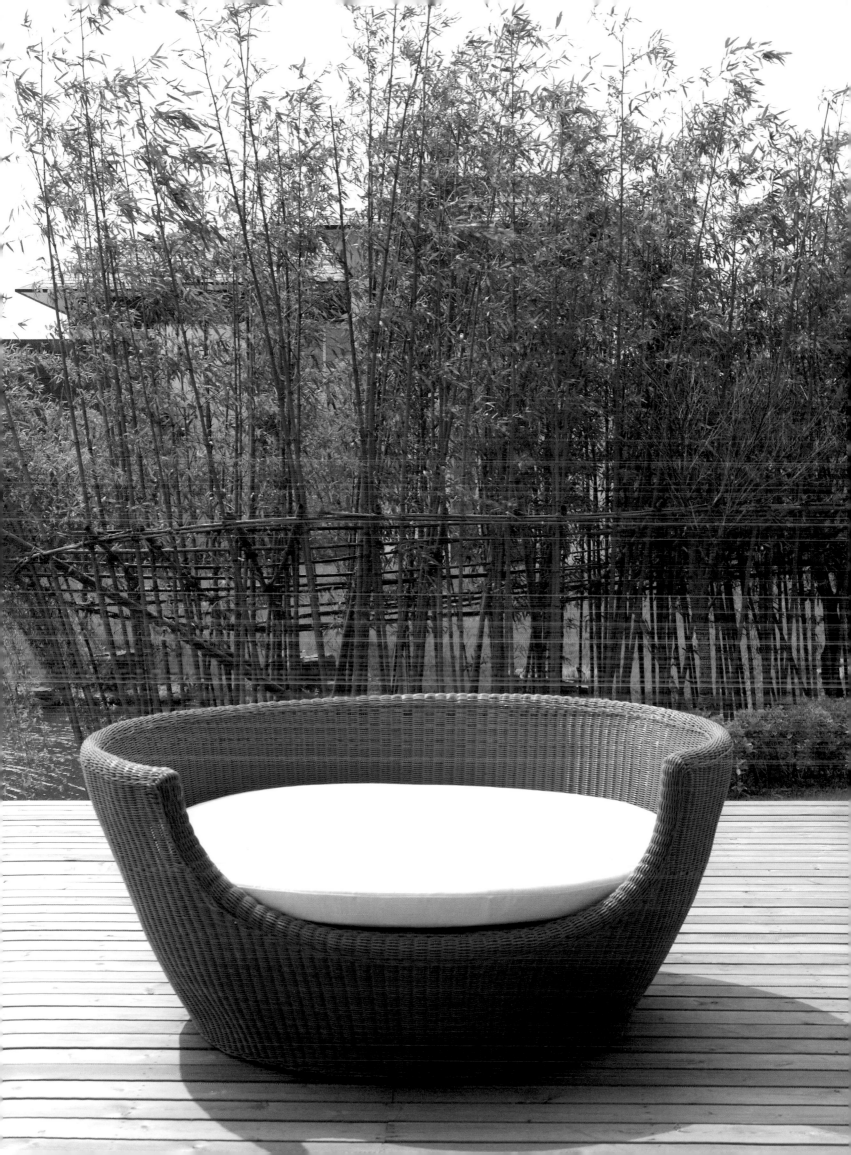

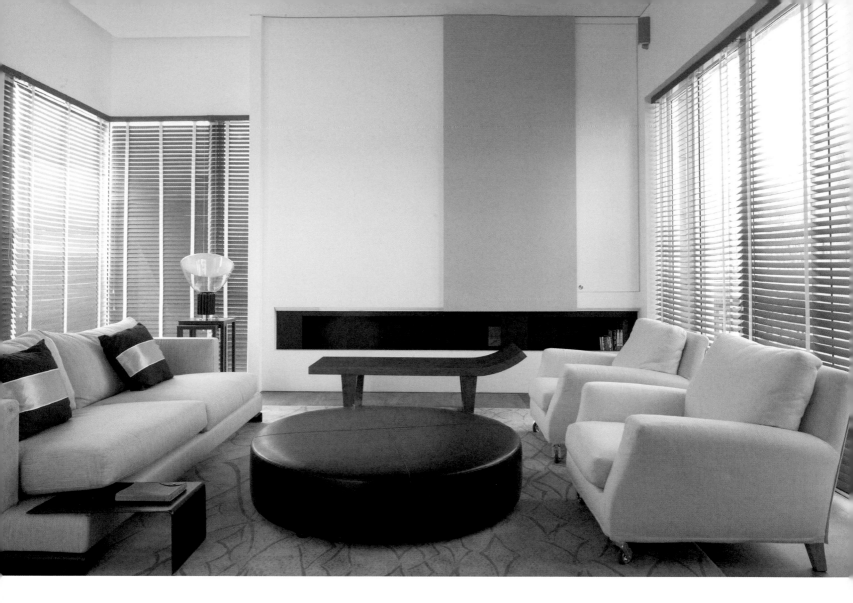

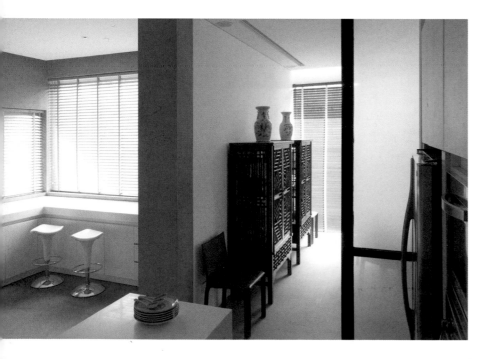

Top The light-filled living room area is shielded from bright sunshine by timber louver blinds. Furnishings are designer modern.

Left A sliding opaque glass door separates the all-white kitchen area from the dining room.

Right In the dining room, modern Italian leather chairs flank a circular table designed by Team HC. A traditional Shanghainese cabinet stands in the background. The flooring is natural Chinese stone.

Below A timber staircase leads from the master suite's dressing room to a mezzanine area above. A double-height lattice screen divides the staircase from the bathroom beyond.

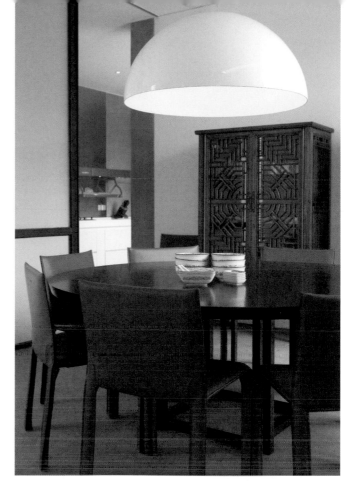

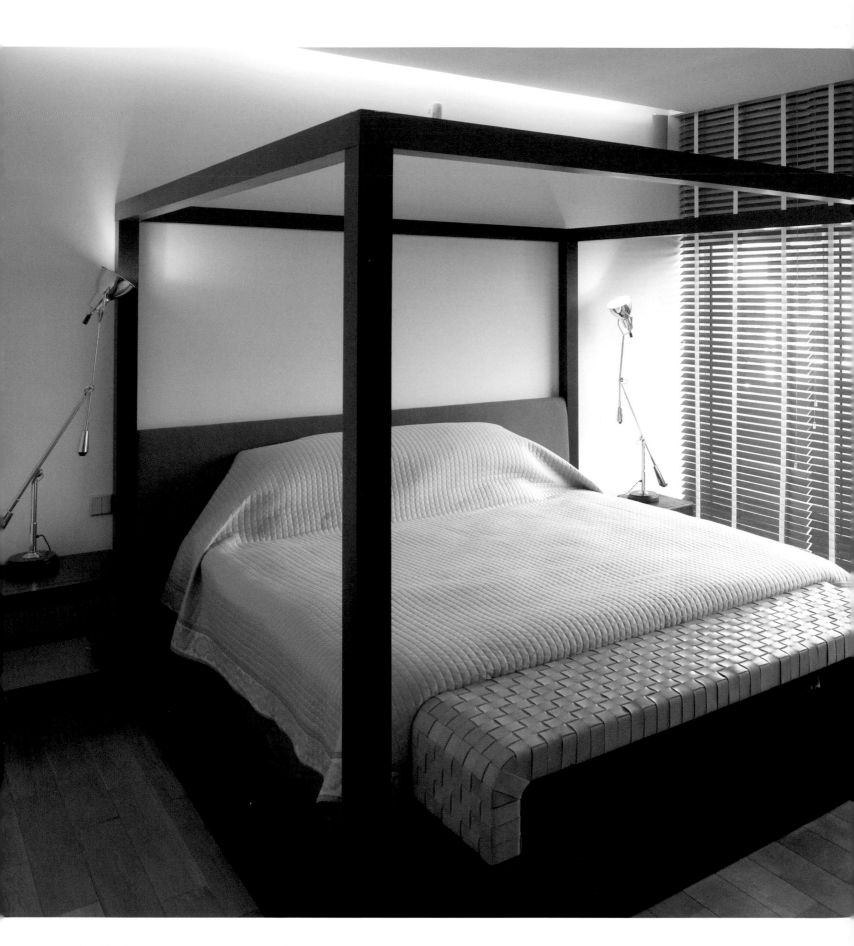

Above The sleek, understated master bedroom features a huge four-poster framed bed with a woven leather bench at the end. Floor to ceiling windows are shielded by wooden louver blinds.

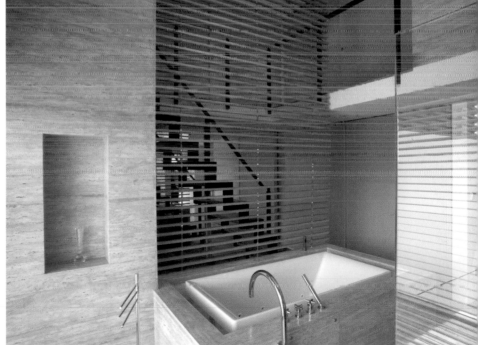

Above The huge, open bathroom is an exercise in understated luxury. A balcony (to the left) allows one to shower and then walk outside.

Top The central staircase is made of 15 by 30-cm (6 by 12-inch) ashwood blocks. Chinese stone, similar to that found in traditional courtyard houses, is used for the flooring.

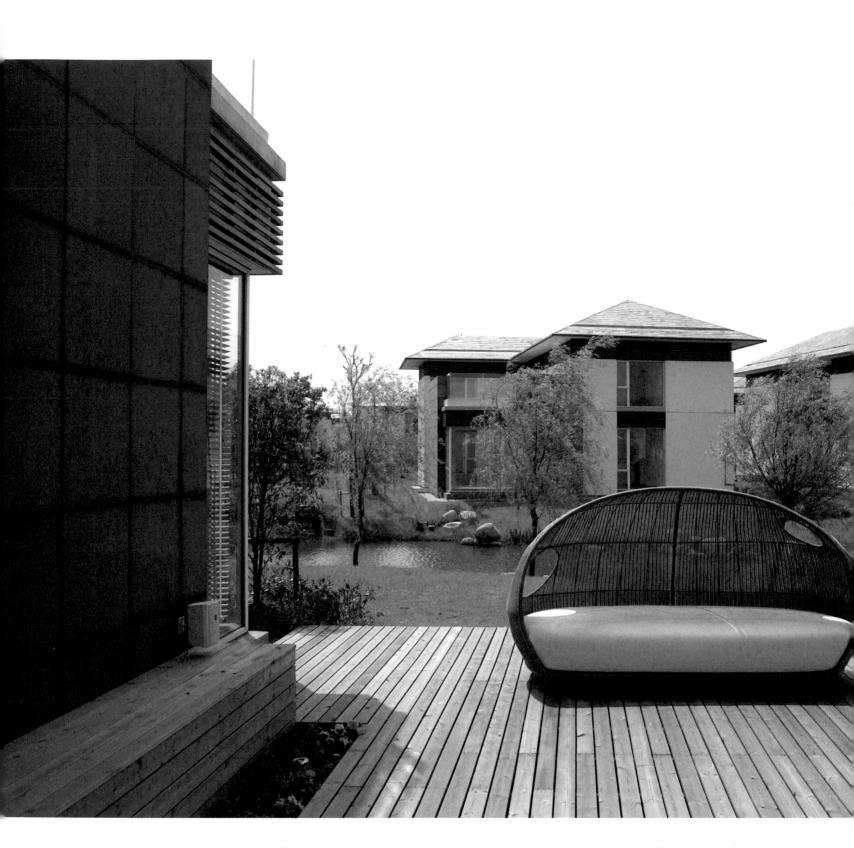

Above Each villa in the complex is uniform in external appearance, separated from its neighbors by a winding stream and bamboo groves. A curvaceous woven rattan couch with overhead sun shield is ideal on a sunny day.

Right top Chiang designed the interior as a series of layers, using natural materials and pared-down shapes to define the minimalist space.

Right bottom The expansive outdoor deck offers ample space for outdoor dining and relaxing.

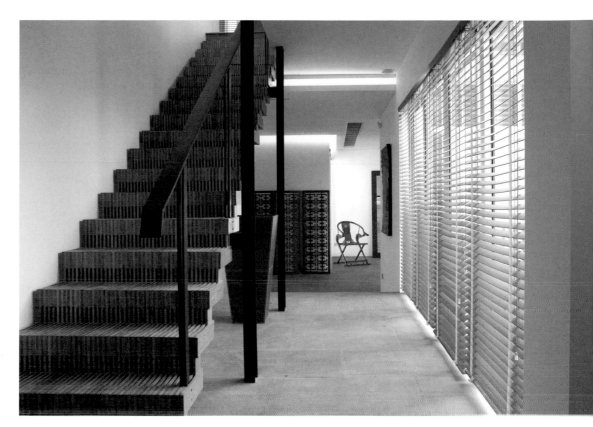

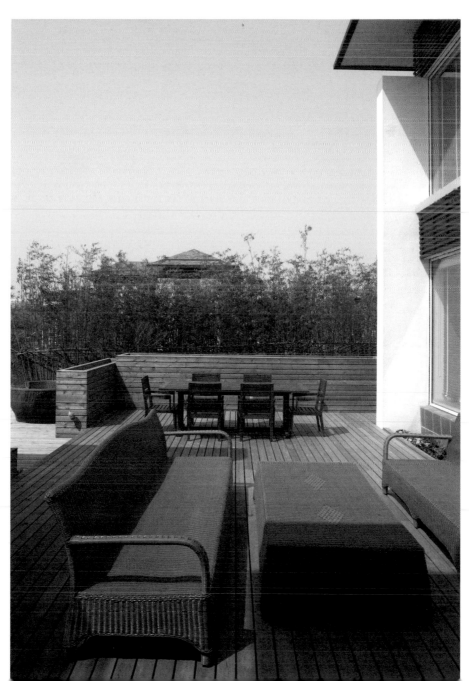

beijing modern
a sense of place

Designer ROBARTS INTERIORS AND ARCHITECTURE | Central Business District BEIJING

BEIJING'S RAPIDLY-GROWING Central Business District, an area of four square kilometers (1.5 square miles) in the eastern part of the city, is home to many multi-national corporations. Top-tier consultancy firm McKinsey & Company is located here, and when it came to refurbishing their offices, wanted to create a look that reflected the high-end image of their firm and yet provided a sense of locality.

Beijing-based design group Robarts Interiors and Architecture, together with consultant architect Pascale Desvaux, produced an interior that is elegant and contemporary and which weaves in elements of Beijing's past. "We wanted to show that it was Beijing, not Shanghai or Taipei or Paris or London, so we introduced some Chinese elements to give a sense of the old China which is at the same time modern," says Desvaux.

"The design is conceived as a dialogue in which the gravitas and historical references of China's capital city are represented in a crisp and contemporary modern workplace with all the latest technologies," explains Adam Robarts. Drawing on inspirations from Beijing's courtyard houses, known as *siheyuan* (four-sided gardens) and from the city's *hutongs*, (the maze of narrow urban footpaths in which courtyard houses are located), the design concept established by Robarts Interiors and Architecture for McKinsey's public areas utilizes historic materials within a contemporary palette. Grey Beijing brick clads the walls, a dramatic open staircase with a deep red backdrop connects the two levels and antique furniture and screens blend seamlessly with modern furnishings. The offices themselves are contemporary and sober, all crisp whites and dark woods to reflect a serious business environment.

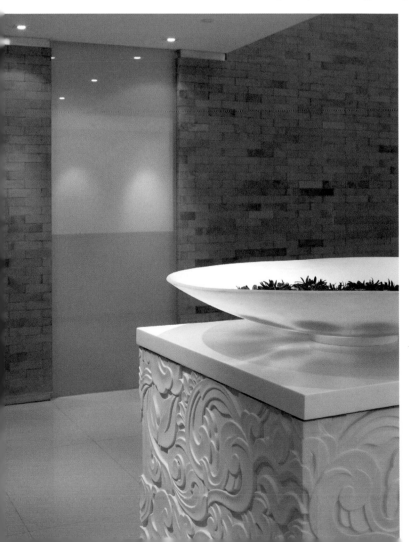

A notable feature of the design is the use of carved white stone which forms the base of the reception desk and clads the rear wall of the dining room. The clean, white stone is carved in a contemporary way and has origins which hark back to old Beijing: "The stone carving pattern was taken from the base of a pair of stone lions in Ritan Park," says Robarts. "We took the basic motif, which we believe is probably late Tang dynasty, and worked with it on our computers." He then sourced a group of local stone artisans who produced a three-dimensional end product with a gentle scalloping which is pleasing both to the eye and the hand. The result is a stylish blend of old and new, acknowledging the past yet looking toward the future.

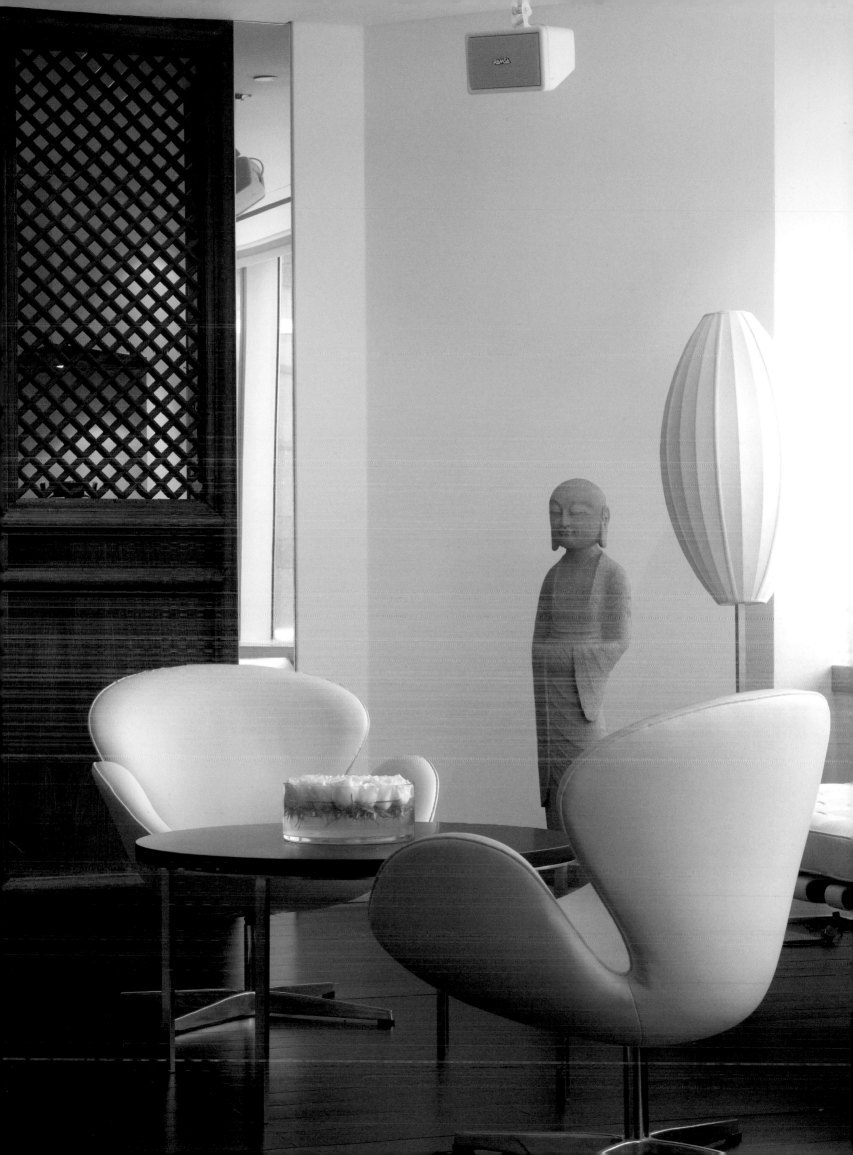

Above An embossed leather wall forms the backdrop to an antique daybed sourced in Gao Bei Dian. The lamp with silk shade was designed by Robarts Interiors and Architecture.

Right A series of five silk lanterns designed by Robarts Interiors and Architecture hang from the double-height ceiling above the reception area.

Left Contemporary bar stools stand in the kitchen, which is divided from the cafeteria by an antique wooden screen door.

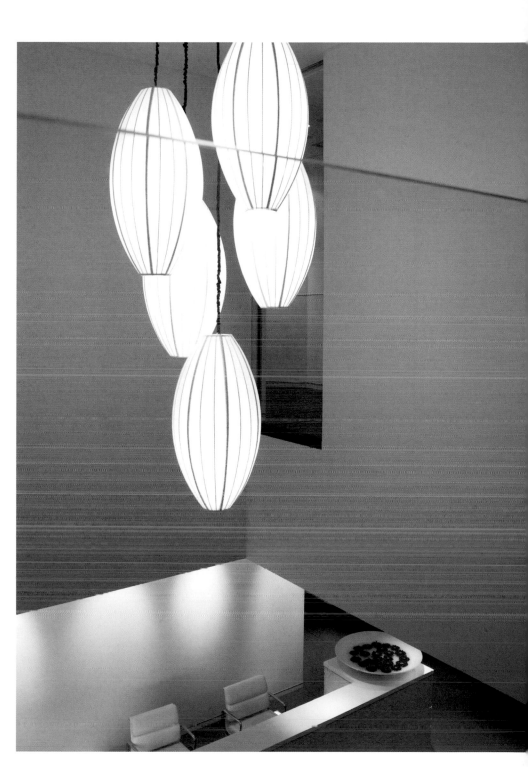

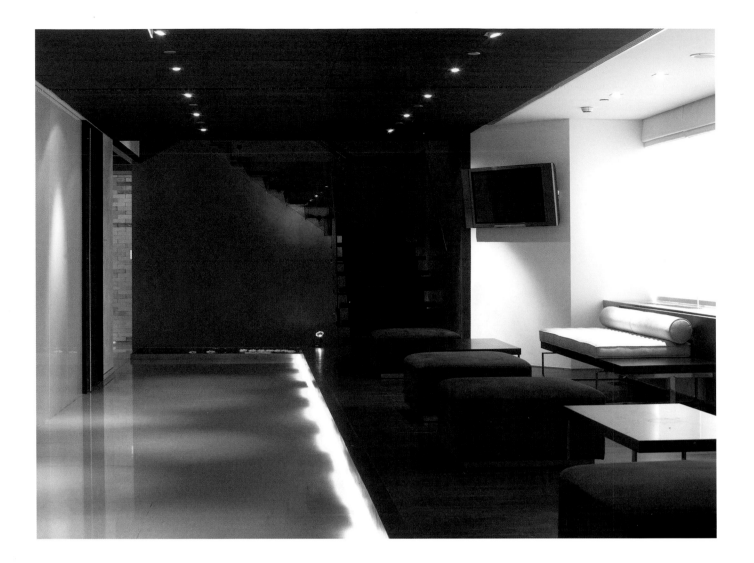

Above Dark woods, red walls and grey bricks add a Beijing spirit to this seating area. Below a modern staircase is a shallow pond.

Left Traditional stone carving techniques have been used in association with modern computer imaging to create a contemporary design which pays tribute to ancient China.

Right The crisp white palette works with dark timber flooring to emphasize that this is a business environment. The Tang dynasty-inspired wall panels run the length of the room.

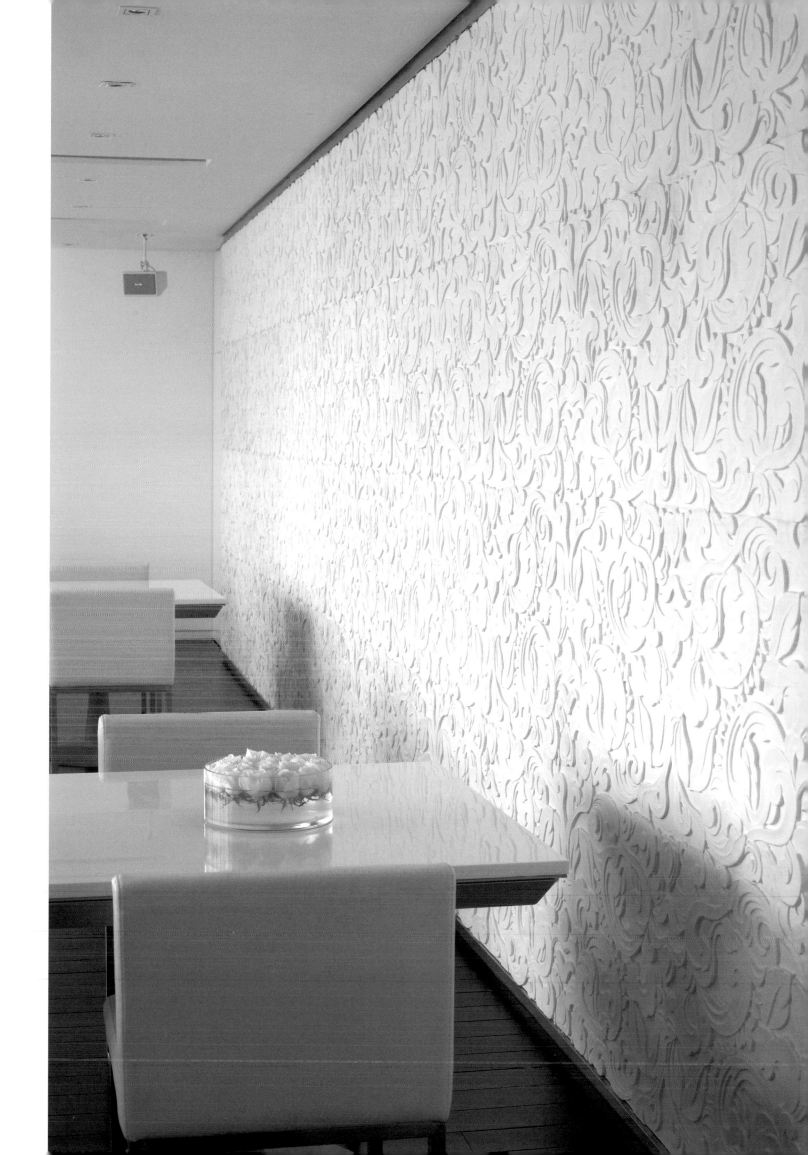

sanlitun apartment
design classics with a twist

Designer JUAN VAN WASSENHOVE | Sanlitun BEIJING

JUAN VAN WASSENHOVE used to live in a traditional 150-year-old Qing dynasty *siheyuan* near Beijing's Forbidden City. These days, however, the courtyard house functions as a deluxe B&B called La Suite Interdite and Van Wassenhove enjoys the comforts of modern apartment living in the city's cosmopolitan Sanlitun district. However, elements of China's rich history still define this 120-square meter (1292-square-foot) interior which cleverly incorporates traditional Chinese materials and antiques with contemporary art and modern pieces.

Taking things a step further than simply decorating, Van Wassenhove has woven Chinese elements into the actual structure of his space. Using local materials whenever possible, and relying on skilled local craftsmanship, his approach is both economical and gives a clear signal that this is China. "I wanted to show that made in China does not have to mean low quality," he explains. "The levels of craftsmanship can be high and the items can also be aesthetically pleasing and very modern indeed."

The flooring uses Ming dynasty roof tiles from Anhui province (similar tiles also provide a decorative wall feature in the living room); antique latticework doors are used for cupboards and country-style painted cabinets become kitchen and bathroom units. "The carpenters were from Anhui and were delighted that I was using local materials. They loved to do different things with them," says Van Wassenhove.

He has also taken advantage of the fact that custom-made furniture is easy to produce in China. He took design classics (the Mies Van der Rohe daybed, Le Corbusier's LCII chair) and reworked them using traditional Chinese materials such as linen from Yunnan and wax cotton from Guizhou. "It's classic furniture with a twist and localized to add that little bit extra. The idea is to have a common language in design," he says. On the walls hang contemporary Chinese art by noted artists like Chen Wenji, Li Songsong and Ai An, sourced with the help of Meg Maggio of Pekin Fine Arts. Such a mix of elements transcends culture and appeals to many nationalities. "When my Chinese friends come they love it, so it pleases both a Chinese and a foreign crowd."

Below A country-style cabinet from Shaanxi Province serves as a kitchen unit, with a modern sink built into it. In front of the breakfast bar is a 1950s Bertoia stool.

Right Above a Corbusier-style chair with Guizhou wax cotton upholstery is a painting by Ai An. A large hanging lantern from the Republican Period sits on the floor.

Left A painting by Li Songsong inspired by the ceiling of the Great Hall of the People in Beijing hangs next to a circular table surrounded by Bertoia side chairs.

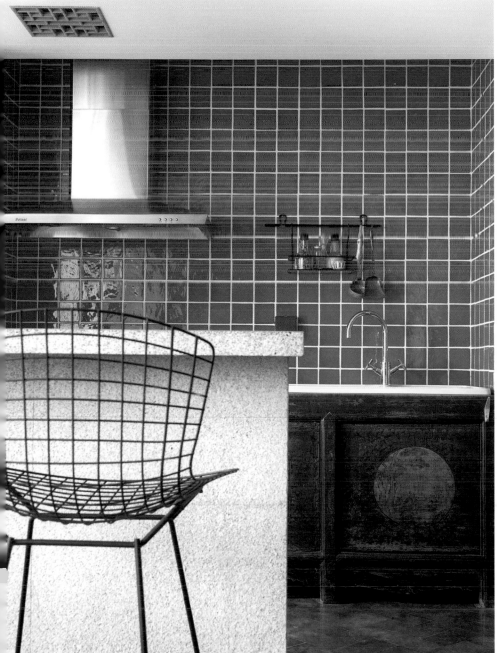

repulse bay house
metropolitan modern

Designer JASON CAROLINE DESIGN | Repulse Bay HONG KONG

IN A CITY KNOWN FOR COMPACT living, Chin and Veronica Chou's airy, light-filled home on Hong Kong Island's scenic south side is a refreshing departure from the norm. Their four-story house, which spans 325-square-meters (3495-square-foot), is an exercise in modern metropolitan living, infused with an impressive collection of calligraphy and art.

Flowing downwards, with the entrance at the top level, the interior offers high ceilings and dramatic views over Repulse Bay. Interior architects Jason Yung and Caroline Ma of Jason Caroline Design chose to keep the decorative palette simple, focusing on pared-down spaces, clean lines and feel-good textures. Each level has a different mood and is linked by a sculptural staircase that changes on different levels.

"The staircase is the backbone of the whole design here," explains Yung. "It links up the different usages of the space and at the same time become a backdrop to each space."

Every flight is different, with the materials used for each section of the staircase echoing the materials used on each floor. There is white marble at the entrance level; stonewashed oak in the upstairs gallery; grey limestone in the living room; bamboo in the master bedroom and raw concrete on the spa level. The balustrade changes too, from an open stairwell to steel cables to tapered glass. "We think that if you are constantly walking up and down so many floors you have to make it interesting," says Yung.

The top level of the house features a gallery area—a serene space perfect for contemplation. It displays the Chous' collection of high quality traditional artwork, much sourced with the help of Chou's art historian father Dr Chou Ju-Hsi. The design is purposefully sparse, to allow attention to rest on the scrolls and paintings which include works by masters such as Zhang Dai Chien, Zhao Shuru and Pu Ru. "Our dream was always to have a gallery room where we could appreciate the Chinese paintings we'd been collecting over the years," says Chou.

On the level below are the living and dining areas framed by huge picture windows overlooking the sea. Modern designer furniture (think Pucci-print Cappellini chairs and a Flos pendant light) is teamed with sleek French limestone floors. Down again is the master bedroom with a curved aluminum entrance and tactile bamboo floor; a gym-cum-spa is on the lowest level, offering a funky vibe with colorful psychedelic wallpaper and concrete walls. Chou loves the redesign. "Each floor has its own unique character. It's perfect."

Below On the lowest level, the house has a quasi-industrial feel with concrete walls, colorful psychedelic wallpaper and an open bathtub/Jacuzzi. A sofa bed allows the space to double as a guest room.

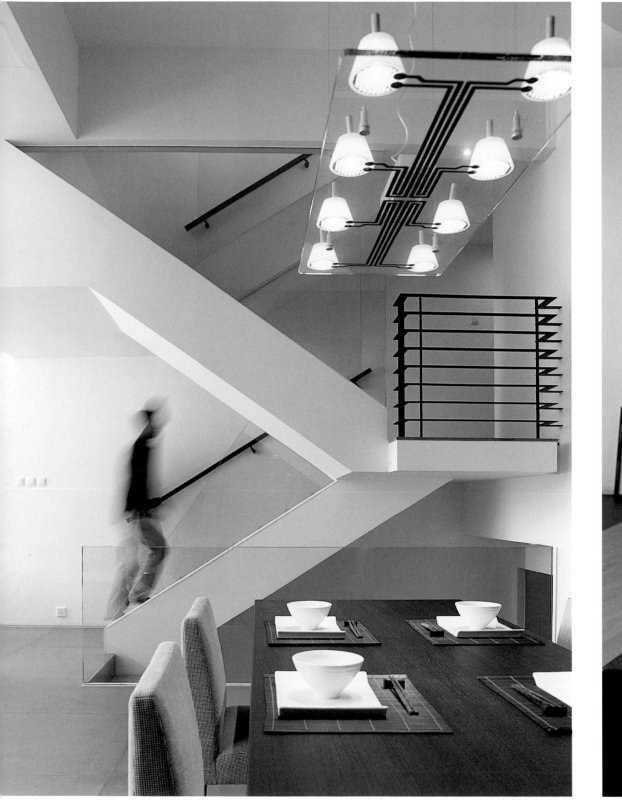

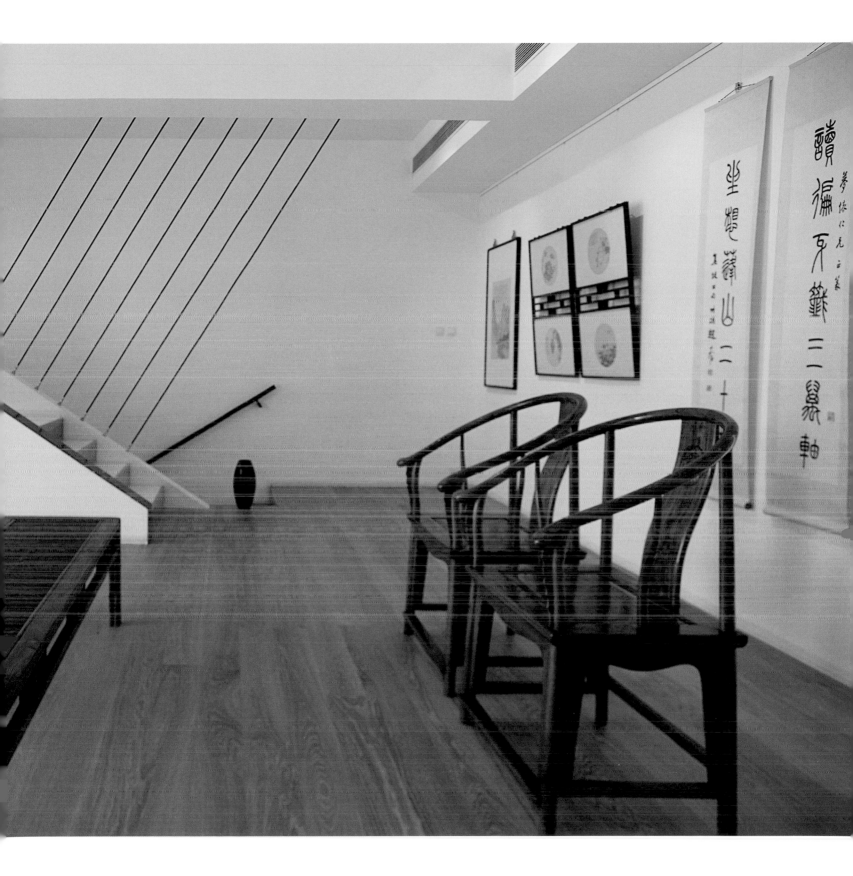

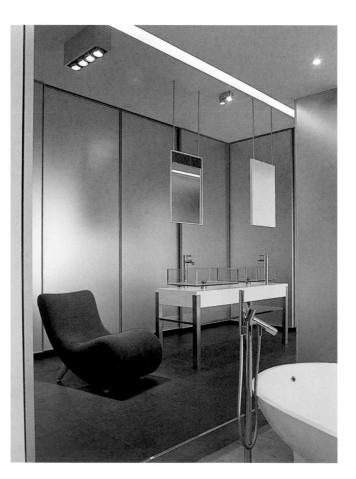

Left The minimalist lines of the living room have been softened by the use of textures, including Italian grey limestone for the floor and staircase and a pair of colorful Rive Droite armchairs upholstered in an Emilio Pucci fabric by Patrick Norguet for Cappellini.

Opposite bottom left The stairway leading into the gallery space has stonewashed oak steps and a steel cable balustrade.

Opposite bottom right The open master bathroom consists of a free-standing tub, double sink and boutique like dressing area. The frosted mirror closet doors add lightness to the space.

Below A single custom-designed cabinet displays one of Chou's older Chinese scrolls. The horizontal painting hanging above it is by Pu Ru (1887-1963), a major twentieth century calligrapher and painter. The bamboo hanging scroll is by master artist Zhang Dai Chien (1899-1983). In the foreground, is a pair of Qing horseshoe chairs and an elmwood bench.

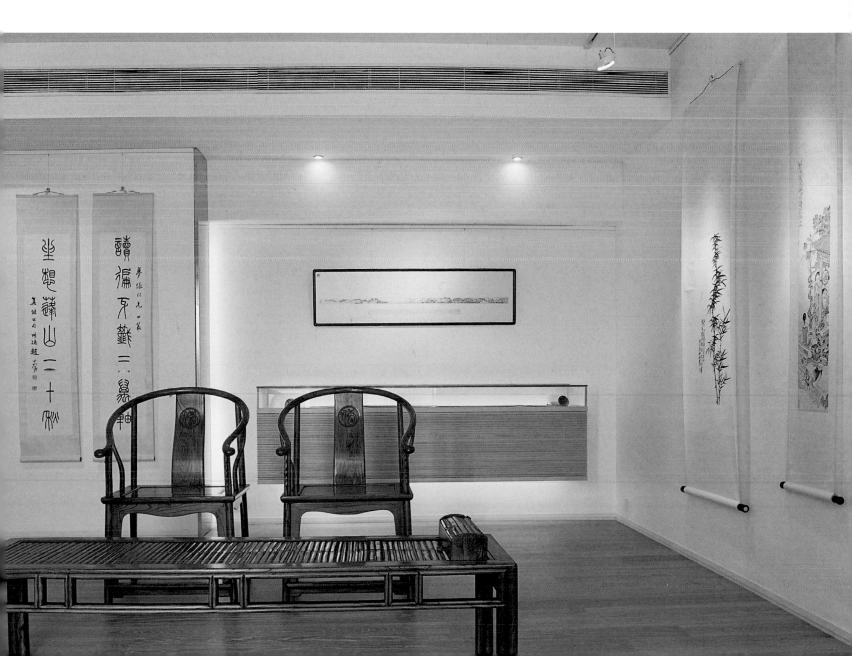

green t house living
redefining chinese design

Designer JinR | Shunyi BEIJING

Right The basement library and bathroom area has a baroque vibe with its ornate chandelier, velvet chaise and purple walls.

Left A gilded mirror hangs near a contemporary version of a classic lowback armchair in purple.

PUSHING THE BOUNDARIES of creativity in today's China comes naturally to JinR. Following the success of her inner city Green T House (see page 26), she has taken the concept of teahouse, restaurant, art and cultural center a step further with a new venture that aims to redefine the modern Chinese lifestyle.

Conceived, designed and decorated by JinR, the starkly minimal Green T House Living is set on a 15,000-square-meter (3.7-acre) plot of land in the residential Shunyi District, northeast of Beijing. Here JinR has drawn on the tradition of the teahouse as a social gathering place at the center of Chinese culture and has mixed it with elements of new Chinese art, music and cuisine, fused with her own sense of style.

Green T House Living makes a statement from the moment guests arrive and are confronted with a series of stark white walls rising from a pebbled floor. Weaving between them one enters an expansive stone courtyard in the middle of which rises a monumental white stone pavilion. Inspired by Zhanguo period architecture (approximately 475-221 BC), the glass-walled structure is dramatic in its clean-lined austerity. Inside, the minimalism continues, infused with a feminine air. Soothing white walls plus polished white stone and crystal flooring form the backdrop to the cavernous interior. A graceful white chimney is suspended over a long fireplace and huge hand-painted silk lanterns hang from the ceiling. White latticework screens, a communal dining table and custom-designed Chinese chairs are positioned throughout the space.

On the lower level—home to the library, merchandise area and bathrooms—JinR embraces the baroque with lush purple walls, a velvet chaise, purple painted twigs winding across the ceiling and an ornate chandelier. The colors and textures reflect off a wall of oversized mirrored doors concealing the bathrooms. An underground passage leads back to the entrance of the complex, a secret tunnel perfect for shadowy assignations.

Plans are afoot to add a tearoom (an all-glass interpretation of the traditional teahouse), a spa (traditional Chinese therapies and healing in a contemporary setting) and a retreat (an open-plan villa with open-air Jacuzzi and fireplace). In her bid to create a new kind of lifestyle destination, JinR is blending ancient Chinese culture and philosophy with contemporary appeal. She says: "Green T House Living presents an authentic Chinese experience but in a way you've never imagined."

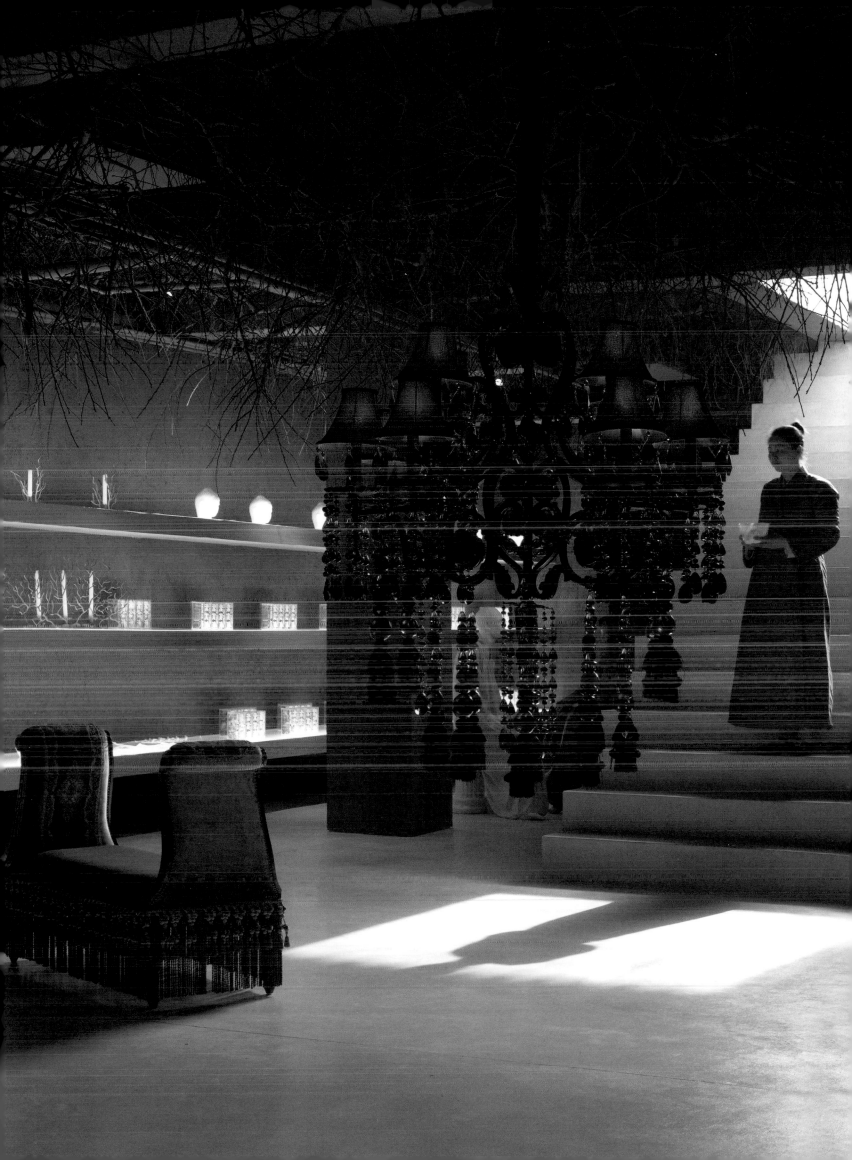

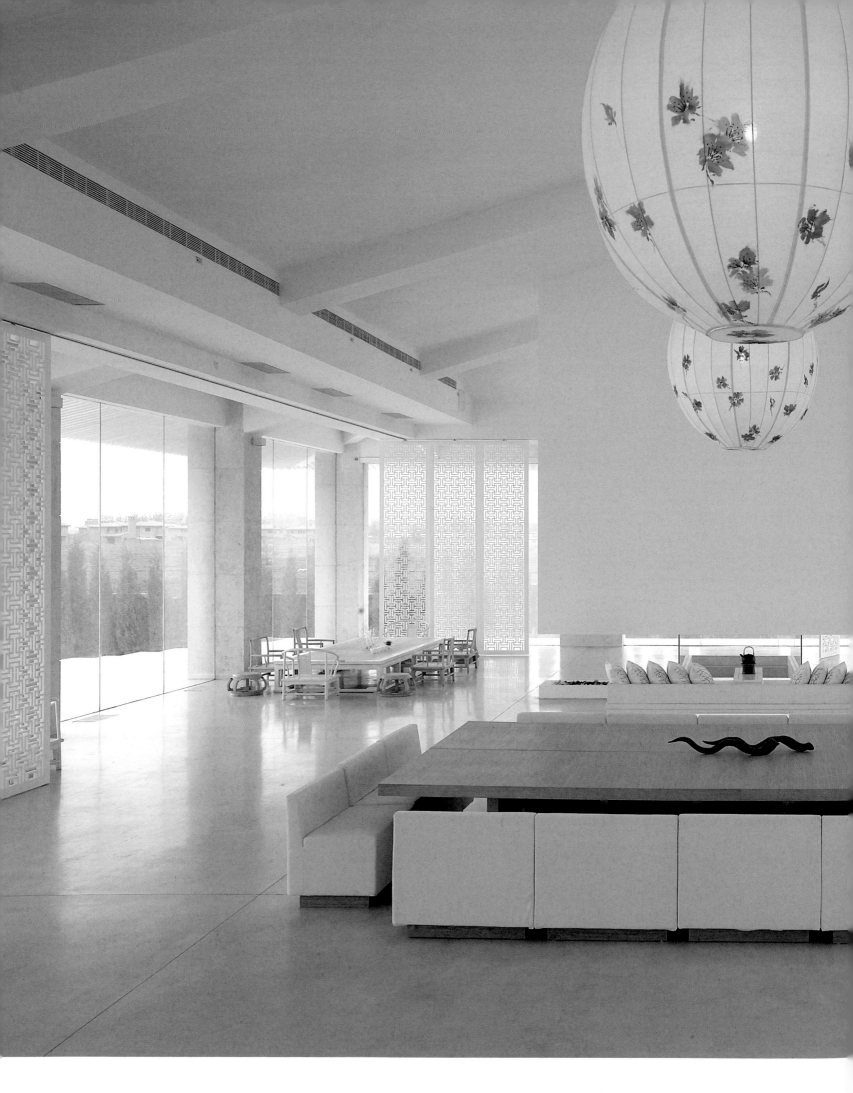

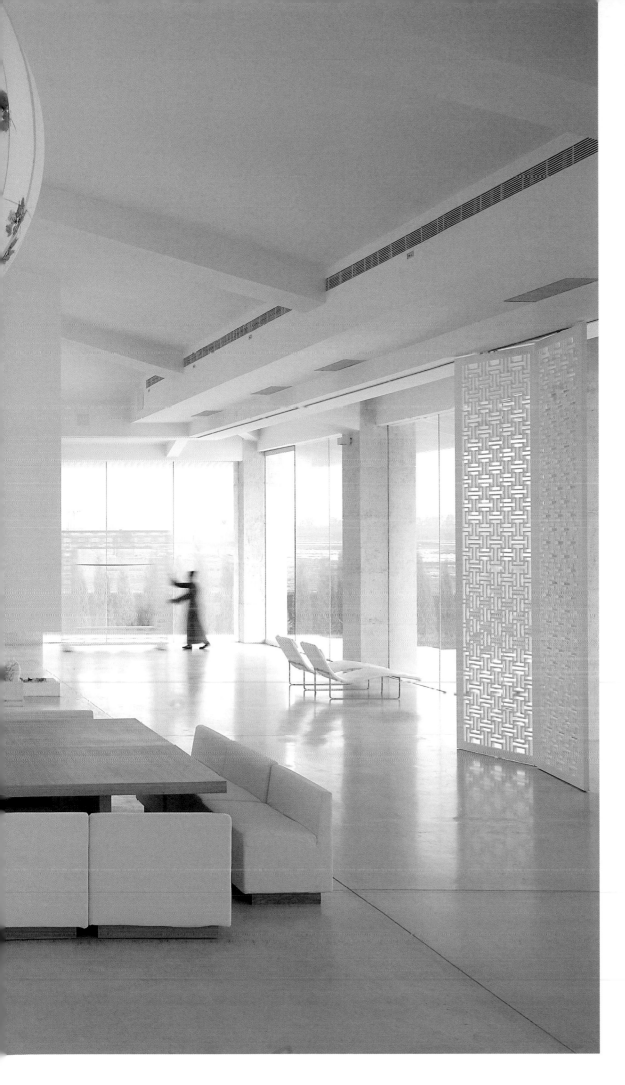

The massive glass-clad dining pavilion is a supremely serene space—with a suspended chimney floating above an open fireplace and hand-painted silk lanterns overhead. The floor is made from polished white stone and crystal.

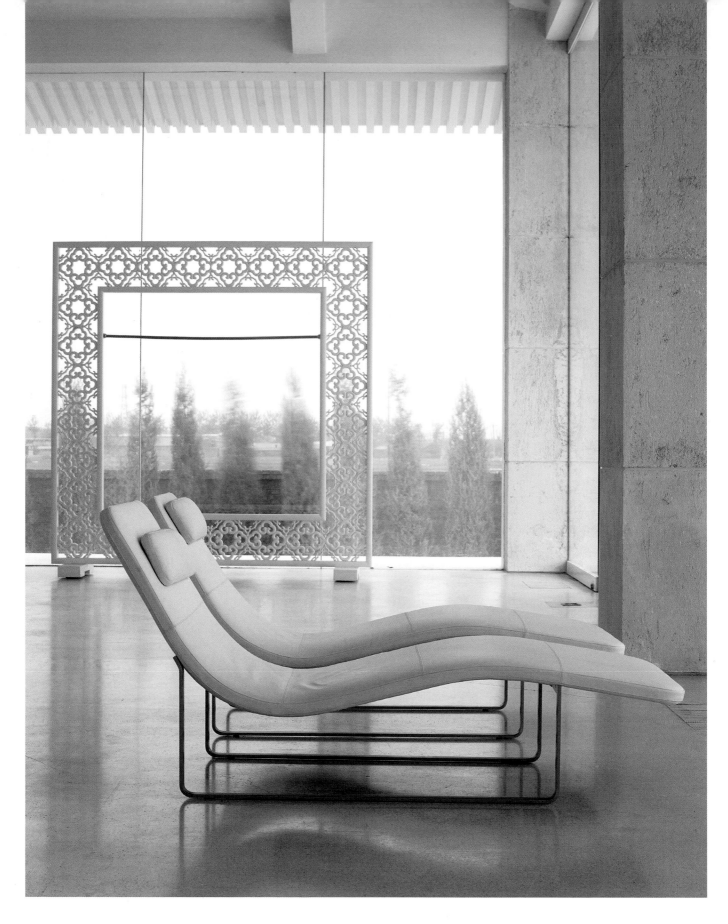

Above A pair of curvaceous white chaise longues stand in front of a hanging rail with a white latticework border. It is on wheels so it can be moved around the space as required.

Right The salon draws on the tradition of the classical teahouse as a social gathering place at the center of Chinese culture. JinR has mixed in elements of new Chinese style such as these low level custom designed armchairs and tables.

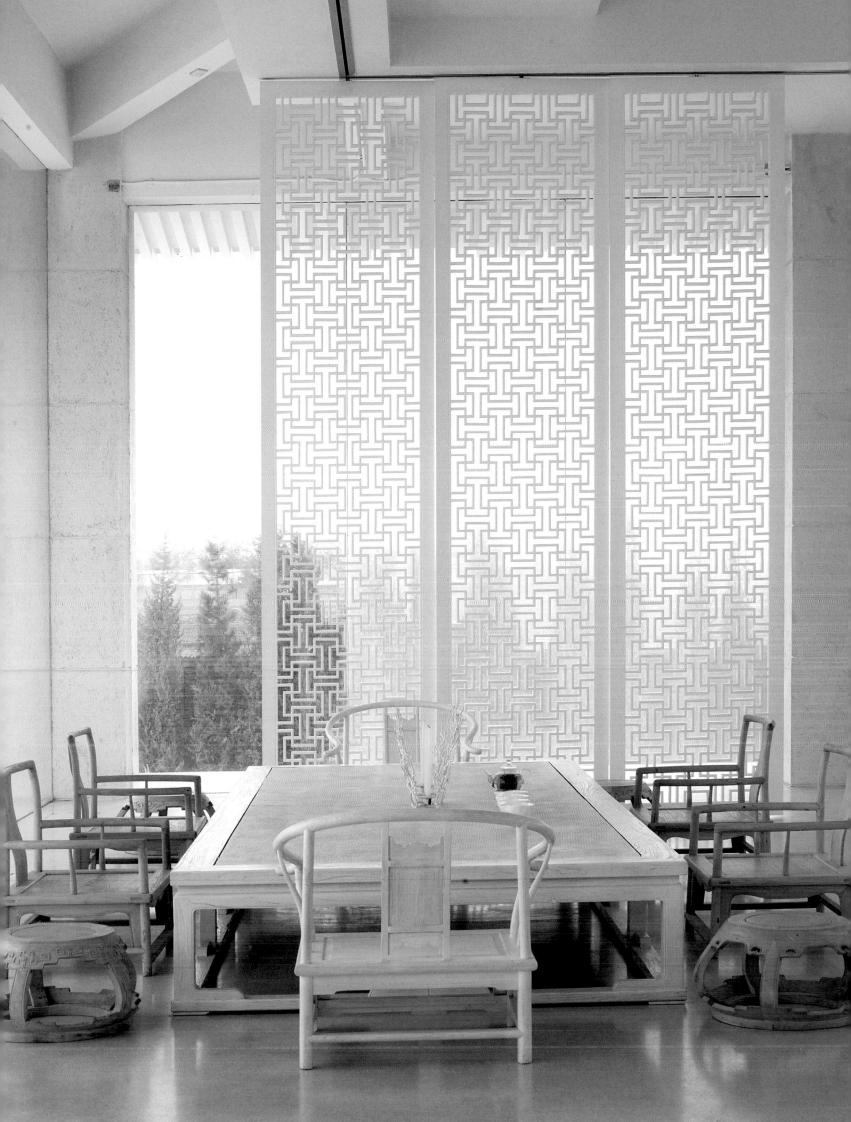

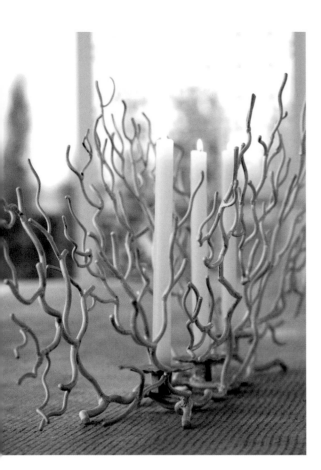

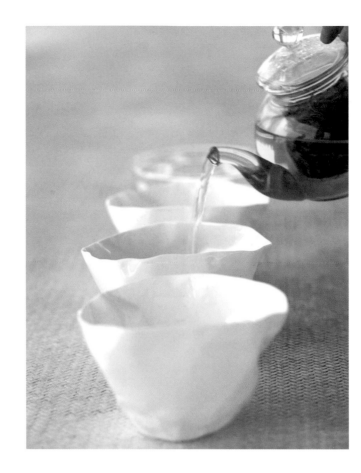

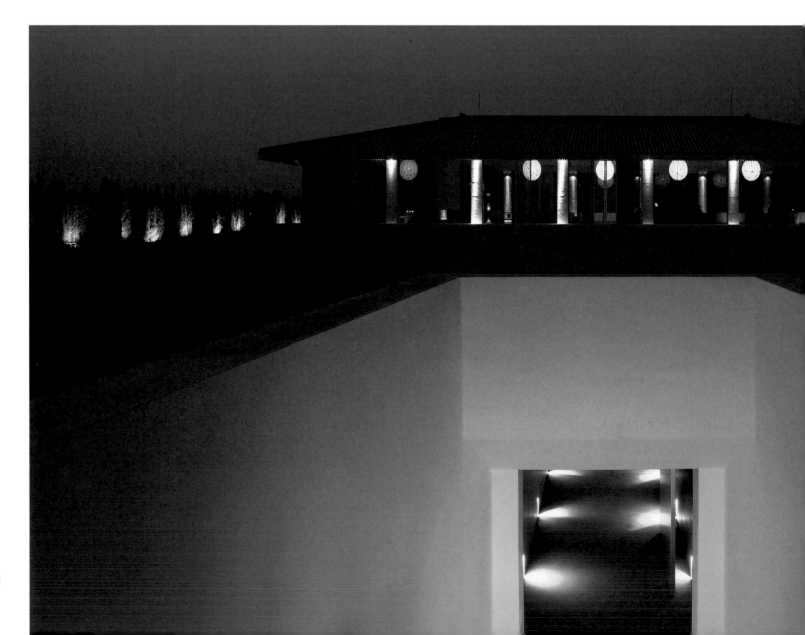

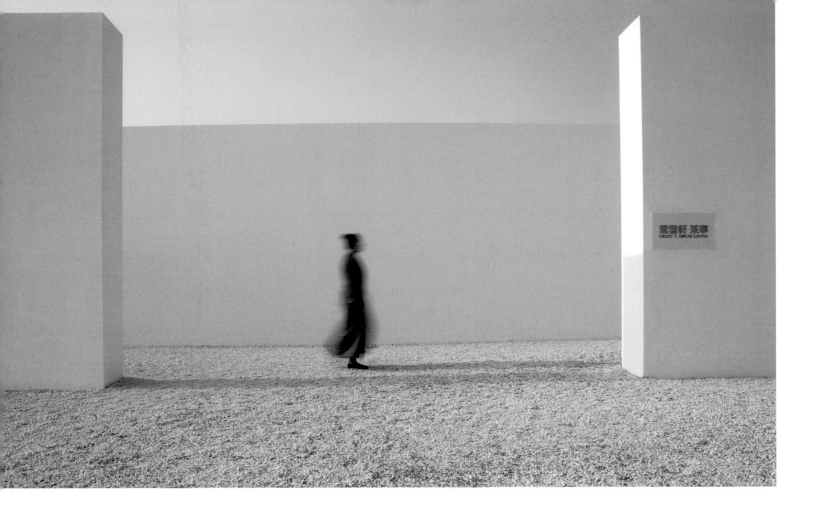

Opposite top left Silver branches make an innovative candleholder.

Opposite top right Hand-blended tea is poured into sculptural white cups.

Left At night the imposing pavilion is illuminated by the glow of oversized hand painted lanterns. An underground passage leads down to the library level, perfect for clientele who prefer a more private entry or exit.

Above A series of three white walls define the entrance to Green T House Living. The ground is covered with white pebbles.

Overleaf The vast pavilion-like structure inspired by Zhanguo period architecture rises from a white stone courtyard. Floor-to-ceiling glass panels offer 360-degree exterior views.

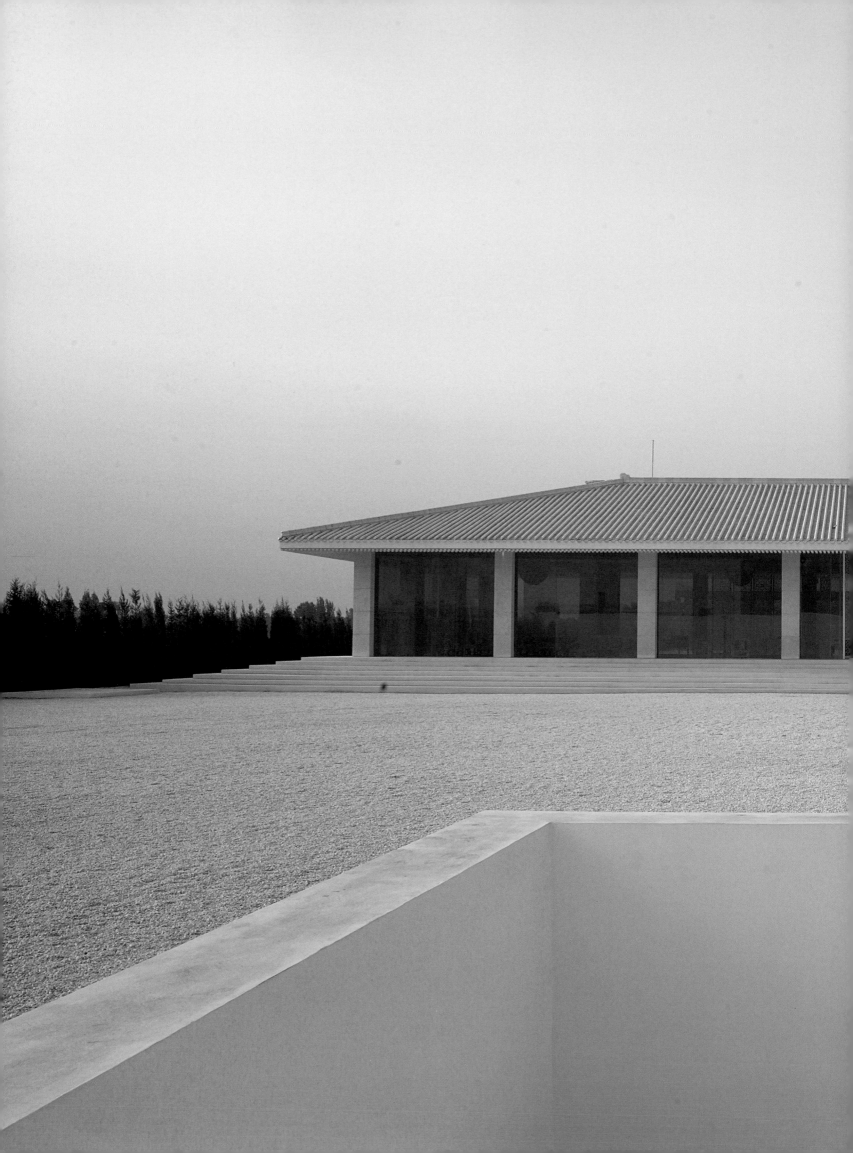

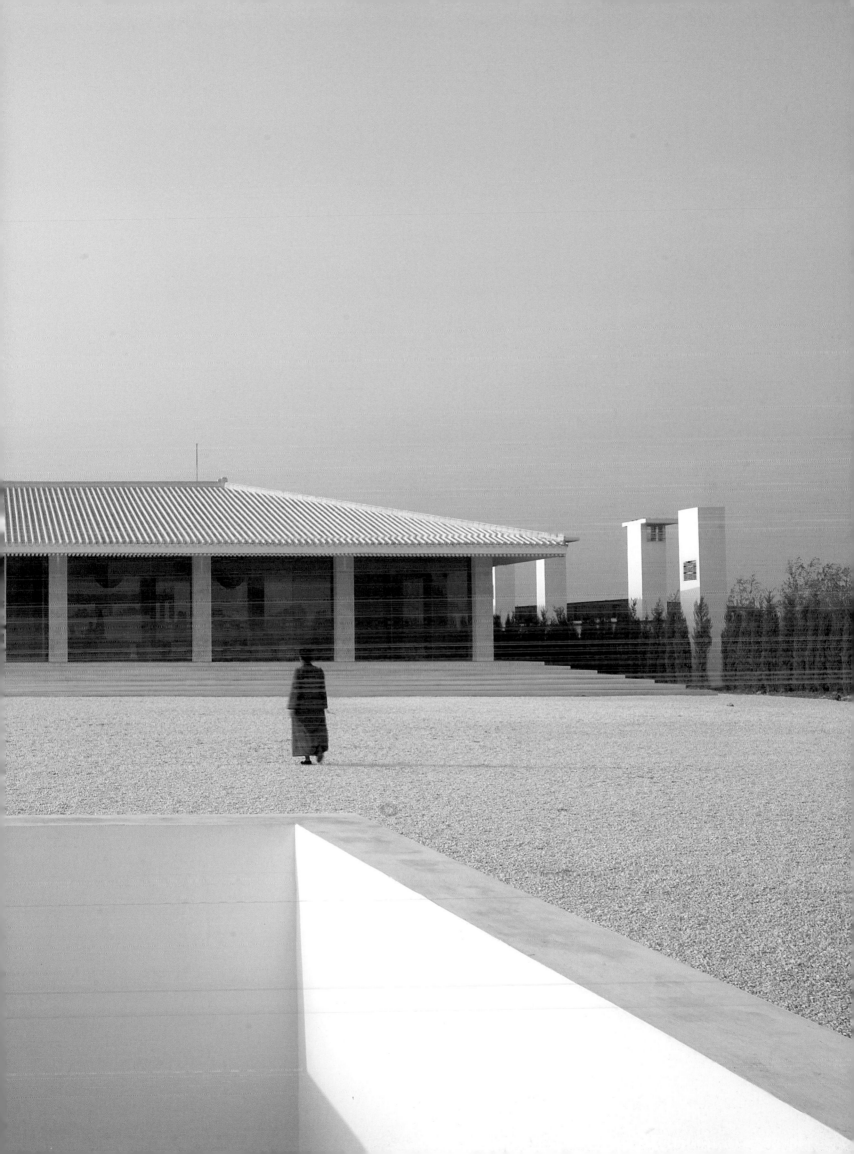

urban innovation

A new generation of designers working in China's major cities have a passion for innovation that respects their locality yet is global in outlook. Urban homes are designed to fit the needs and lifestyles of the users, with an emphasis on space efficiencies and experimentation with new materials and technologies. From disciplined minimalism to eye-popping creativity—the designs in this chapter are all world-class in their execution.

precision apartment
lounge living in the city

Designer DARRYL W. GOVEAS | Mid-Levels HONG KONG

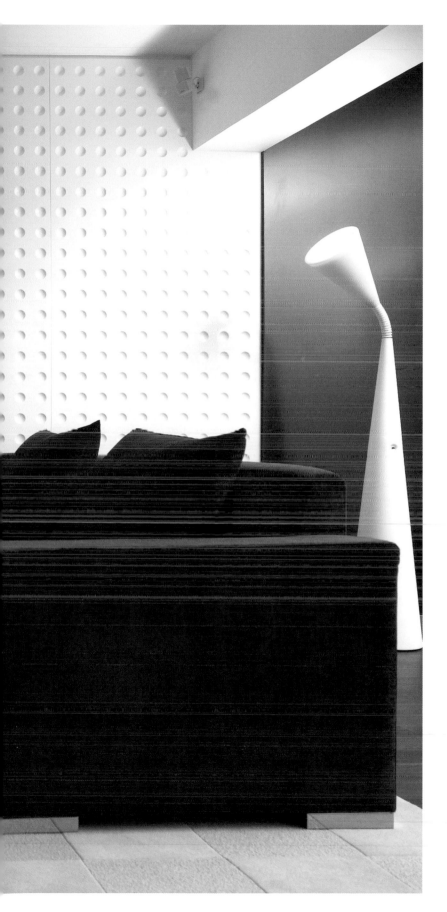

As a cool, chill-out zone by day and a club-like lounge at night, this edgy apartment on Hong Kong Island has a rhythm all its own. With its deep red lacquer and rich brown wenge wood walls interspersed with white lacquer panels and reflective stainless steel trim, the home of architect and designer Darryl W. Goveas of Pure Creative International is a clever blend of warmth and minimalism, comfort and luxury.

Measuring 140 square meters (1507 square feet) the space feels expansive. Each room interlocks with the next, drawing the eye forward and increasing the sense of space. "I wanted to make the space very efficient," explains Goveas, who chose to create just one bedroom, one office and a large living area for himself and his wife.

The use of three contrasting colors adds energy to the design scheme. "I like to have three colors per room which gives more contrast," says Goveas. "White, brown and red are clean and yet dramatic." Wide, reflective stainless steel panels clad the doorframes, interior pillars and shelving units—and in so doing add a lightness and airiness to the space.

This home is all about contrast—of colors and materials. In juxtaposition to the lacquer and wenge wood living area, the dining room has an elegant patterned rear wall. Says Goveas: "I wanted something that was a bit more traditional here. You see this kind of wallpaper in old hotels and it gives a good contrast between the new and the old, the classic and the modern."

The quality of finishes is high, with clean lines and a seamless flow of the space testifying to the precision that went into its creation. Ultimately, this is a space designed for relaxation and enjoyment, a creative haven to recharge and refresh. With this in mind, Goveas added some light-hearted creative elements, such as a white lacquer wall in the living room carved with half circles, like a series of golf balls. "I wanted something unusual, something a bit young. Many people who come here say it is like a club, although that was not really intentional."

Left Less is more in the sleek and streamlined open-plan living room. The white lacquer coffee table and oversized sofas were designed by Goveas.

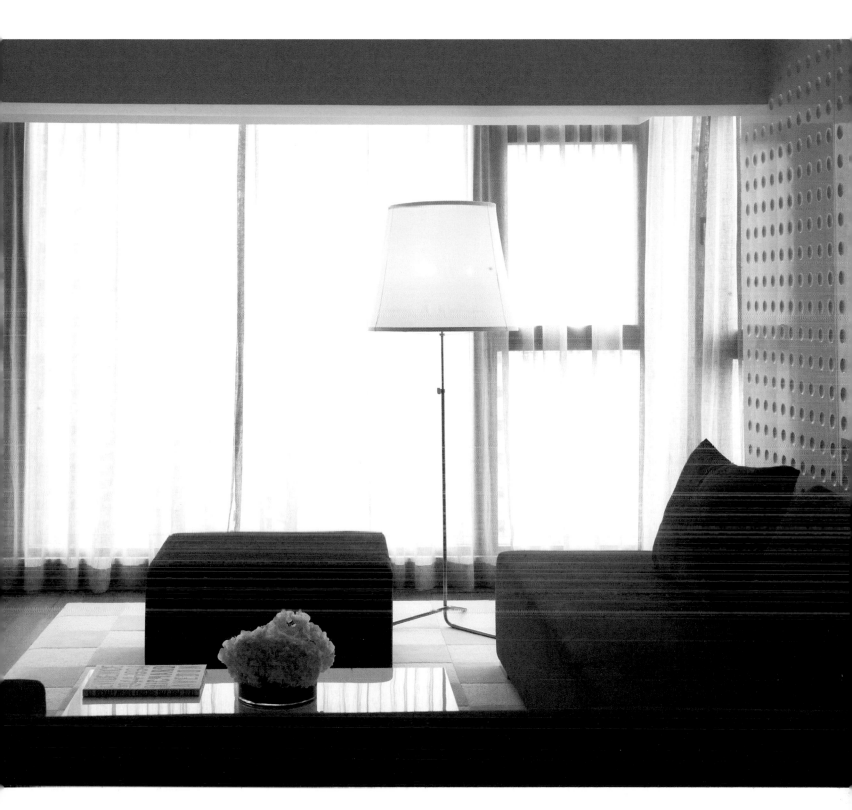

Left top The white lacquer wall has circular indentations like golf balls. It adds rhythm and movement to the space.

Left Recessed shelving features a red lacquer base and stainless steel trim that contrast with dark timber paneling.

Above A large, one-piece glass window creates an airy, loft-like feel during the day and provides panoramic views of the city at night.

Left Patterned wallpaper similar to designs found in old hotels adds a touch of classic color to the dining room. Reflective stainless steel trim conceals the thick concrete columns.

Below Dark brown wenge wood and stainless steel surrounds a doorway leading to a red lacquer lined corridor. The lacquer paneling required 20 coats of paint to achieve the desired finish.

Above A striking yet simple visual juxtaposition is created by the white "golf ball" wall and dark wood panel. On one side is a leather barstool; on the other a polypropylene Camp Lamp by Jakob Timpe.

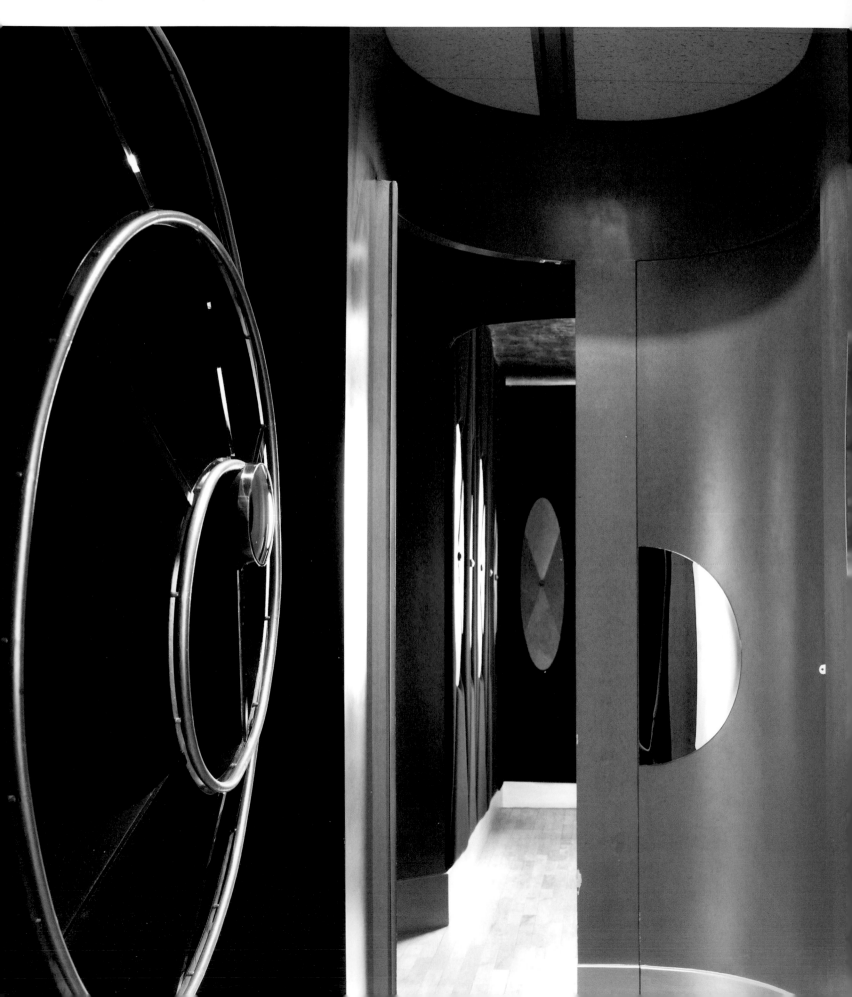

contrasts gallery
an explosion of creativity

Designer PEARL LAM | Central HONG KONG

HONG KONG ART DEALER Pearl Lam is known for her sense of drama. Her avant garde gallery, Contrasts, aims to create a new Chinese design aesthetic by focusing on individual creative talents and introducing China's heritage to the world. Founded in 1992, Contrasts is represented in Hong Kong, Shanghai, Beijing and Hangzhou and with the eyes of the world turning East, Lam is gearing up to make sure that contemporary Chinese art and design are on show for all to see—and the more daring and innovative, the better.

Chinese artists such as Shao Fan, Luo Xu, Liu Jing and Pan Dehai are represented alongside international names such as André Dubreuil, Andrée Putman, Mattia Bonetti and Martin Szekely. By promoting artists from different cultures, Lam recognizes that cultural exchange is a positive force that should be encouraged. She takes Chinese artists overseas, brings international artists to China and holds traveling exhibitions in a bid to foster new design directions.

Lam's gallery and workspace in Hong Kong is situated in Jardine House, a harborside building famous for its huge circular windows. Here, aesthetics and style clash gloriously, as baroque meets chinoiserie meets James Bond meets Austin Powers in a kaleidoscope of color, shape and form. Inspired by the building's huge circular windows, Lam created a series of interlinking, pod-like spaces, all sensual curves, yellow satin padded walls, circular mirrors and metallic paints.

Inside, a series of dramatic spaces unfurl in an often illusory way. There is a cyber luxe sci-fi reception area, a spaceship-like red mirrored library, a black and white op art kitchen and a metallic white feng shui-inspired office. Oversized jewelled chandeliers hang from the ceilings, mirrored submarine-like circular doors whir open electronically and a spiral bookcase is mounted on royal purple velvet walls. Startling, surprising and unique, this is one-of-a-kind design.

Left Spiral bookcases are located at the entrance to a conference room with royal purple velvet walls.

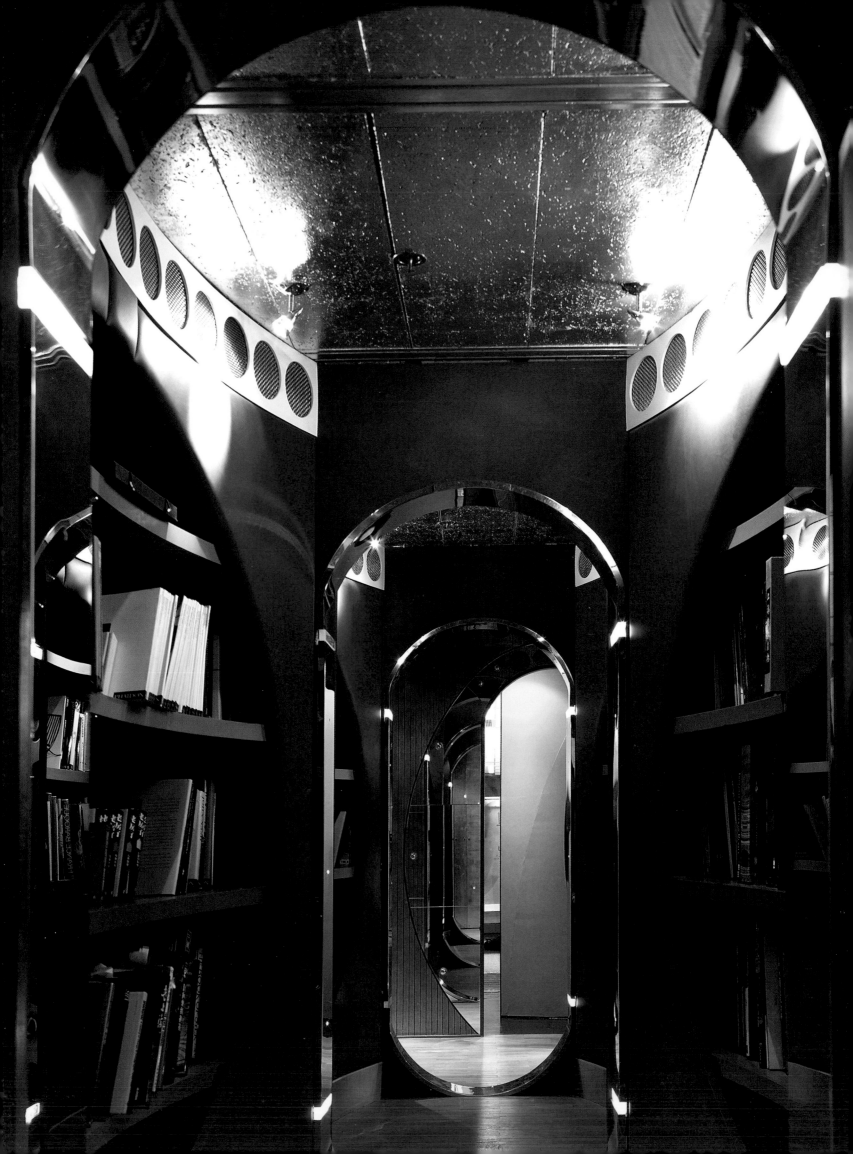

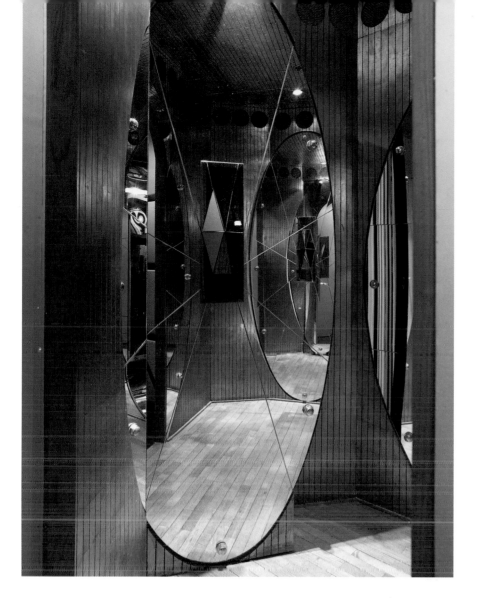

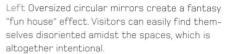

Left Oversized circular mirrors create a fantasy "fun house" effect. Visitors can easily find themselves disoriented amidst the spaces, which is altogether intentional.

Below The ornate reception desk is cocooned amidst padded gold satin walls.

Bottom Quilted gold satin upholsters the walls and doorways of the cyber luxe reception area. A mirrored ceiling adds to the psychedelic experience.

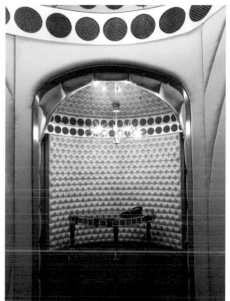

Left A reflective and illusory space, this corridor is composed of metallic capsules lined with bookshelves.

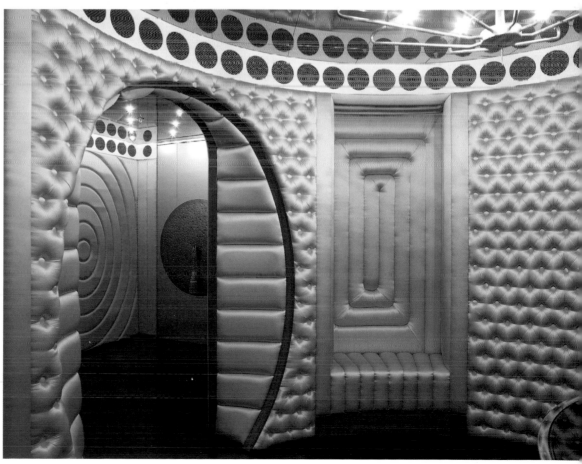

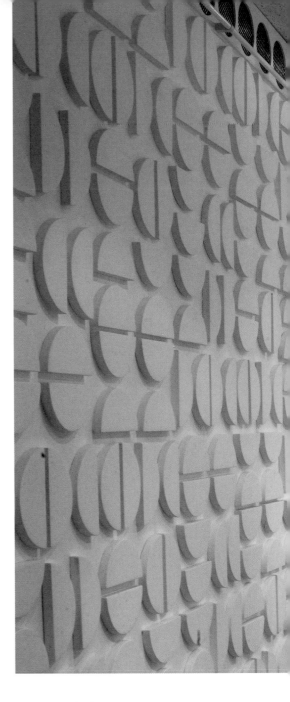

Left top Inside the op art pantry; a linear medley in black and white comprised strips of formica board.

Left An antique gong on the wall of Lam's office creates symmetry with a mirror (shown at right) hanging on the opposite side of the room.

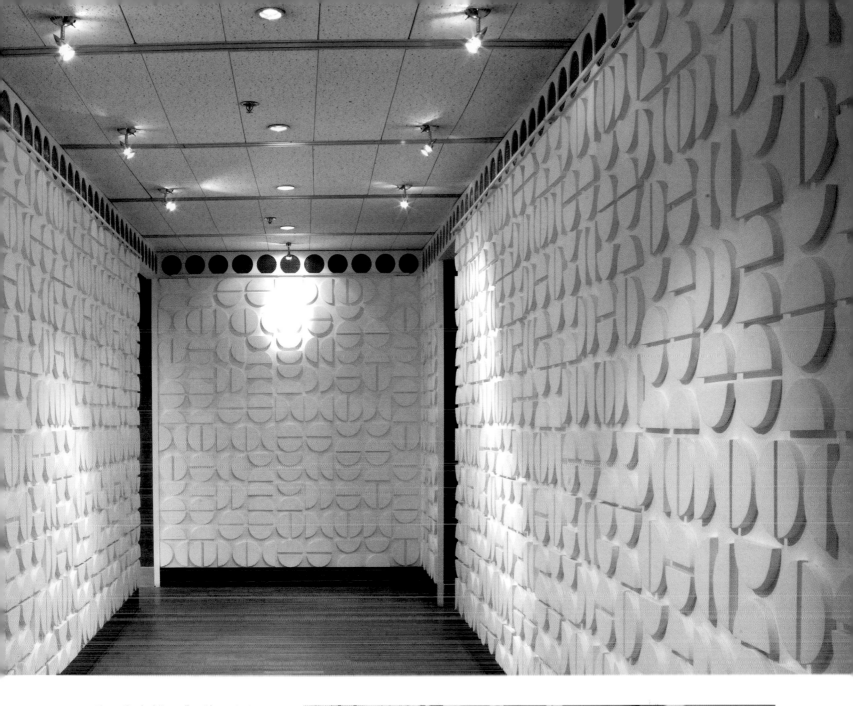

Above Cool white walls with semi-circular reliefs in the gallery offer a break from the visual overload

Right A round convex mirror positioned for feng shui reasons is the focal point of a shelving system reminiscent of an antique Chinse bookshelf running along the side of Lam's office.

Occidental and oriental, old and new—a commitment to crafts-manship underlies Lam's creative energies. In this conference room, marble and mirrors clad the walls and a cyber-stylish chandelier hangs overhead.

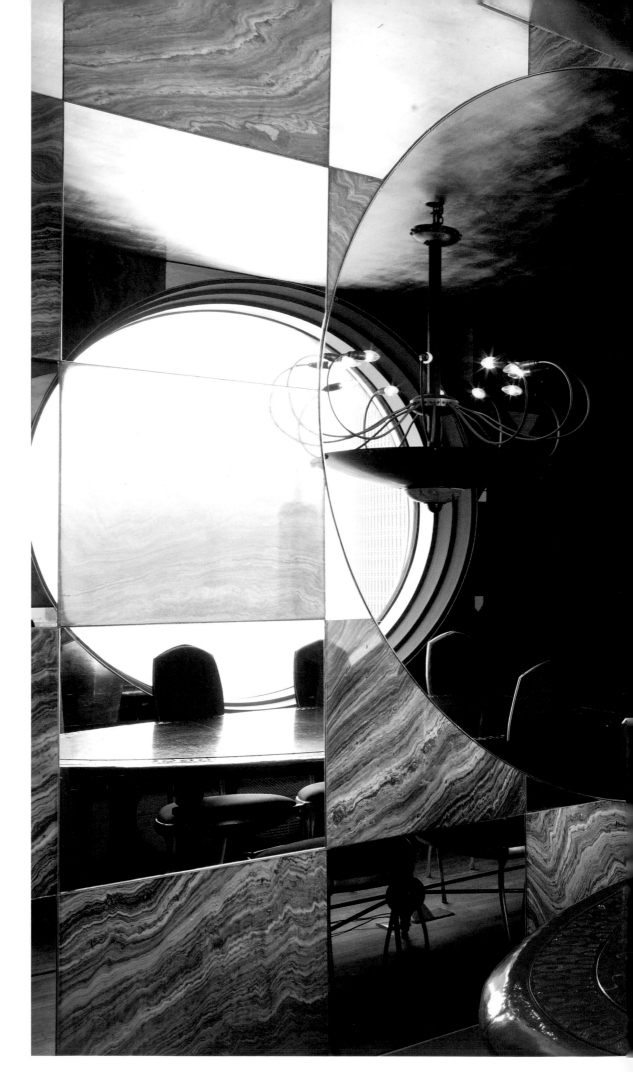

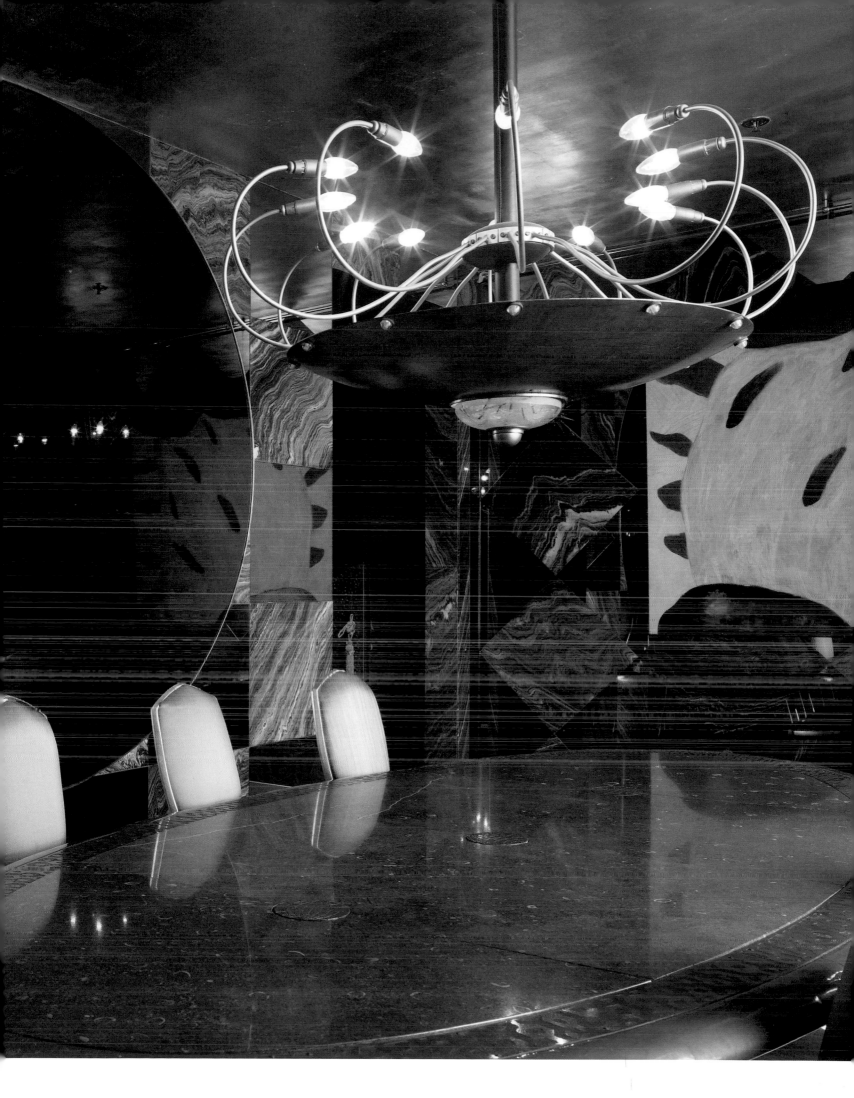

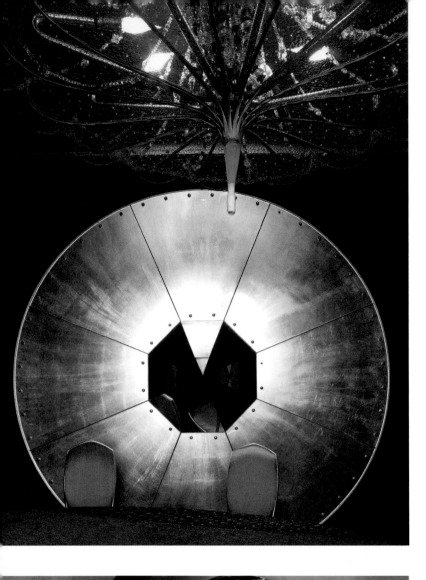

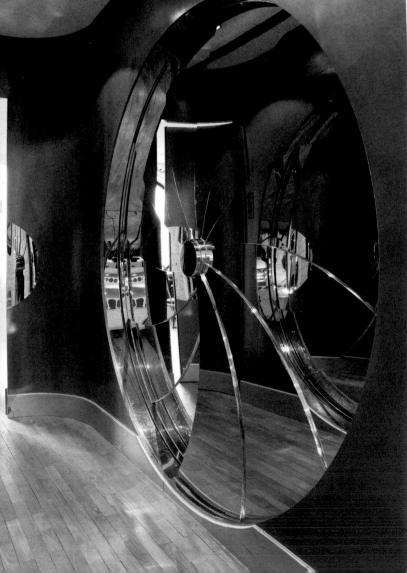

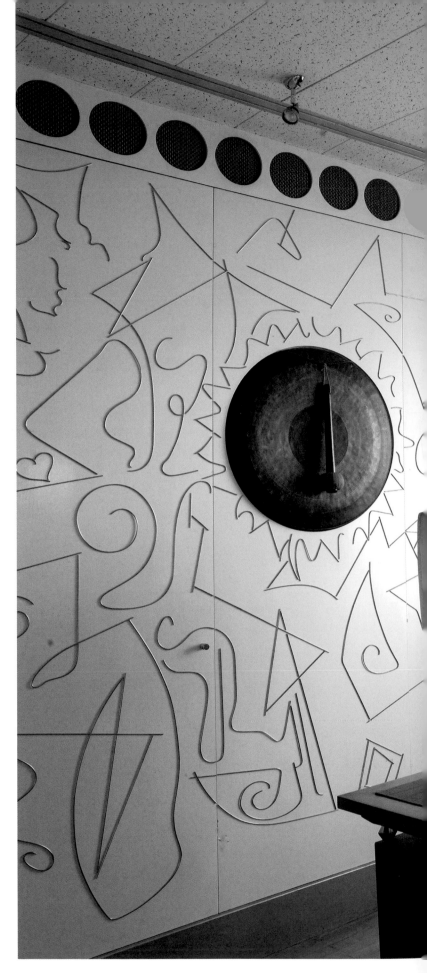

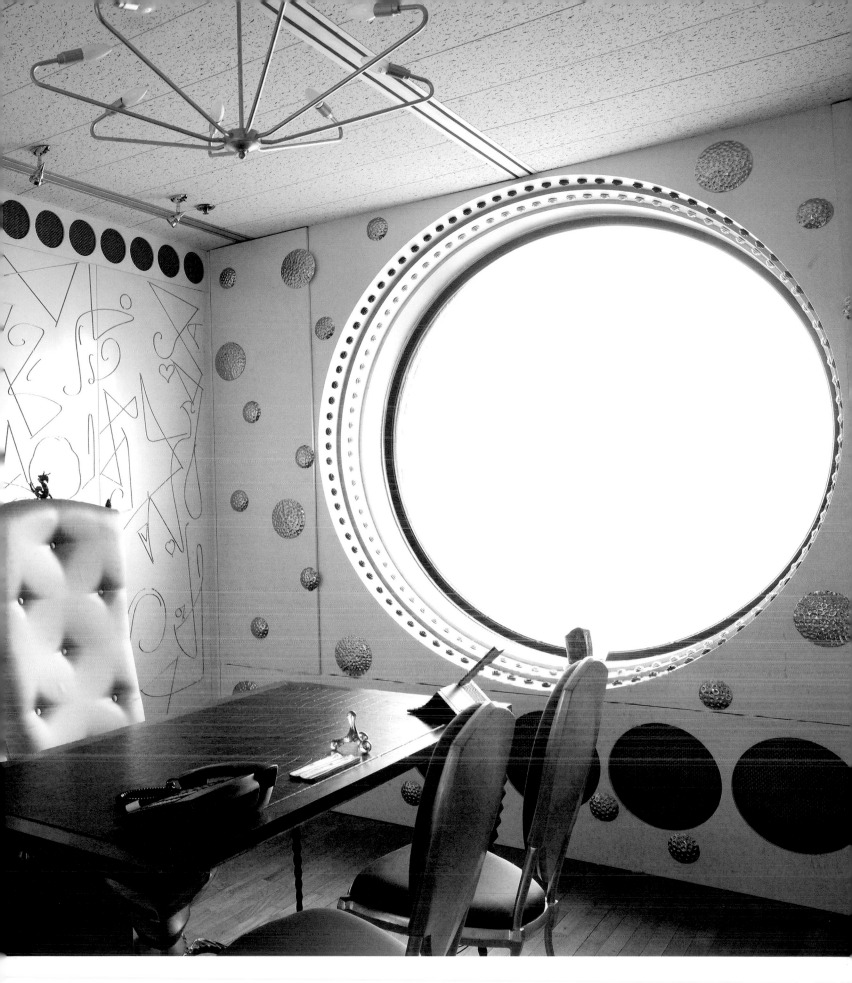

Left top A large metallic disk with a mirrored center and a jewel-encrusted chandelier create a dramatic, yet slightly sinister, vibe in one of the conference rooms.

Left Jules Verne-like mirrored doors lead to small offices. The walls are coated with metallic automotive paint.

Above The signature round windows of Jardine House formed the basis for Lam's interior design scheme which, like the gallery itself, celebrates and exaggerates differences.

riverside residence
the spirit of modernity

Designer JIANG QIONG ER | Suzhou River SHANGHAI

IN TODAY'S CHINA, talented creative types are jumping disciplines with ease. Accomplished artist and designer (interior, graphic, furniture and jewelry) Jiang Qiong Er is a case in point, creating a unique style which interprets both Chinese and Western cultures in an abstract yet spirited manner.

Jiang, a Shanghai native, studied interior and furniture design at the National School of Decorative Arts in Paris. She was the first Chinese designer to be invited to attend the Exhibition of French Furniture Salon in Paris and her work is displayed in the Pompidou Museum of Modern Art. Today she divides her time between Shanghai and her workshop in Paris. "I had a very traditional education with two very famous Chinese artists, one for calligraphy (Han Tian Hong) and one for traditional painting (Cheng Shi Fa) so I am influenced by ink and brush painting," she explains. "Afterwards I studied in France, so I try to mix these influences in spirit rather than in form."

She lives in a modern apartment situated on the banks of the Suzhou River. The area has recently proved popular with Shanghai-based artists and designers who are renovating the district's run-down warehouses and breathing new life into them. For Jiang, the river evokes memories of the Seine in Paris. "The river represents inspiration for artists and designers. It is very important."

So important, in fact, that Jiang has based her life and work around the river. As well as her apartment being located here, her furniture gallery, Number D, is in the block next door, and her office is in a renovated warehouse in trendy Moganshan Lu, five minutes' drive away.

Inside the 180-square-meter (1950-square-foot) apartment, she has reworked the space to produce a semi-open, light-filled interior. Its beautiful proportions are enhanced by furnishings which mix contemporary Chinese style and French savoir-faire. Alongside her own design furniture and artworks are antique Chinese pieces, European designs and French sculptures. The elements may vary but the color scheme is constant: a bold palette of red, white and black is made feminine under her direction. "Black, white and red are my colors," she says. "I use them in my paintings, my furniture designs, all my creations."

Below Jiang has created a glamorous open living area which includes design classics, contemporary furniture and reupholstered 1930s chairs. She customized a large mirror with her signature palette of red, black and white.

Right A calming, meditative atmosphere in Jiang's light-filled study.

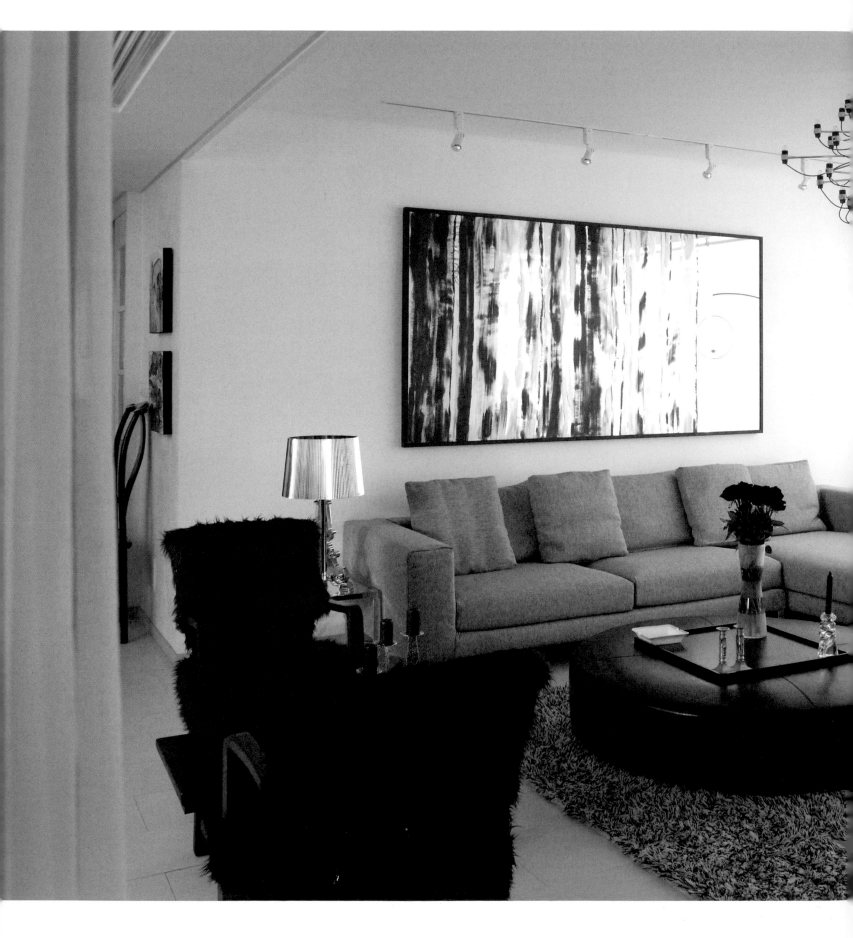

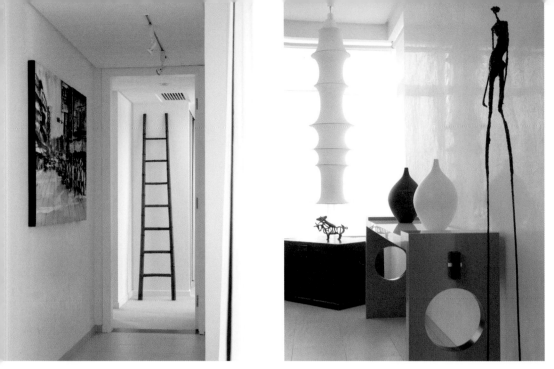

Far left A bamboo ladder leans against the wall at the end of a corridor. On the wall hangs a painting of Bangkok's Chinatown, purchased in Thailand.

Left In the living room, a modern interpretation of a classic Chinese side table, designed by Jiang, rests against a polished white wall.

Below The comfortable study is separated from the living room and dining area by white curtains which can open or close. Books, bronzes and ceramics fill the shelves behind a Corian-topped desk designed by Jiang.

Right The modern steel and glass dining table was designed by Jiang; in place of dining chairs are wooden Chinese stools from Number D Gallery. The red lacquer cabinet behind is also from Number D.

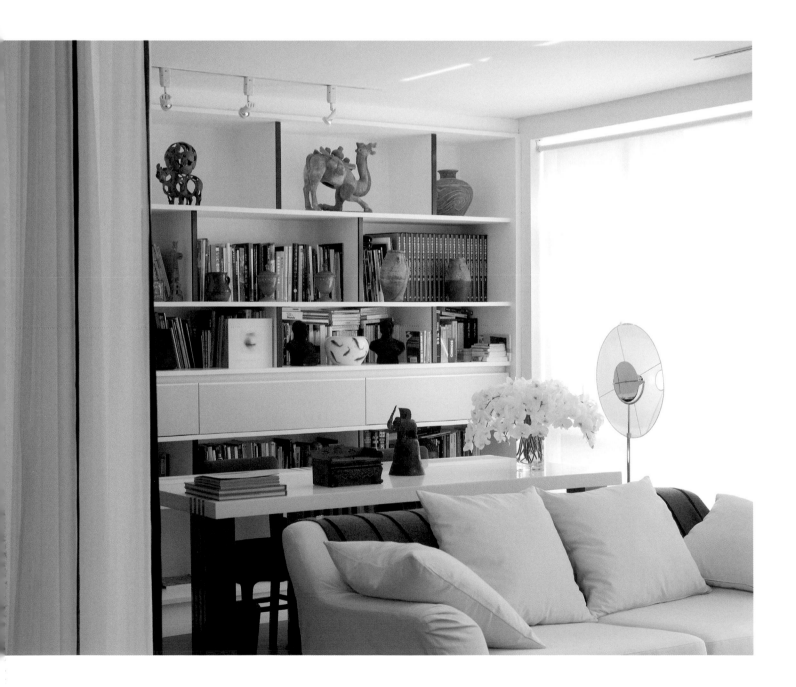

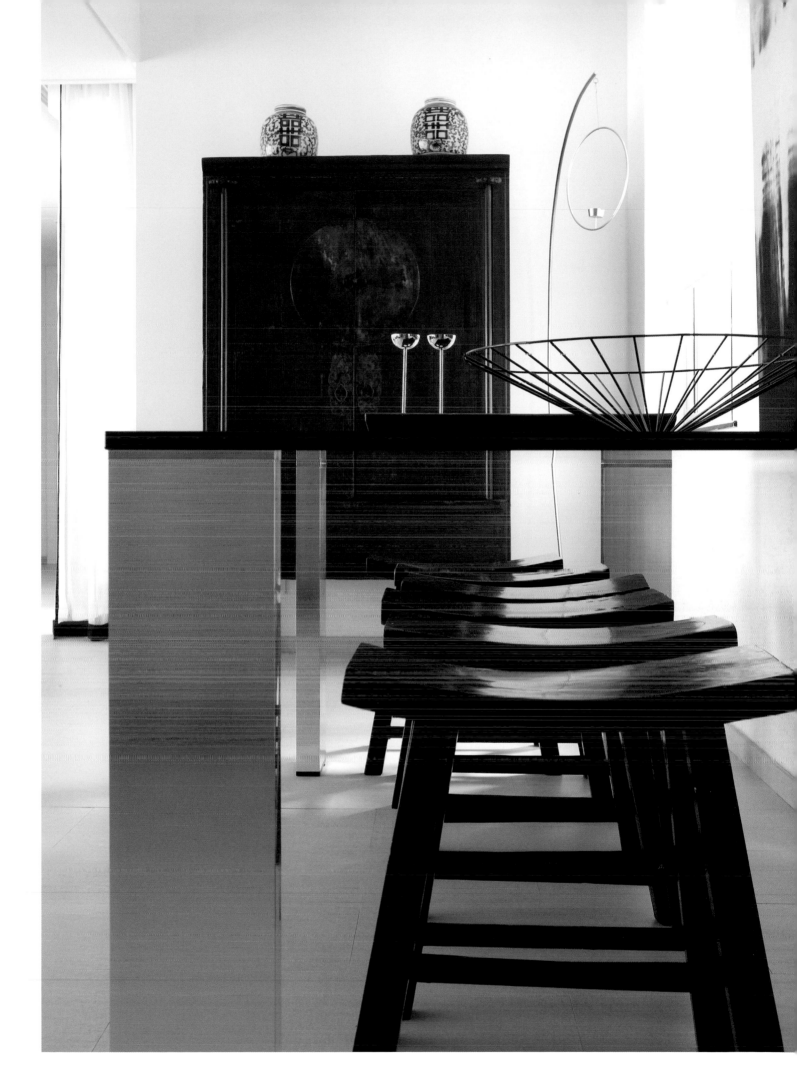

the transformer
less is more

Designer GARY CHANG | Mid-levels HONG KONG

HONG KONG HOMEOWNERS do battle daily with small living spaces, so when architect Gary Chang of Edge Design Institute was commissioned to revamp a 70-square-meter (750-square-foot) apartment in Mid-Levels (one of the city's most popular housing areas), he knew the key was "flexibility."

Chang, who won international accolades for his "Suitcase House" at the award-winning Commune by the Great Wall villa development near Beijing (see pages 176-9) decided to use some of his concepts for the villa and scale them down to suit small apartment living. What was needed, he realized, was a space that could transform itself according to the needs and desires of its users.

Thus he turned the apartment into a slim, rectangular studio space by removing most of the internal walls—except for the one between the kitchen and bathroom. He was rewarded with expansive green views over the hills outside. The focal point of the design is an undulating green "crazy wall" which runs the complete length of the room. The flowing, sculptural wall-cum-screen is both decorative ("an artwork in itself," says Chang) as well as practical (behind it are basic necessities such as a wardrobe, kitchen essentials and the bathroom door).

Designed for a young, city dweller who likes to entertain often, the palette of green, orange and purple is fresh and lively. The adaptable furniture—all designed by Chang—is integral to the design and divides the space into a dining area, a living area and a sleeping zone. Comprising a wall-mounted bed at one end, a wall-mounted dining table at the other and a stand-alone modular sofa in the middle, the flexible furniture can quickly and easily transform when required.

The bed can be folded down and retracted using just one hand, as can the large dining table. The modular sofa can morph into different seating positions, doubling as a spare bed and—with the addition of a moveable counter top—turn into a bar, a study or a desk as required. Living proof that less really can be more.

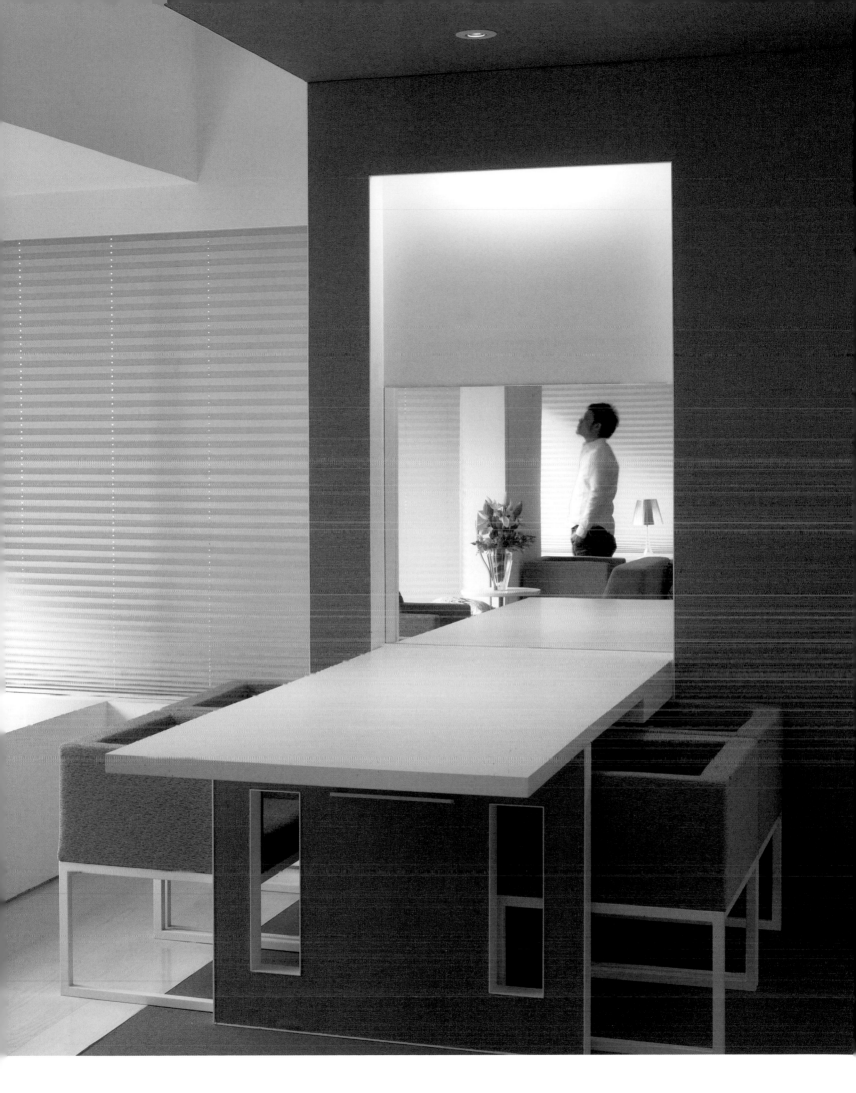

Above A corridor leading to the living room is made extremely functional by setting a wine rack into the wall. A recessed cabinet with built-in lighting on the right displays the owner's crystal collection.

Left An unusual color palette creates visual interest in this minimal, pared-down space. Electronic window shades allow a soft light to filter through.

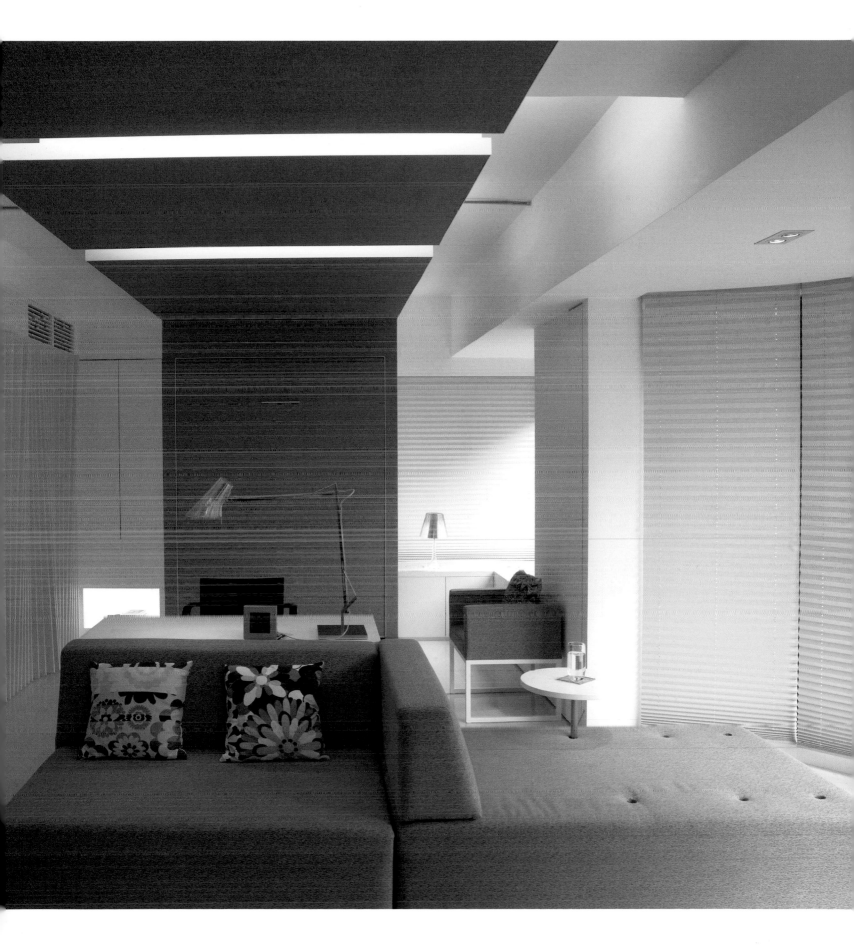

Left In the evening, the bed pulls down and a curtain can be drawn for privacy. For extra comfort and convenience, Chang designed a padded wall above the head-board and installed down lighting.

Above The modular sofa acts as a room divider in the middle of the long, narrow space. By adding or subtracting cushions, back-rests and side tables, the sofa takes on different functions.

Left The green ribbed wall panel can be positioned as required and keeps the space clean and clutter-free. Behind it are copious cupboards and shelving for clothes, personal accessories and household goods, as well as the entrance to the bathroom.

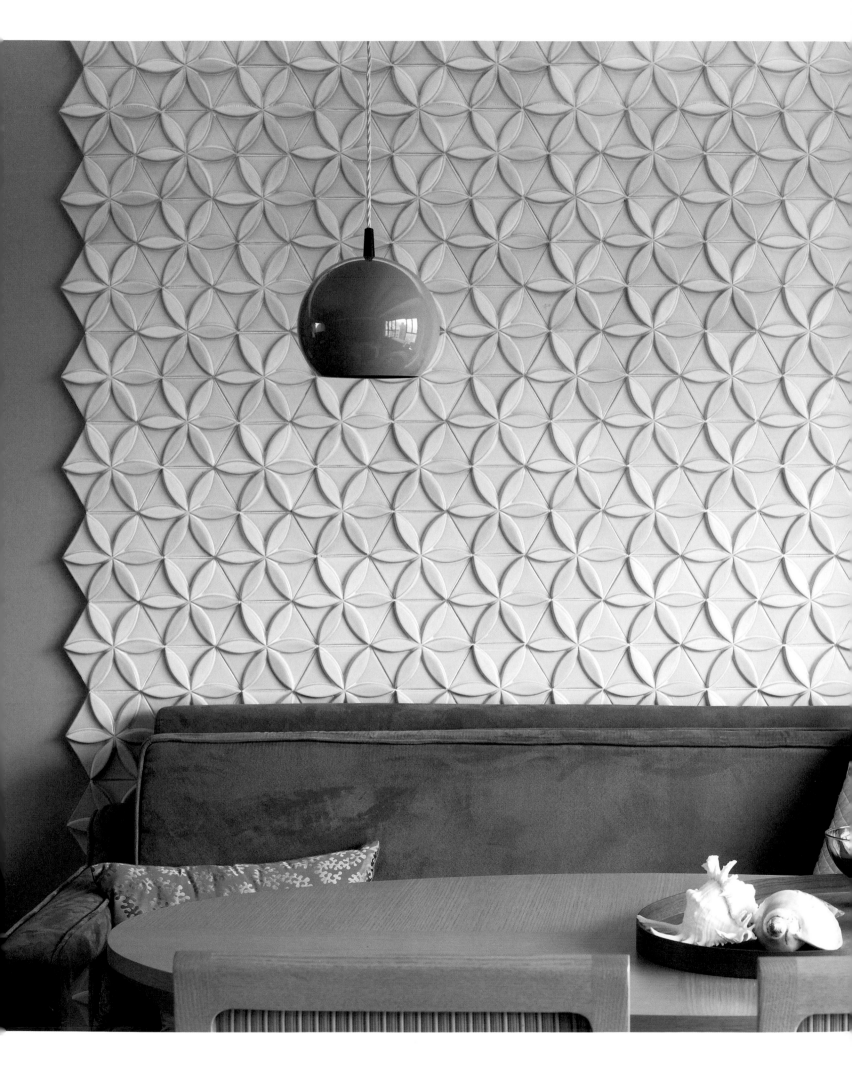

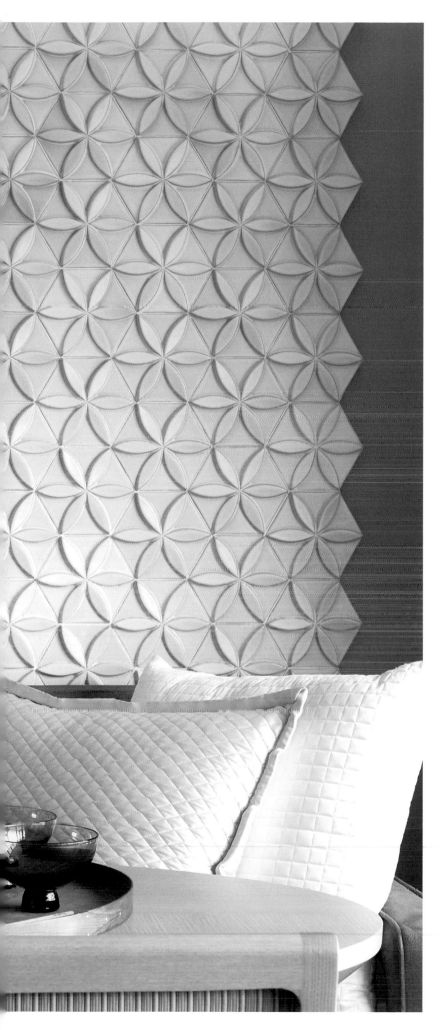

proportional living
hip to be square

Designer ANDRE FU | Mid-Levels HONG KONG

HONG KONG-BASED interior architect Andre Fu of AFSO is a name to watch. An advocate of minimalism, structure and order, he weaves together patterns and classical elements with a great sense of playfulness and fun.

In his 110-square-meter (1200-square-foot) apartment in Hong Kong's Mid-Levels district, Fu plays with perceptions and proportions. He divided what was a long, rectangular space—which offers city views to the front and green mountain views behind—into two perfectly proportioned squares. The front square is the public space for living and dining; the rear square is a more private area for sleeping, bathing and reading.

The first "public" square is all about horizontality. "I tried to make it very landscape in shape so everything is linear and horizontal," says Fu. "When you come in it looks like a very pristine space with an open kitchen and counter. It looks quite simple really because everything is hidden away."

Fu manipulated the proportions to extend the room visually by washing the walls with a full frame of indirect light—a treatment more often seen in art galleries than in residential projects. Colors are muted, with warm grey walls and splashes of green, blue and brown plus a panel of bespoke hexagonal flower petal tiles to add visual interest. The furniture is a mix of classic chairs, 60s pieces from Hong Kong and custom items by AFSO.

So distinct are the two spaces that the entrance to the rear square is almost hidden. A line of paneled full-height lacquered sliding cupboards separates the two squares, with the central cupboard door leading into the private area. In contrast to the horizontal living area, the private space is all about verticality—with the sense of height increasing the moment you pass through the full-height pivot door.

Here, the square is divided by a raw textured brick wall which runs almost to the end of the zone. The master bedroom is positioned against the left side of the wall; a guest bathroom, a study and a master bathroom are to the right. At the end is an open closet in stained white oak running the entire width of the back wall. Once again the color scheme is of muted pastels to emphasize visual calm and allow the space to evolve and grow.

Top Carefully chosen accessories such as this pod-like bowl provide restrained splashes of color.

Left Tailor-made hexagonal flower petal tiles from China add subtle patterning and texture to the living room.

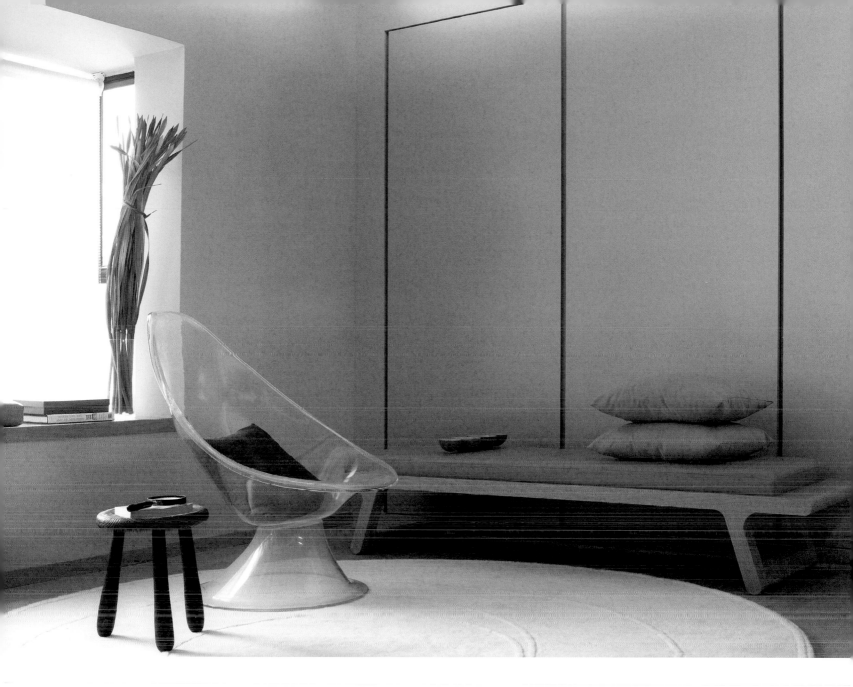

Above Full height lacquered cabinet doors line the wall that separates the two square zones. The central cabinet (not shown) opens into the private zone. The oakwood Hakabench, designed by Fu, is a multi-purpose coffee table which doubles as a seat with a cushioned leather surface. The transparent chair is from the 1960s.

Right A celadon bowl filled with seashells in shades of off white and pearlescent grey complements the decor.

Left top The public space comprises a seating zone with city views and an open kitchen with mountain views. A 3-meter (10-foot) long stainless steel kitchen island is set off from the rest of the room by a low oak wall

Left Fu has manipulated horizontal proportions to emphasize the width of the space. Warm grey walls are washed with light and furnishings are an informal mix of vintage pieces and bespoke furnishings such as these brown leather chairs and a 1.8-meter-tall (6-foot-tall) Arch lamp.

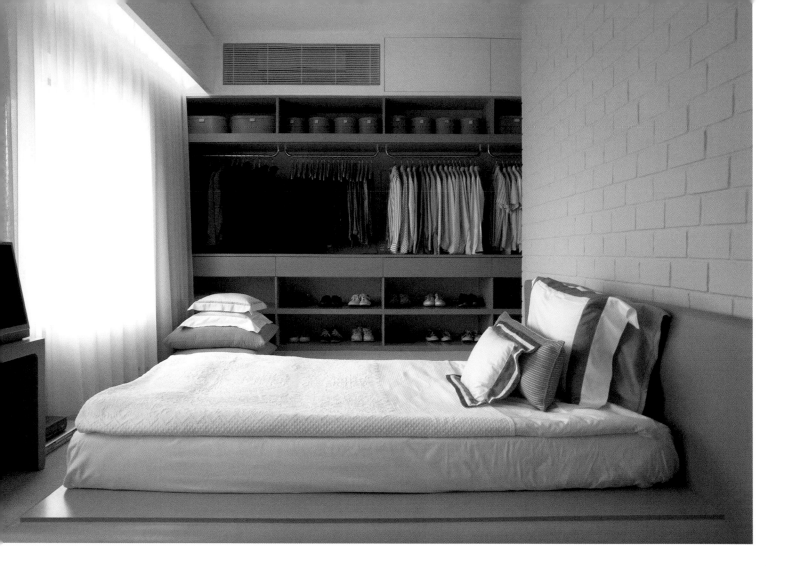

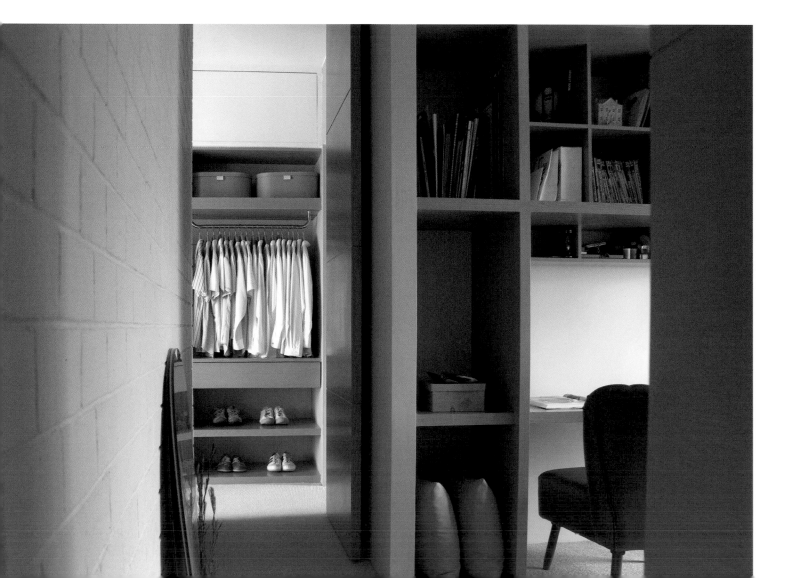

Left The master bedroom has a textured brick wall which divides the private area in two. At the end is an open closet in stained white oak. Muted colors and natural materials create a feeling of calm.

Left bottom The study is on the other side of the brick wall. A geometric shelving system with harmonious proportions was inspired by the work of minimalist architect A.G. Fronzoni. The perpendicular lines and full-height pivot doors emphasize the verticality of the space.

Right In the corner of the bedroom stands Fu's favorite wishbone chair by Dutch master Hans Wegner. Above the pale purple Button table designed by Fu hangs a peacock fan from old Hong Kong.

Bottom Fu is an advocate of structure and order, favoring simple lines and understated materials. In the bathroom he has used St Julian beige limestone for a touch of low-key luxury.

purity of space
white on white

Designer ED NG | Park View HONG KONG

INTERIORS DON'T GET MUCH more minimal. This perfectly peaceful, white-on-white apartment is located on the edge of Tai Tam Country Park, just 10 minutes drive from central Hong Kong. The serene interior, with its grey sandstone floors, white walls, sliding oak panels and opaque glass dividers is an effective counterbalance to the lush greenery outside. Here, the design scheme contrasts with, rather than embraces, the countryside location.

Working to emphasize the purity of the space, architect Ed Ng of AB Concept says that the 250-square-meter (2700-square-foot) unit is the most minimal design scheme that he has ever conceptualized. Together with his client he spent months meticulously planning the apartment, scrutinizing every detail to ensure the space was as pared-down and minimal as possible. "One of the hardest things was going into such detail to make it look as though there are no details," says Ng.

Internal walls were knocked down, new partition walls erected, overhead lights eliminated and replaced by light troughs, ceilings lowered and floors raised to hide utilities. Functional items have vanished: cupboard doors look like paneled walls; doorknobs are absent and washbasins have been designed without conventional plugholes. In the master bathroom, the WC has disappeared (it is hidden in an oak cupboard) and even the front door is without a traditional lock, utilizing a hi-tech key card and sensor instead.

The result is a totally streamlined interior which flows seamlessly from room to room. Some may find it austere, but the owners revel in the pristine nature of the space which echoes, in many ways, the classic Chinese concept of Taoism. Here, clever spatial discipline meets simplicity and elegance, an approach that has laid the foundations for balanced, ordered living for centuries.

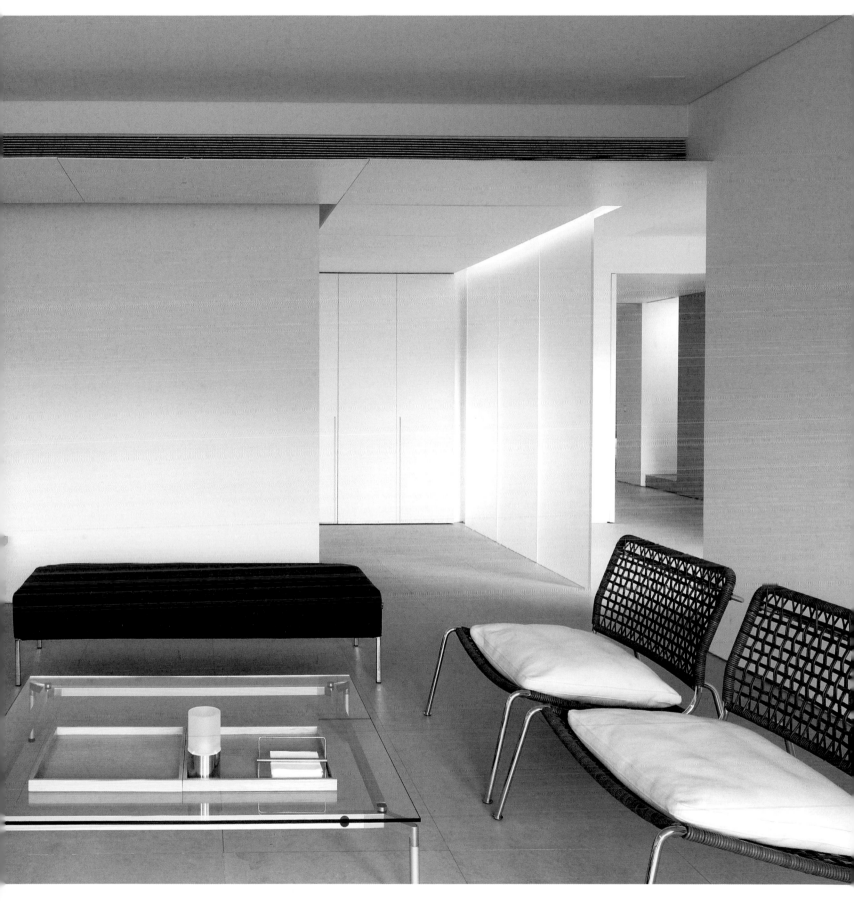

Below A peaceful Zen-like interior plays on space and light. Streamlined white cabinets, concealed down lighting and grey sandstone flooring form an immaculate backdrop to the modern designer furnishings.

Opposite The corridor floor has been raised to install recessed blue "runway" lights and to conceal the piping to the master bathroom.

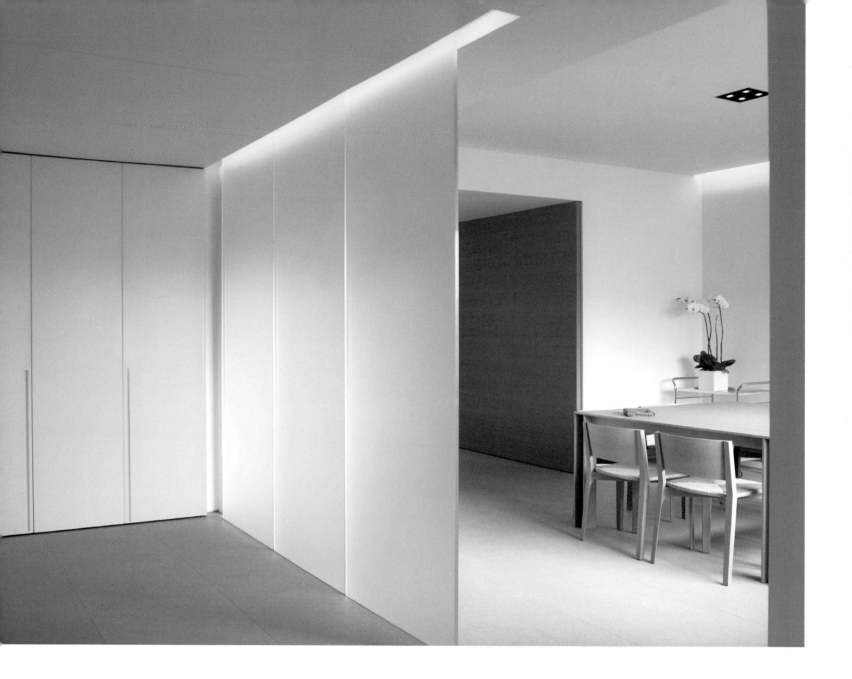

Above Invisible storage cabinets without handles, opaque glass divider panels and sliding oak panels feature in this precision-planned pristine space.

Right A curved picture window in the bedroom has been squared off by adding partitions on either side. The bed and bench are by B&B Italia; the table is by Desalto.

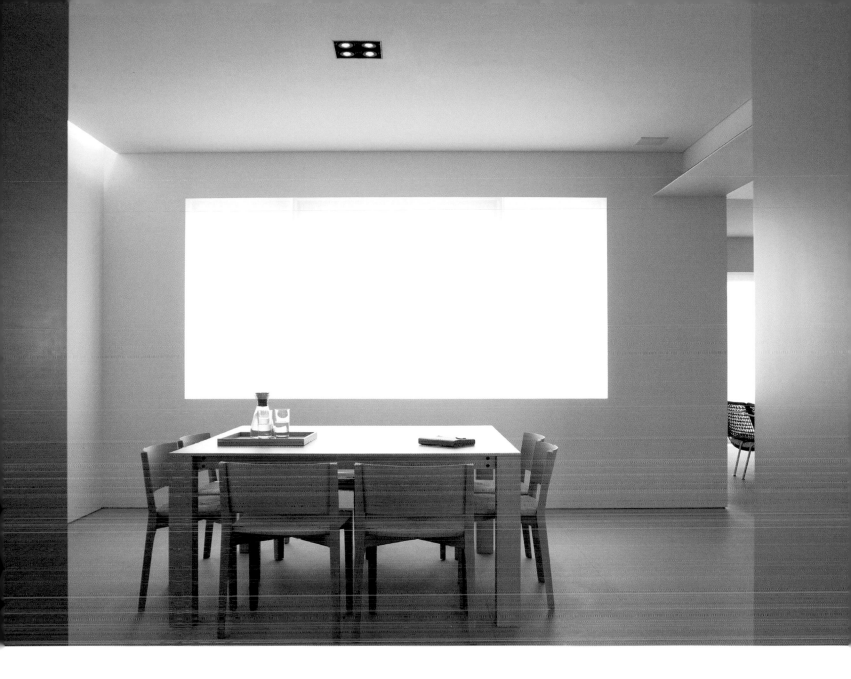

Above Light filters softly
through the large picture window
in the totally minimal dining room.
The oiled white oak dining table
and chairs are by Piero Lissoni.

Right Spaces have been
designed so that the eye travels
unimpeded from room to room.

Far right In a corner of the living
room is a pair of side tables on
wheels by Ligne Roset. Cathode
lighting washes down from a
shallow trough in the ceiling.

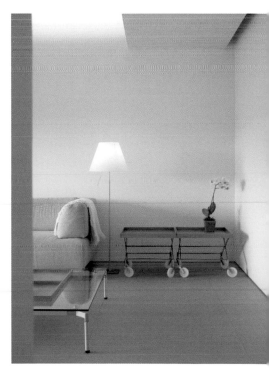

smart home of the future
living in cyberspace

Designer JAMES LAW | Kowloon Tong HONG KONG

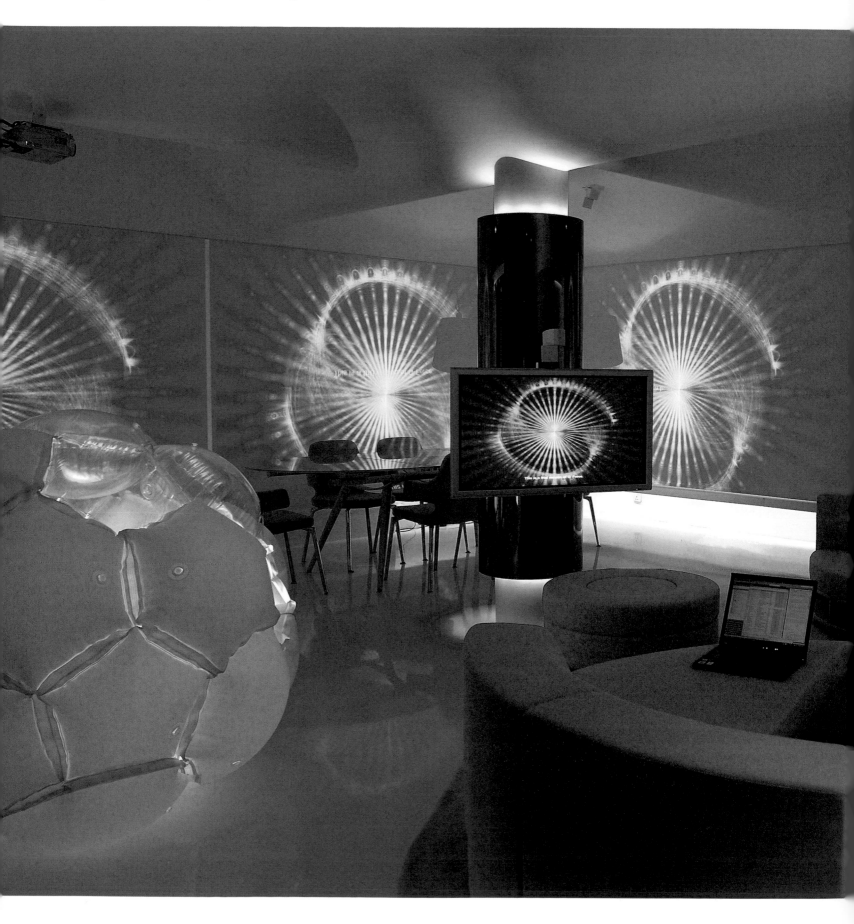

Right An inflatable chill-out room is constructed of interconnected hexagonal pvc pillows.

Below The intelligent home relies on technology to enable the space to interact with its users. A large format LCD screen is positioned on a rotating column; the external walls overlook a park but the view from inside can be changed using a layer of "digital wallpaper" onto which different images can be projected.

JAMES LAW of James Law Cybertecture International looks to the future to find innovative solutions for contemporary living. "Cybertecture aims to enhance and improve the quality of life by harnessing the power of technology," he explains, citing past projects which include the world's first artificial intelligence media laboratory for the Hong Kong Government and the first "morphable" house in partnership with IBM in Denmark.

In his own award-winning "smart home" in Hong Kong's Kowloon Tong district, Law shows how electronic and cyber forces can influence the way we live and work. His home is controlled through a network system which provides home automation, communication and virtual reality. In other words, it is designed to be intelligent enough to interact with its user.

The open-plan space is made flexible by a series of animatronic walls and partitions which can be repositioned to change the spatial configuration. In the center of the space is a rotating animatronics column with a large-format LCD screen that rotates 360 degrees. The screen presents all types of digital media from TV to PC.

A "cyber butler" is accessed by voice recognition technology and wireless web pads and controls all this technology. It learns user habits such as your favorite TV channels, room temperature and can even turn down the music when the phone rings. "Cybertecture incorporates the latest technology into every facet of daily life through visionary design," says Law.

The interior walls feature a layer of "digital wallpaper" that turn into huge digital screens onto which different content and external views can be projected. These screens also allow video conferencing with other spaces so that the living room can be visually extended into the living room of another home in another part of the world.

Law believes that such technology is ideal for compact Hong Kong apartments. "The obstacles of limited space living are overcome by merging Cyberspace and Real Space," says Law. "Everyone can have a great view from their window, even if they are landlocked inside a dense city. This is the power of Cybertecture living."

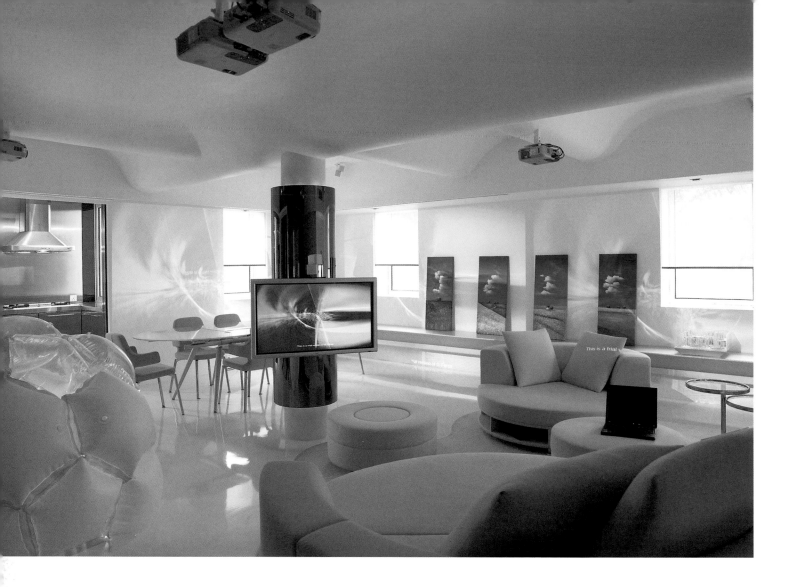

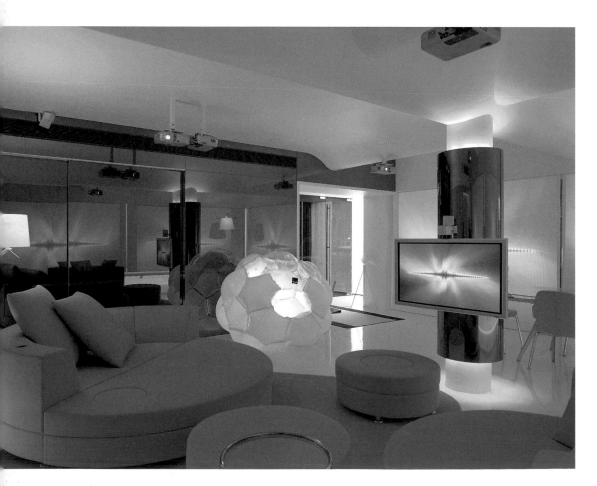

Above The screen in the center of the living room turns 360 degrees so it can be viewed from any part of the apartment. It is controlled by a Bluetooth pin worn on Law's lapel.

Left A "cyber butler" is attuned to the needs of the homeowner, selecting favorite TV channels, temperature and music levels. State-of-the-art lighting allows different colors to wash over the space, depending on one's mood.

Right Cyberspace and real space merge using digital wallpaper that allows Law to beam up a vast array of content.

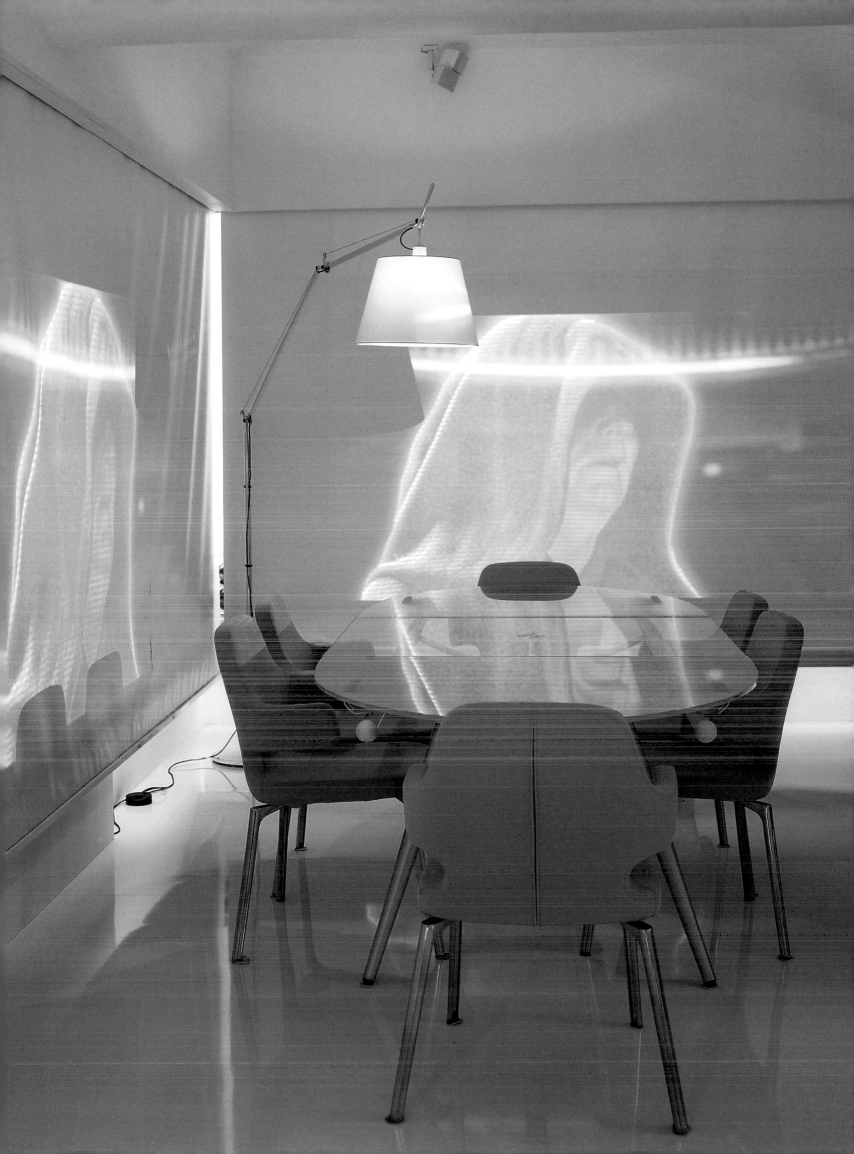

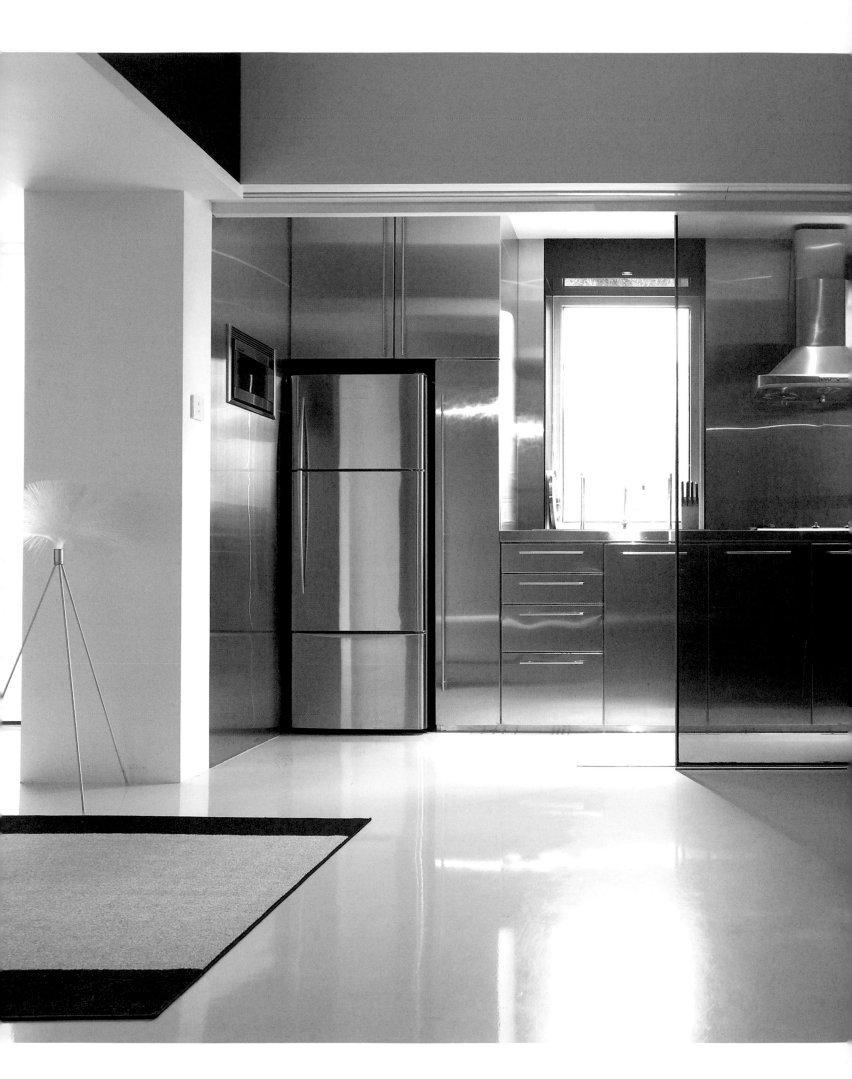

Left Sliding panels and screens can be mechanically repositioned to change the spatial planning of the apartment. Both the kitchen and the dining room are futuristic in terms of styling.

Top Law enjoys views of the great outdoors, both real and imaginary.

Above View of the kitchen and dining zone with repositioned sliding doors and abstract colors beamed onto the digital wallpaper. The system uses a combination of voice recognition and wireless web pads.

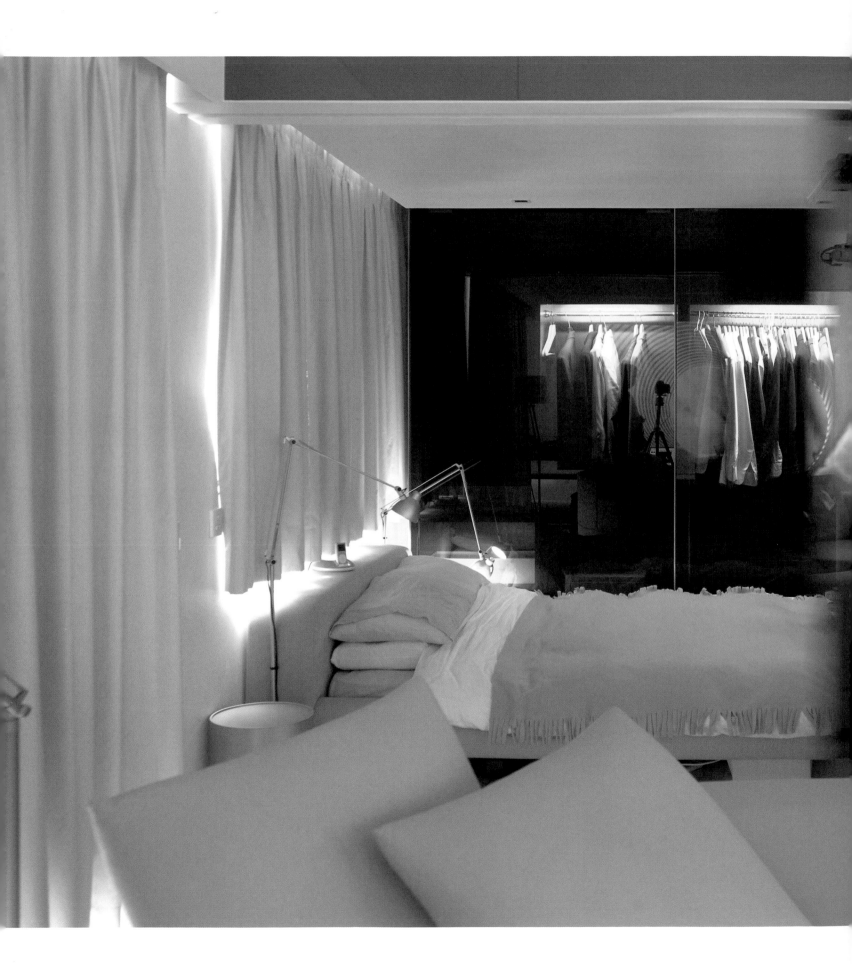

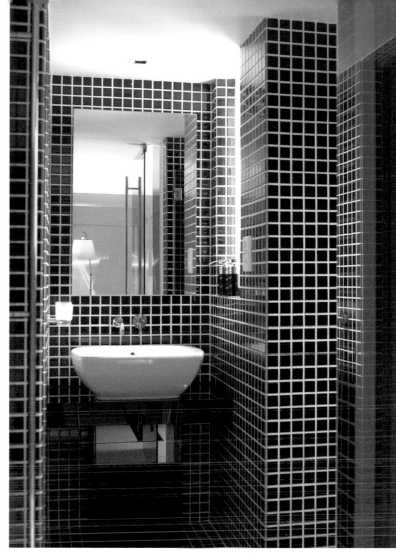

Above Black and white mosaic tiling in the masculine bathroom.

Left The bedroom area is surrounded by panels that morph from clear to mirrored. Curtains lend softness to the space.

sculptural duplex
bold colors and contours

Designer ODILE MARCHAND | Chang Ning SHANGHAI

Right A curveaceous entranceway leads into the bold green living and dining area. Timber flooring helps to anchor the color palette.

Left On the upper floor terrace, a curved wicker chair stands before a traditional Chinese side table that has been painted green.

THE HOME OF FRENCH interior architect, sculptor and painter Odile Marchand is anything but predictable. Her 270-square-meter (2900-square-foot) duplex in downtown Shanghai is a sensual combination of shapes, textures and colors that reflect a boldness of spirit evident in the city today. "I transform places and change their shapes through an extravagant architecture which follows no artistic rules," she explains.

With inspirations ranging from the surreal architecture of Antoni Gaudi to the ripe sculptures of French artist Niki de Saint-Phalle, Marchand has infused her Shanghai home with color and vibrancy. "I surprised myself," she says with reference to her design approach. "It was more of an organic process." Color appears in bold sweeping palettes of green, yellow and blue. "I used a lot of green as I thought it would be nice to live in a green space compared to all the pollution outside."

Spread over two levels—the open-plan living area, kitchen and children's rooms downstairs and the master bedroom and family room upstairs—the interior reveals sweeping curves in every direction. From the voluminous entrance to the undulating padded satin banquette, from the sinuous hallway to the curvaceous bathtub and vanity unit, it is a celebration of femininity and fecundity. "I love that it reminds me of the shape of a woman," Marchand explains.

To add depth to the color palette, Marchand introduced a range of paint effects to add energy and drama to the space. These include a stucco texture in the living room and special finishes produced by mixing color pigment, marble powder and concrete to Marchand's own recipe. Hardwearing surfaces were spray-painted with shiny epoxy paint. The result: an interior that is bold, original and full of surprises.

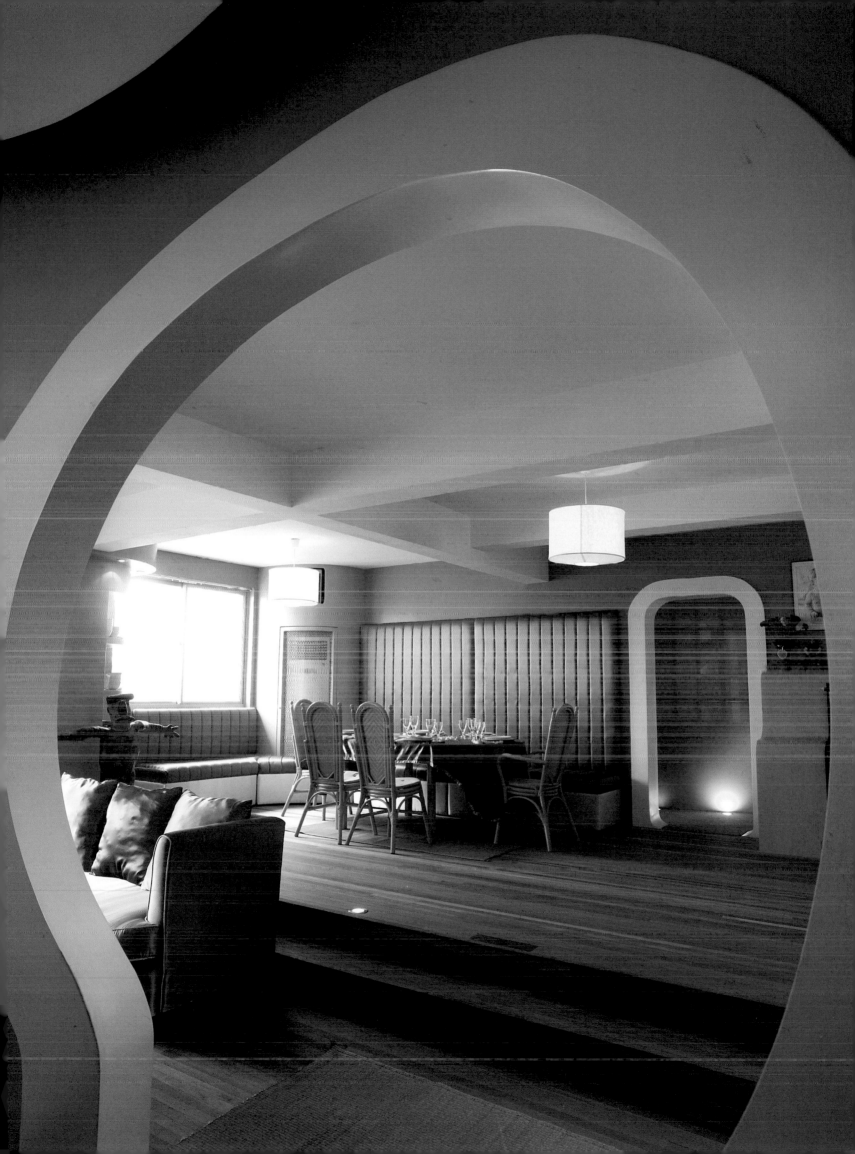

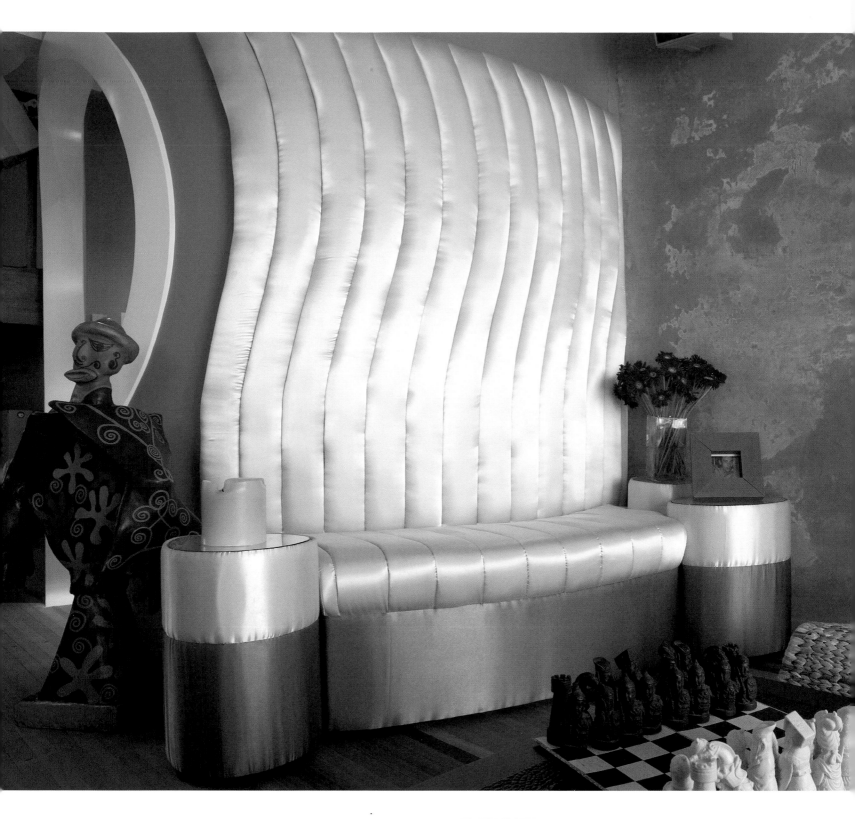

Above An undulating satin banquet in green and gold is a glamorous seating option. To the left is a papier-mâché sculpture by Marchand.

Right Fresh flowers go very well with the colorful paint finishes in the kitchen.

Right top The green color palette used inside the house contrasts with the grey urban environment outside. A curved breakfast bar divides the living and kitchen zones.

Right Marchand's signature marble powder and concrete finish has been used in the organic kitchen. Epoxy paint has been sprayed onto the jigsaw-like cupboard doors.

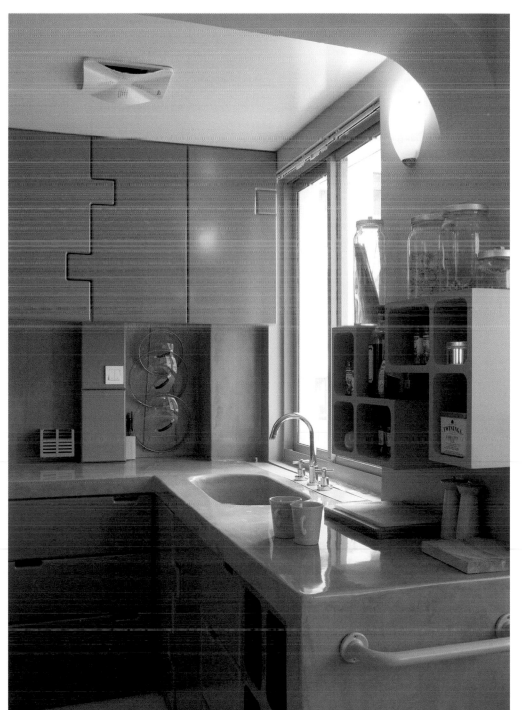

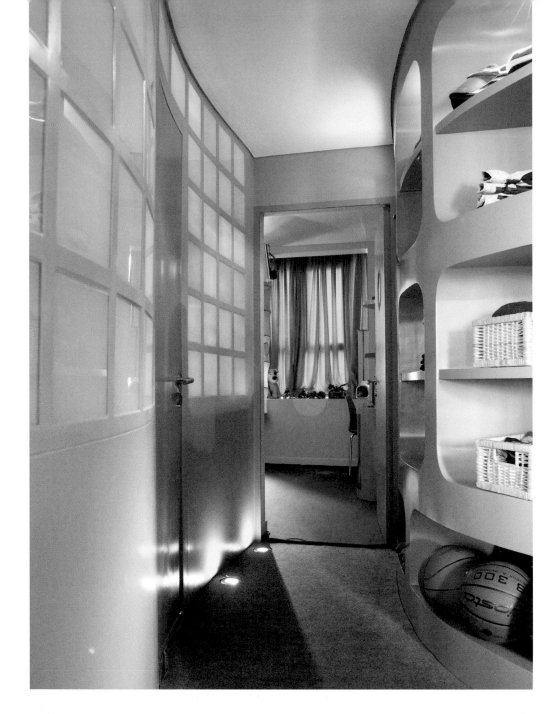

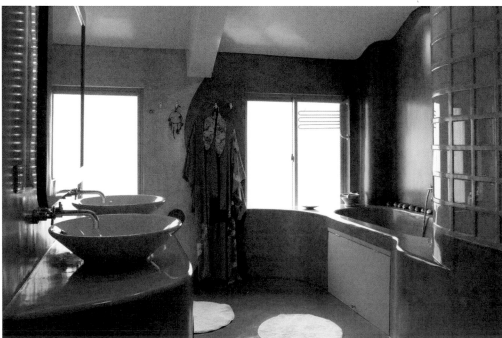

Left top A corridor leading to the children's bedrooms curves sinuously. To the right is the bathroom; straight ahead is her son's blue room.

Left bottom The spacious master bathroom features an undulating vanity unit and bathtub. A mix of concrete and marble powder provides a glossy green finish.

Below The bedroom is a sensuous sanctuary featuring a curved padded headboard designed by Marchand. One of her playful papier mâché sculptures stands next to the bed.

The long-awaited opportunity to express creative aspirations through design is now in the hands of a small but increasingly high-profile group who are pushing boundaries in a bid to produce statement-making designs. Experimentation is the catchword and the challenge lies in the creative process itself—with both experienced and self-taught architects, designers and creatives vying to produce the most exciting work. The results are often contradictory—austerity with luxury, innovation with tradition.

Beijing best exhibits this creative tension, but the movement is spreading. Experimental designers favor simple, elemental materials and then apply new styles and techniques to them. Innovation and understatement are valued; lavish budgets are not always required. A respect for the natural environment and skilled craftsmanship are coupled with a freedom that only uninhibited creativity can provide.

elemental appeal

artists' studio
collaborative space

Designer RongRong and inri | Chao Chang Di BEIJING

CAO CHANG DI DISTRICT, on the northeastern fringes of Beijing, is home to increasing numbers of art galleries and artists' studios. Avant garde artist and self-taught architect Ai Weiwei was one of the first to build a house here and has designed many of the stylishly austere galleries-cum-residences in the area.

This grey brick house next to China Art and Archives Warehouse (CAAW) was designed by Ai Weiwei and is now home to Chinese-Japanese photographer couple RongRong and inri. With its high exterior walls, inner courtyard and white framed windows, the minimalist residence redefines the traditional Chinese courtyard house. Whilst maintaining the principles of privacy and seclusion, the house has a contemporary outlook with its clean lines, subdued materials and an expansive, light-filled interior.

For RongRong and inri, the 500-square-meter (5382-square-foot) space is both home and workspace. Downstairs is the public area, an all-white studio space with soaring double-height ceiling, exposed pillars and concrete floor. To the left is an intimate dining area and a brick-walled Japanese tea room, recently added by the couple. An open stairway leads up to the second more private level, which has a balconied corridor with bedrooms and a study leading off.

Despite the minimalism of the space, the atmosphere is serene and welcoming. Since meeting in 1999 and marrying a few months later, the couple has lived in numerous residences, from a rundown courtyard house to a newly-built tower block. But in each they attempt to produce a peaceful, nourishing environment. "Home can help us to forget the outside world. It is a place for free thinking."

The walls are decorated with the duo's work, which has been exhibited in galleries around the world. Their outlook, in every sense, is a collaborative one. "All the things in our home, from the biggest structure to the smallest details, we discuss together," says inri.

Left Photographer couple RongRong and inri in their secluded grey brick courtyard. Its high walls ensure privacy from the outside world.

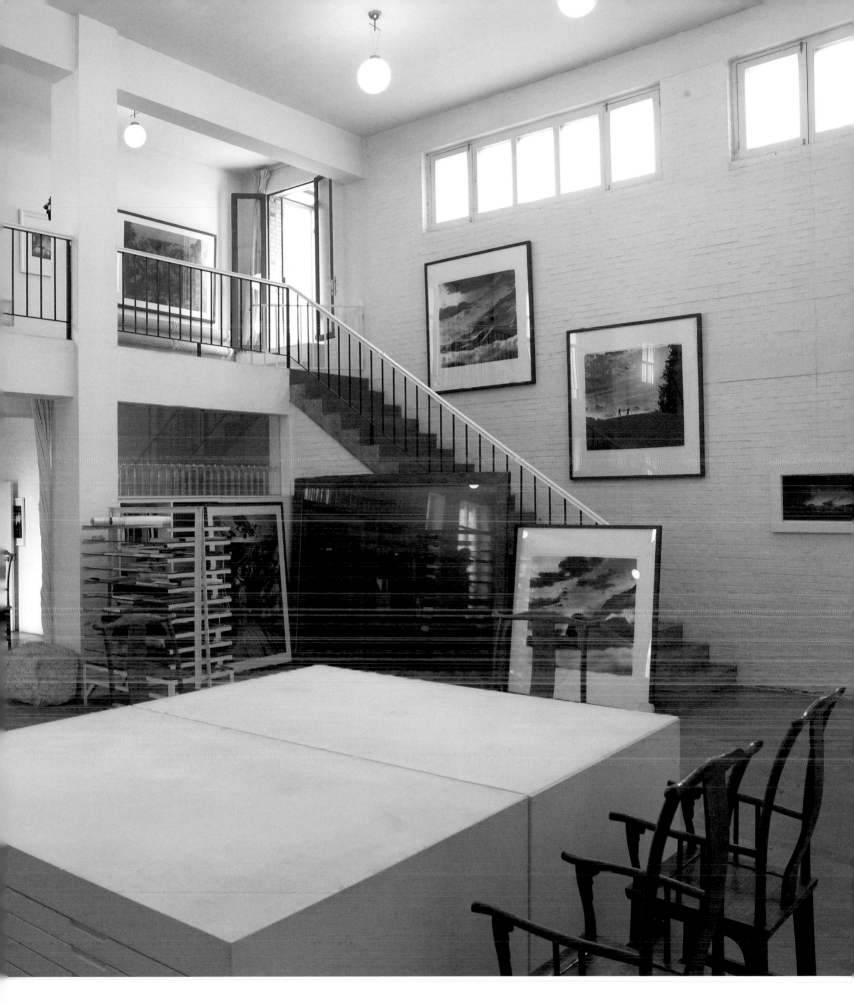

Above The couple is known for their evocative figurative work in extreme outdoor environments such as Japan's Mt Fuji. Their work hangs on the walls of their modernist home with its white walls, concrete floors and abundant natural light.

Left On the upper level, a light-filled corridor leads to a study at the end. Photographs are propped against the wall; furnishings are quiet and neutral.

Above A serene atmosphere permeates the house, encapsulated by this Buddhist stone deity which stands to the left of the entrance.

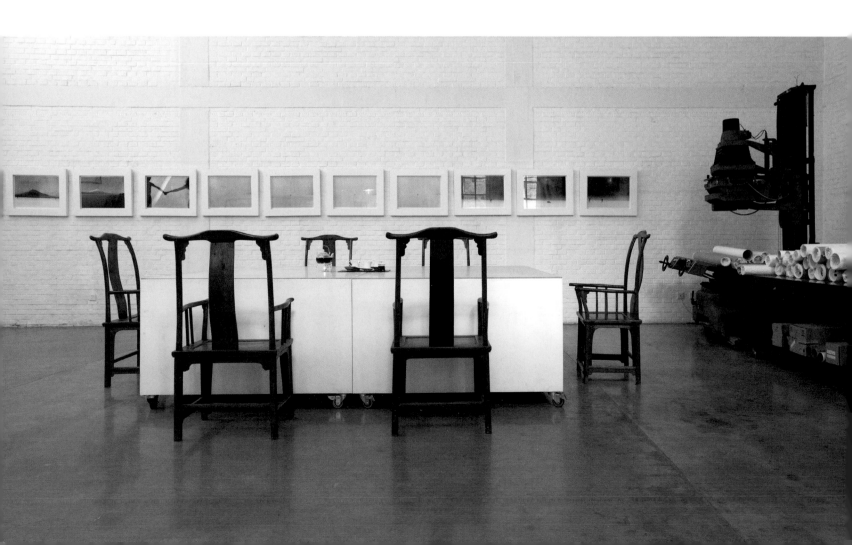

Left Lining the rear wall in the studio is a series of black and white photographs from RongRong and inri's famous Mt Fuji series. The large white two-piece table on wheels was designed by the couple and functions as workspace, storage unit and dining area for parties.

Left top The intimate dining room is a cozy space in which to relax. The modern table and chairs are offset by an antique official's hat armchair stripped of lacquer.

Above The couple recently added a Japanese tearoom. A roughly-hewn wood table, tatami mats and concertina doors opening to the courtyard encourage inter-action with nature.

split house
adaptive architecture

Designer YUNG HO CHANG | Commune by the Great Wall BEIJING

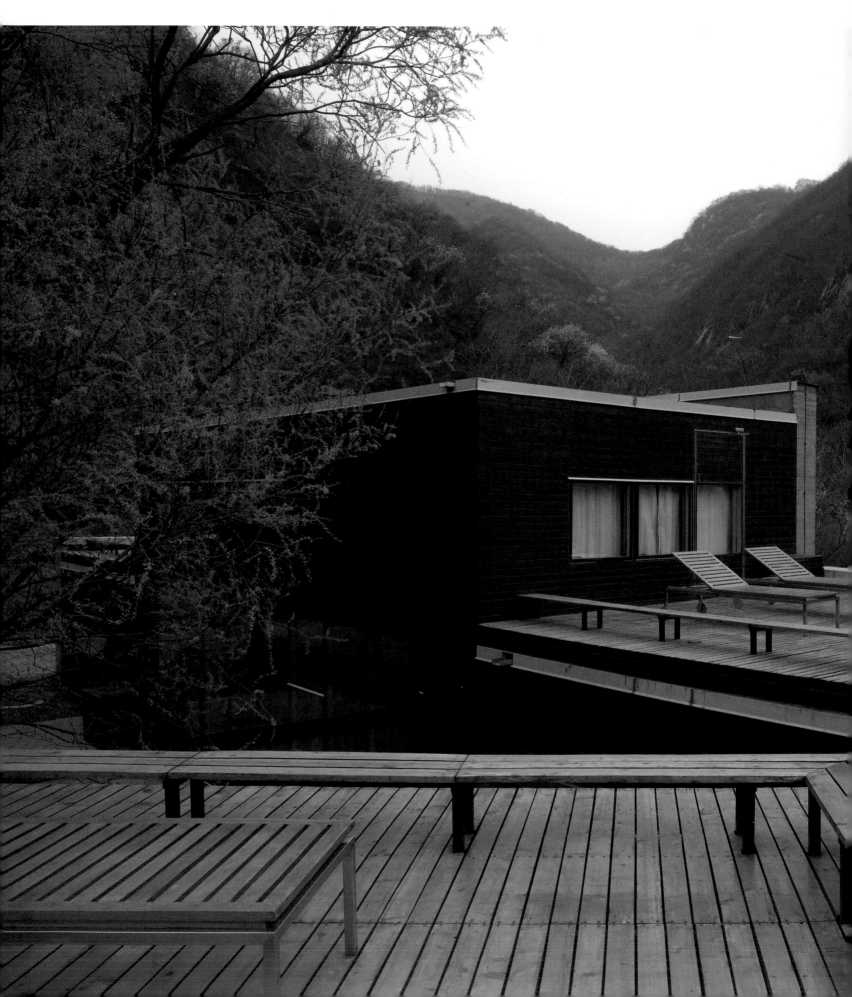

Below Yung Ho Chang's Split House stands at the top of the Shuiguan Valley. Its design reworks the traditional Chinese courtyard house with angled geometry and an extensive use of timber. Views from the terraces on the upper level stretch down through the valley.

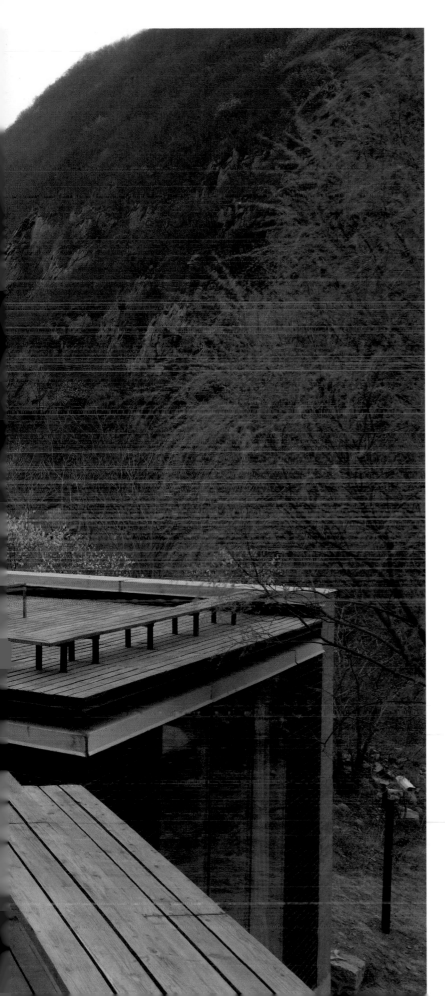

POISED AT THE HIGHEST POINT in the Shuiguan Valley, Yung Ho Chang's Split House at the Commune by the Great Wall is a prime example of the harmonious interplay between natural and built environments. The well-known architect, admired for his ability to combine Chinese traditional concepts with global modernism, established China's first private architectural firm Atelier Feichang Jianzhu (Atelier FCJZ) in 1993. Today he divides his time between Beijing and the United States where he is Chair of the School of Architecture at the Massachusetts Institute of Technology (MIT).

For the Split House, Yung Ho Chang literally sliced a traditional compressed earth structure in half to create two narrow angled buildings, joined by a single-story corridor under which flows a small stream. "The two wings of the house encircle the mountain slope, creating a courtyard that is half natural, half architectural," states Yung. The design is extremely versatile as the two wings could have been placed in a linear, parallel or angled arrangement, depending on the topography of the site. In this way Yung's goal was to create an adaptive architecture that would always be in harmony with its surroundings.

As in the other villas at the Commune, the Split House uses local materials in its structure. Made using a timber frame with traditional Chinese rammed earth walls, it aims to be ecologically sound. Yung chose rammed earth because it has high insulation value, is warm, natural and durable. It also anchors the building to its site. By using ancient building techniques in a contemporary way, Yung not only signals a respect for the past but also that these materials are acceptable for use in modern construction.

Inside, the 450-square-meter (4850-square-foot) space—with its huge glass windows looking out into the courtyard and the hills behind—combines a sense of rustic integrity infused with touches of contemporary design. There are open, wood-beamed spaces for living and dining and large bedrooms with huge terraces offering stunning views across the valley. Furniture is by contemporary designers such as Karim Rashid and Matthew Hilton juxtaposed with simple antique Chinese pieces and traditional hand-woven carpets.

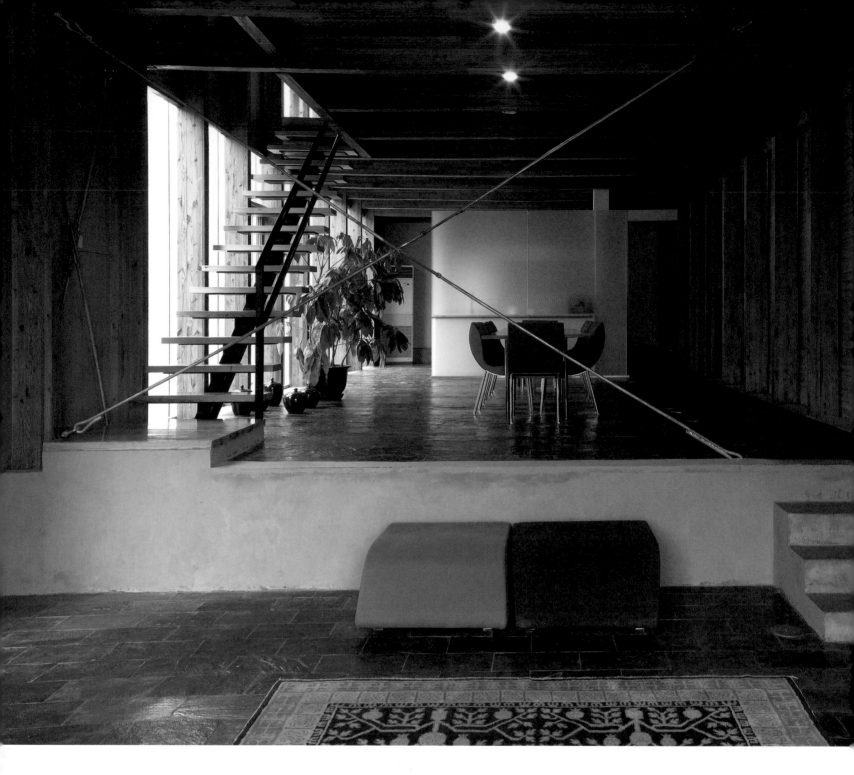

Above Rustic wooden beams, rammed earth walls and slate floors lend a calm and contemporary simplicity to the space.

Right top A floor-to-ceiling three-panel window offers views across the valley. Tibetan rugs and modern designer furniture add touches of color to the interior.

Right Windows on the other side of the house look into the private courtyard which is flanked on one side by the mountain slope. Wooden stairs lead to the sleeping areas above.

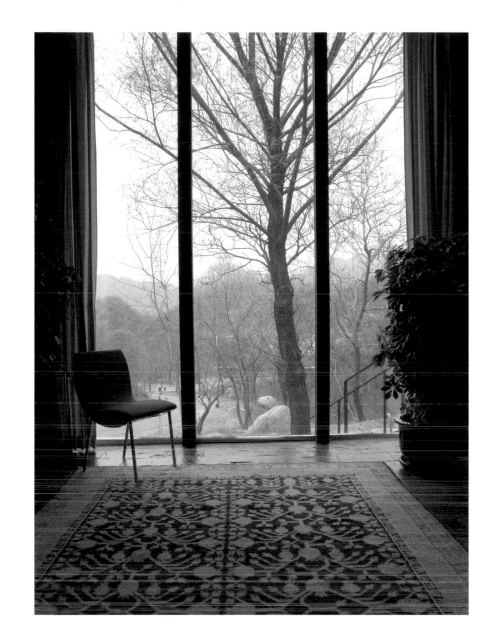
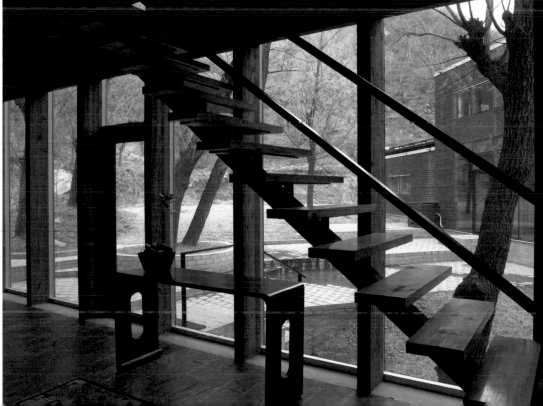

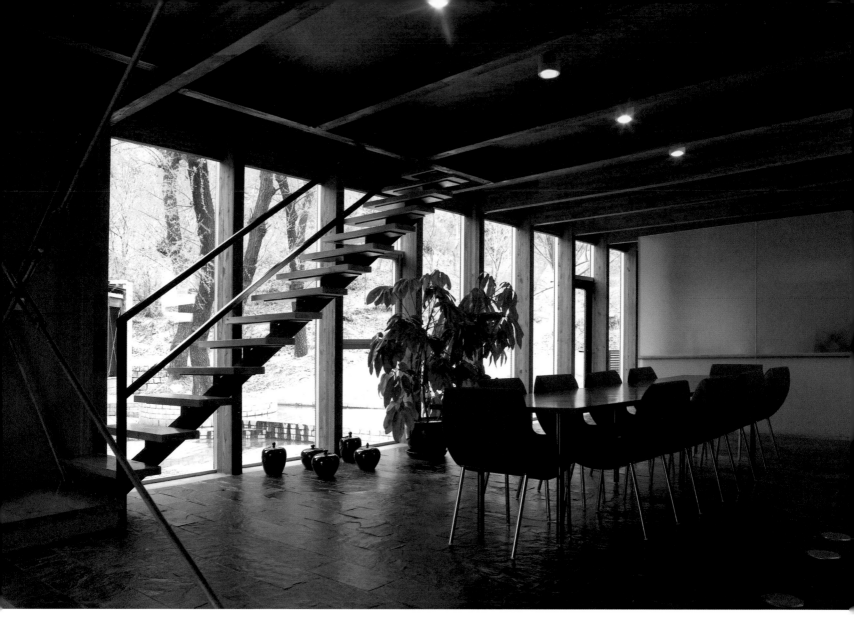

Left With its timber frame and rammed earth walls, the house aims to be ecologically sound and respectful of its environment.

Left bottom On the living room side, a pair of antique chairs is positioned for guests to enjoy views across the courtyard to the mountain beyond.

Right One enters the house through a central corridor with glass flooring across a flowing brook beneath. This device provides the ideal home entrance according to feng shui precepts.

Below The house has two angled "wings" encircling the mountain slope, and was designed so that it could be placed in a linear angled arrangement, depending on the topography of the site.

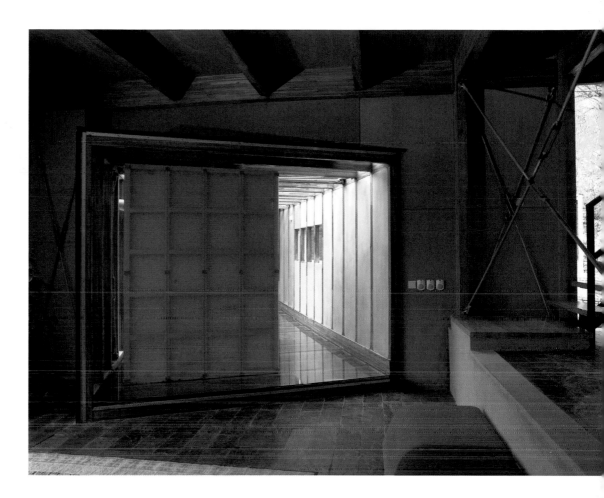

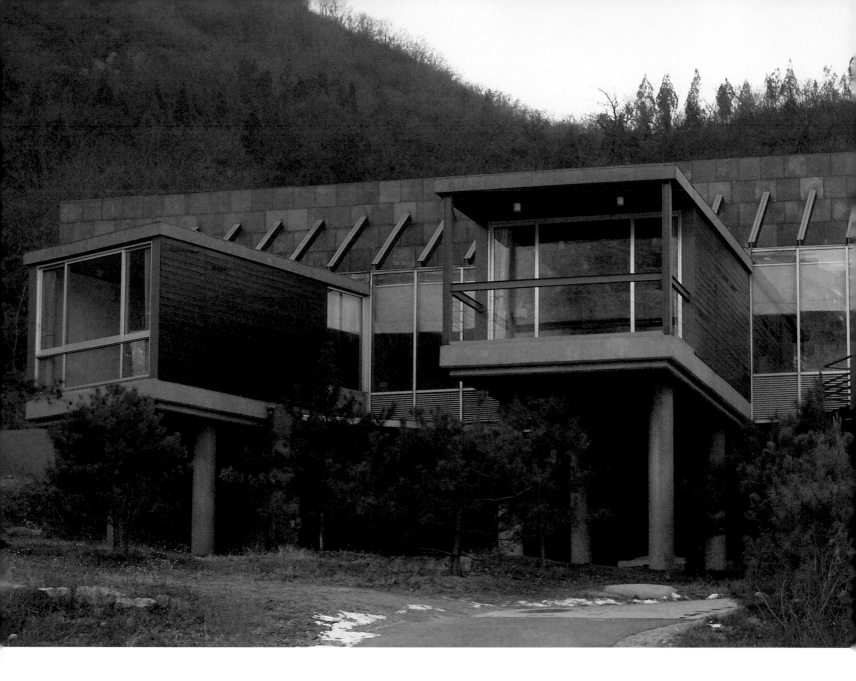

airport house
perfect landing

Designer CHIEN HSUEH-YI | Commune by the Great Wall BEIJING

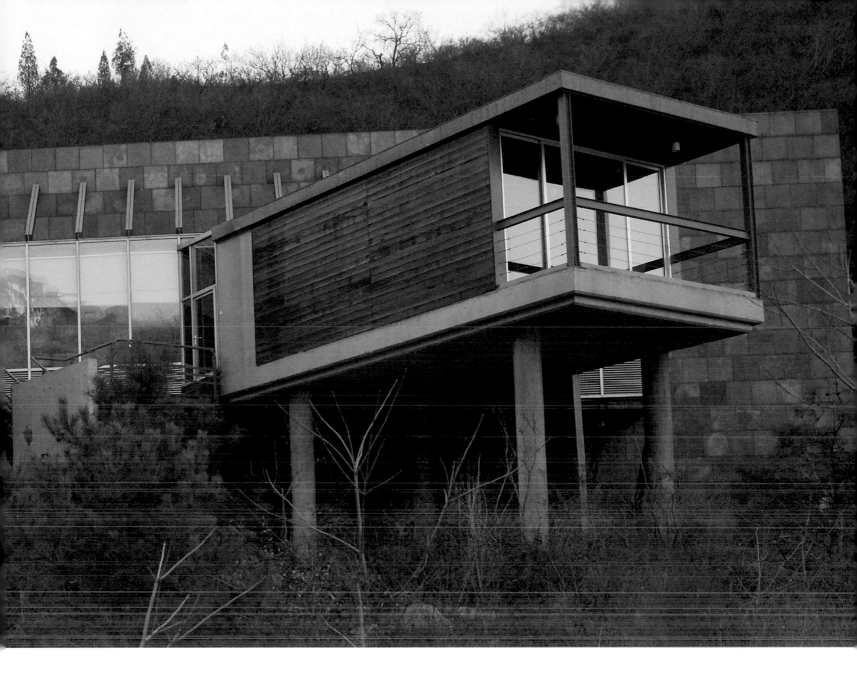

At FIRST GLANCE, the Airport House by Taiwanese architect Chien Hsueh-Yi at the Commune by the Great Wall appears almost overwhelmingly austere. But once inside—with sunlight flooding through the floor-to-ceiling windows and the overhead skylights—the concrete, glass and wooden structure takes on a softer perspective, perfectly at one with the natural environment. "Because of the special historical and environmental significance of the site, our first principle was to respect the history of the land and design a structure that would blend in with the environment and return to nature," explains Chien Hsueh-Yi.

Set into a steep slope halfway up the valley, the 600-square-meter (6500-square-foot) house consists of a main rectangular three-story structure from which protrude three "boarding gates" angled in different directions. Dividing the long main structure in two is a central wall, which creates two long corridors—one in front and one behind.

The front corridor provides access to the "gates" or public rooms for lounging, eating and meeting. The space here is open and light filled, facing away from the hillside. The rear corridor provides access to the bedrooms, bathrooms and service areas, and faces into the hillside, enclosed and safe.

The finishes are masculine: materials such as dark grey concrete, wood, metal, glass and stone create an almost monastic interior that is at the same time starkly elegant. Little stone staircases and varying ceiling heights add visual interest and offer different perspectives to the space.

Opposite The masculine finishes including wood, concrete and leather are starkly elegant.

Above Three living, dining and meeting rooms extend in different directions from the house like boarding gates at an airport.

Above Muted colors and soft furnishings enhance the connection with nature. Here, in the living room, a floor-to-ceiling window ensures unobstructed views across the valley.

Left The house has four bedrooms in total; this one in brown and slate grey tones is a restful sanctuary.

Right With its grey concrete walls, wooden beamed ceiling and glass paneling, the interior is almost monastic in appearance. Bedrooms lead off the rear corridor; their windows look out onto the green hillside behind.

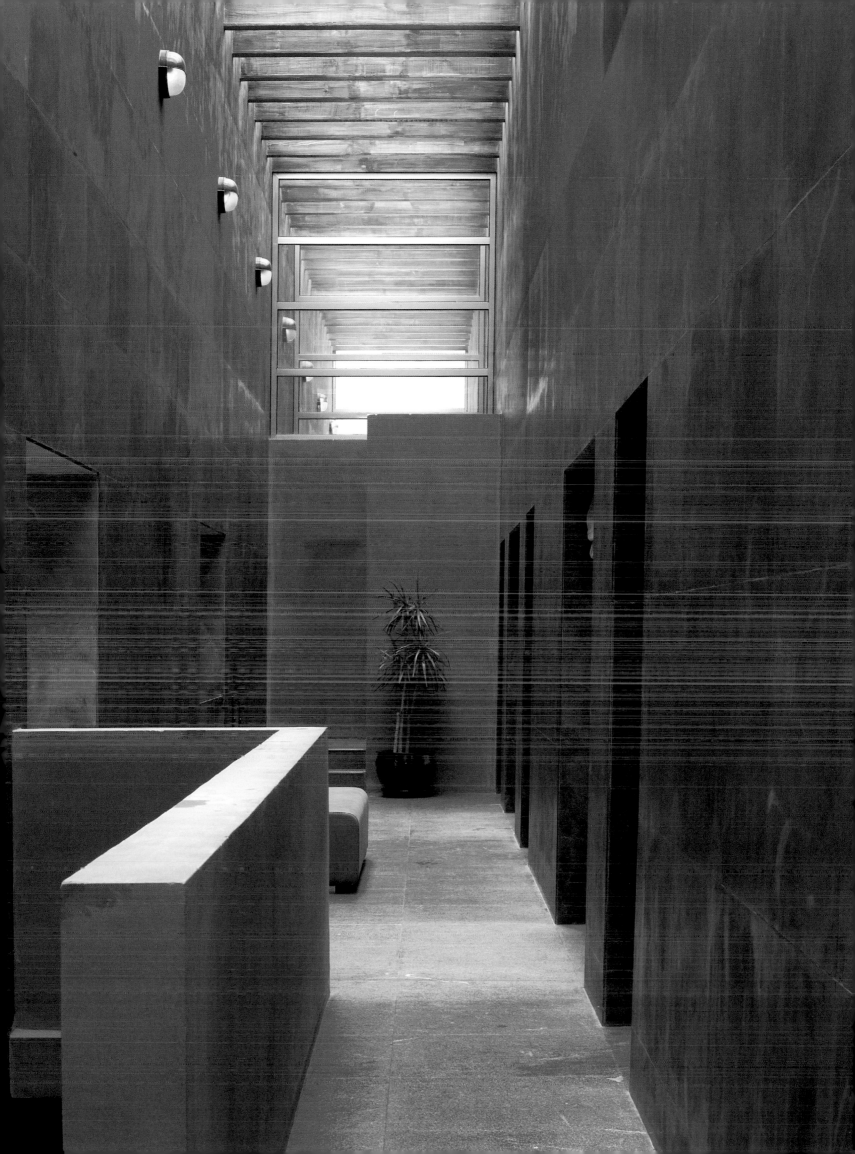

Below The guest bedrooms face the hillside and feel enclosed and protected by it. Panels of dark grey concrete line the corridor walls, adding a spartan elegance to the space.

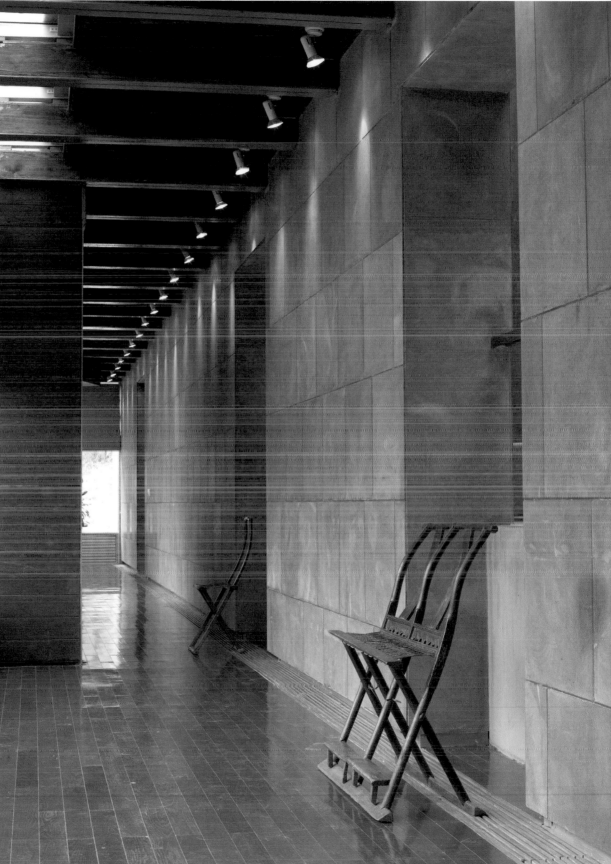

Below The front corridor acts as the circulation spine of the building, connecting the terminal-like rooms. A pair of antique Chinese folding chairs adds a touch of warmth to the 14-meter (46-foot) long corridor.

loft living
beijing's art world

Designer HUANG RUI | Dashanzi BEIJING

DASHANZI IS A THRIVING ARTISTIC COMMUNITY located in the northeast of Beijing in what was formerly a cluster of state-owned military factory buildings. Today Dashanzi—or 798 Art District as it is known—has been compared with Greenwich Village or SoHo in New York and is a bold example of the evolution of China's contemporary art movement.

Artist Huang Rui, a founding member of China's first avant garde art group known as Xing Xing ("The Stars"), is an active promoter of the Beijing art scene. One of the founders of 798, Huang believes contemporary art has a lot to offer the development of China, not least in the area of freedom and self-expression.

Huang's loft-like studio residence is in the heart of 798. Opaque metal-framed glass doors swing open to reveal a large living room with double-height ceiling. The room is dominated by a huge terrazzo table and with two long benches—one of which is a carved tree trunk. A steep, timber-plank staircase leads upwards to a Japanese-style tearoom at the rear of the space which nestles beneath large sloping windows and an arched ceiling. Another stairway leads to a light-drenched studio and master bedroom.

With its exposed brickwork and white-painted concrete, the space has its roots in Bauhaus design ideology, successfully blending modern elements with industrial roots. Huang believes in the integrity of history and tradition, believing a place should develop naturally—like Dashanzi itself—rather than simply knocking down the old to build the new, a scenario all too common in today's Beijing.

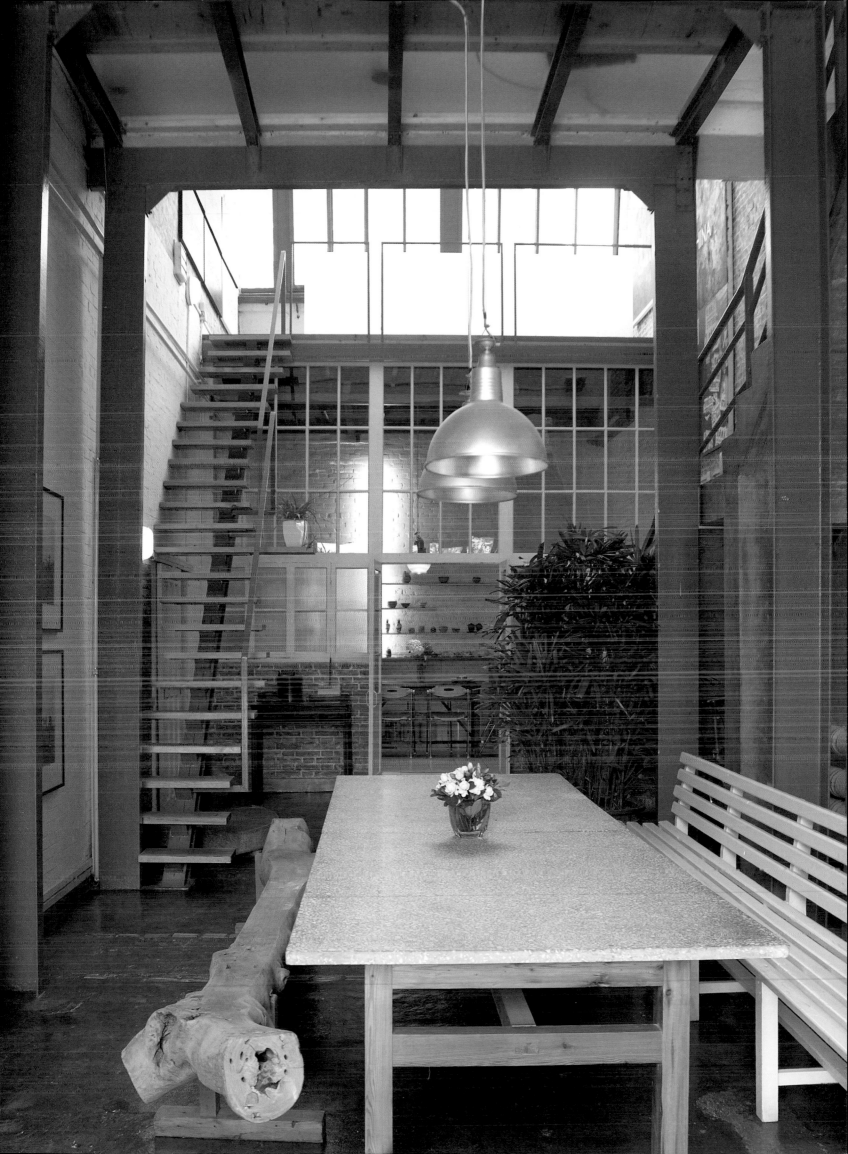

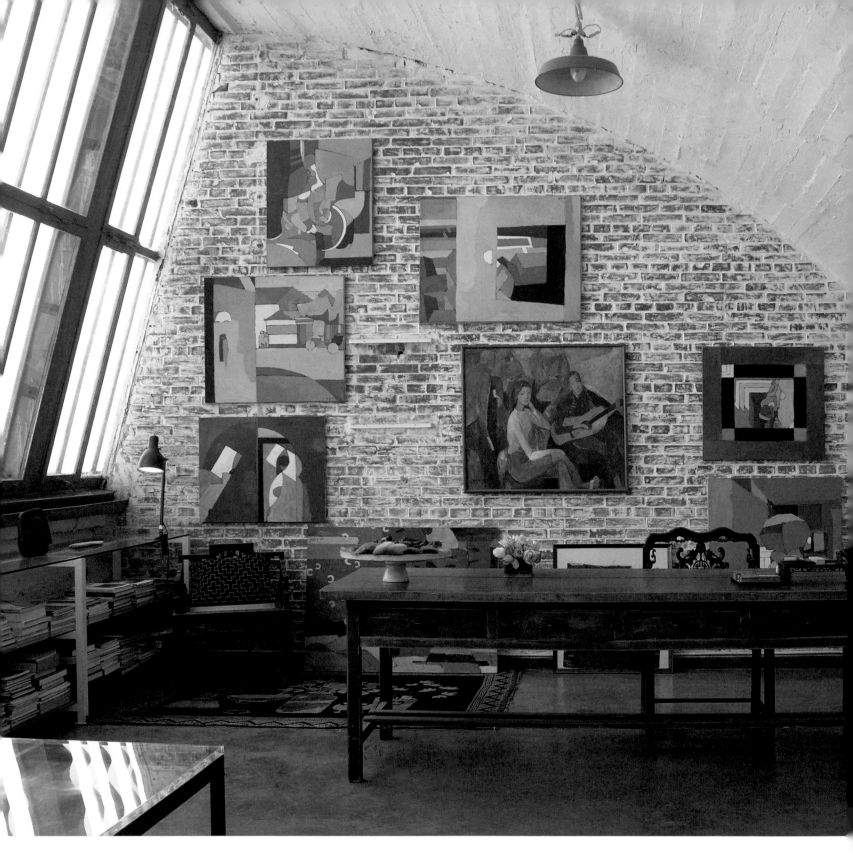

Above In the brick-walled study hang some of Huang's prized paintings, including many from his art group's first exhibition in the late 1970s. On the large wooden desk are traditional calligraphy brushes and an inkstone.

Right top The utilitarian kitchen is located at the far end of the ground floor living room area. Ceramic teapots, cups and bowls fill the shelves.

Right The industrial roots of Dashanzi are still in evidence. The artist is a firm believer in history and meaning, preferring organic development to rapid demolition and rebuilding.

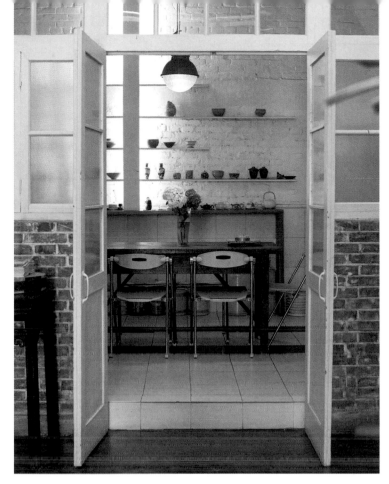

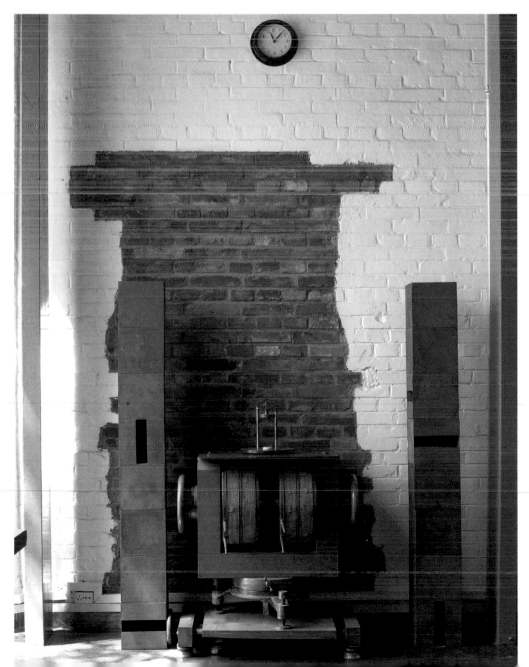

1969-1979

1999-2009

Left top The high arched ceilings of the Dashanzi factories add a distinctive character to the spaces. Through the study doorway, the master bedroom is separated from the stairway by a slim line of wardrobes.

Left An antique Chinese table and stool function as a vanity unit. To their right is a 3-meter (10-foot) canvas on which Chinese characters denote the sexual points of a woman's body.

Above The artist spent much time in Japan and has embraced that country's design culture in a serene mezzanine tearoom furnished with tatami mats and white pebbles.

villa shizilin
at one with nature

Designer YUNG HO CHANG & WANG HUI | Changping County BEIJING

SET IN THE HEART OF CHANGPING County to the north of Beijing, not far from the Ming Tombs, is an expansive villa that is totally in sync with its rural surroundings. The 4,800-square-meter (1.1-acre) site is flanked by mountains and set amidst an undulating landscape filled with persimmon trees. Here swans glide serenely on a freshwater lake and Arabian ponies run free.

Villa Shizilin was designed by architects Yung Ho Chang and Wang Hui for property developer couple Zhang Bao Quan and Wang Qu Yang. The architects set out to create a modernist house that blends in with the spectacular setting and produced a multi-angled structure that blurs the division between inside and outside. Comprising nine tapered wings oriented in different directions, the villa's sloping roof lines echo the mountain ridge behind.

"The fact that the villa is open to nature is very important," explains Wang Hui. "When people are inside the villa it is important that they do not feel inside." Huge floor-to-ceiling windows, an extensive use of glass to give the impression of endless space and light, and soaring ceilings emphasize the natural rural environment. The house bends itself around nature—incorporating existing persimmon trees into its internal structure by enclosing them in small internal courtyards. "In this location there were many existing trees so we had to design the building to create gaps so that the trees and the building could meet," says Wang.

In every aspect of the villa—whether in the public entertaining area, the hotel wing for guests, the private family zone or the stunning indoor swimming pool—an appreciation for natural materials, craftsmanship and local culture is clear. Stone from a nearby mountain—more often used locally in dam construction—was cut into cubes and used as a structural element. With its steel and glass façade, rusted Corten steel panels and half-hidden by rows of persimmon trees, the structure melts seamlessly into the surrounding environment. "We didn't want a flash new building here," says Wang. "We wanted time to work like a tool, to change the building over the years."

Below Set amidst beautiful grounds, exterior views are key to the design of the villa. The owners requested that from all parts of the building, one should be able to embrace nature.

Left Designed to blend into its surroundings, the villa, with its nine tapered wings, creates a sense of harmony between the natural and built environments.

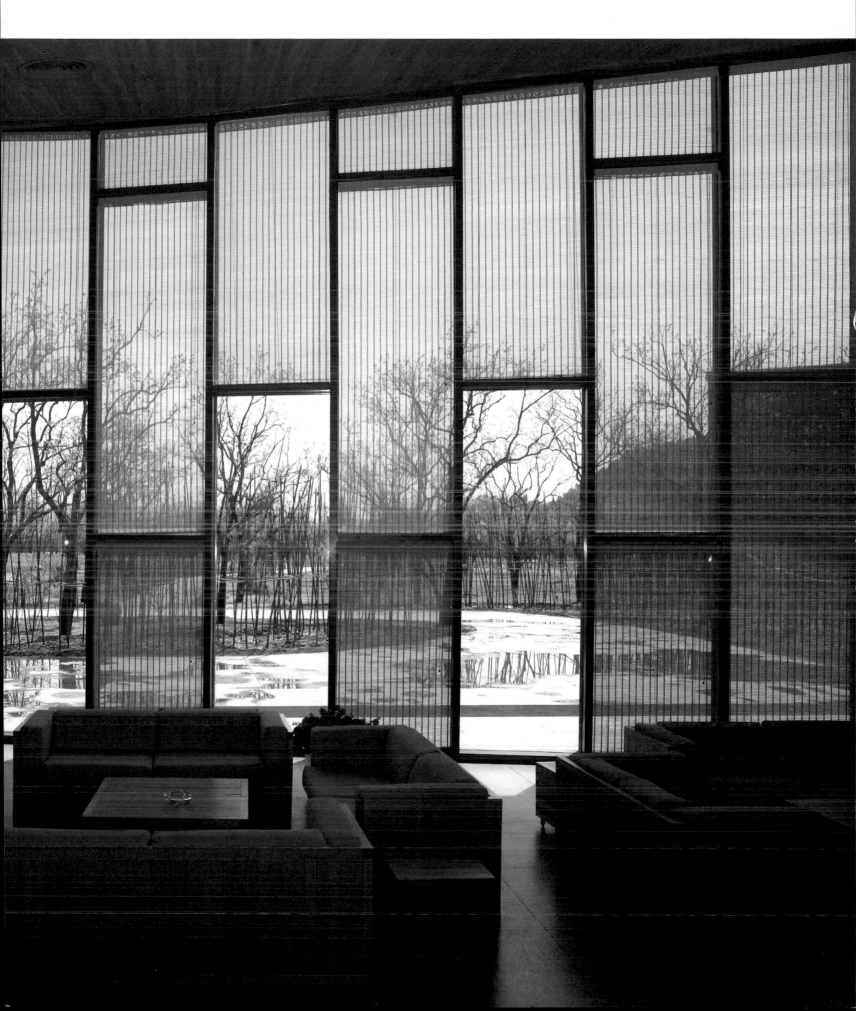

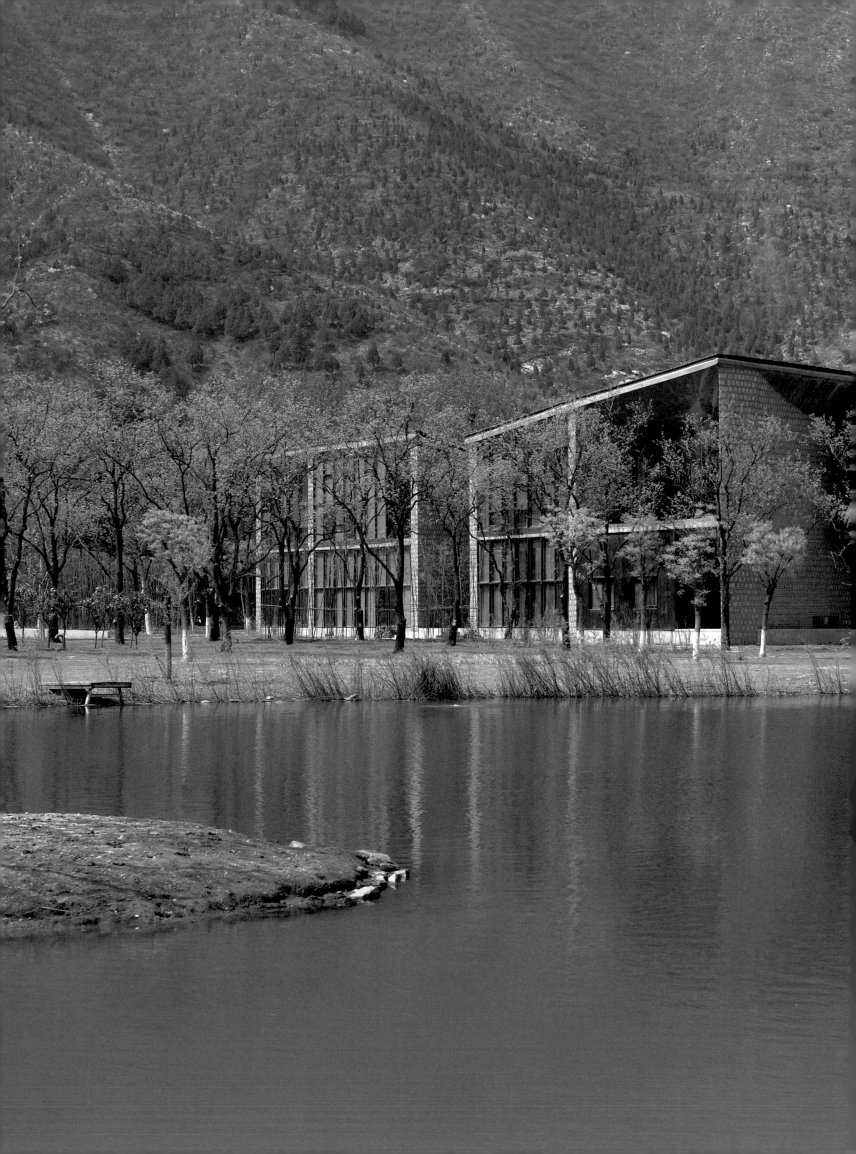

Previous pages The rooflines are designed to echo the mountain ridges behind it. Walls are made from local stone to allow the villa to almost camouflage itself and melt into the natural backdrop. In the foreground, black swans swim on the lake.

Below Windows flank both sides of the huge main living area with its angled concrete ceiling.

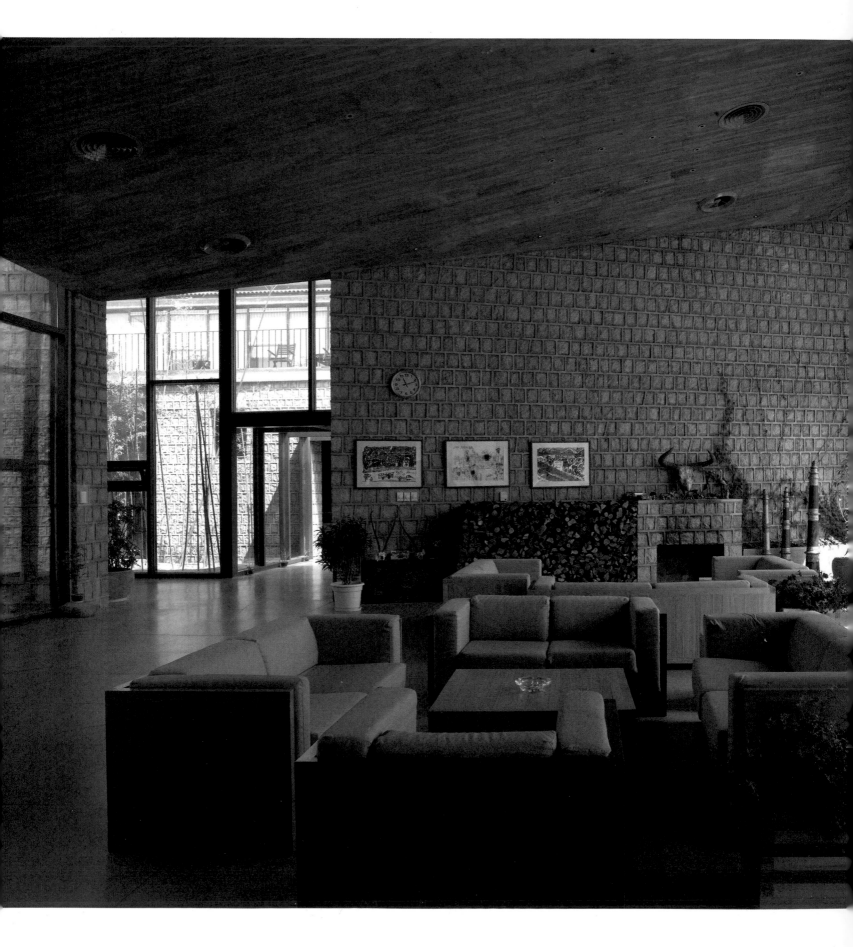

Below The villa is designed around a series of internal courtyards to allow the house to enjoy a dialogue with nature.

Bottom Existing persimmon trees were enclosed in small internal courtyards. At the back of the building are undulating ridges and a persimmon orchard.

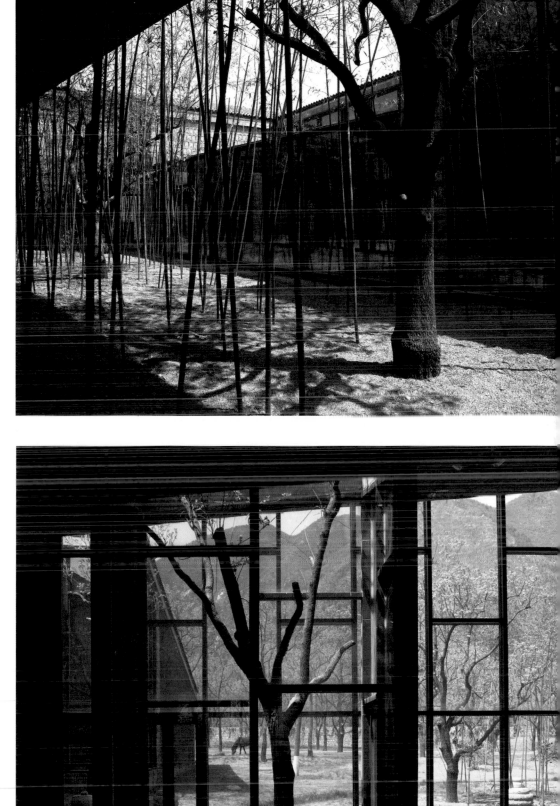

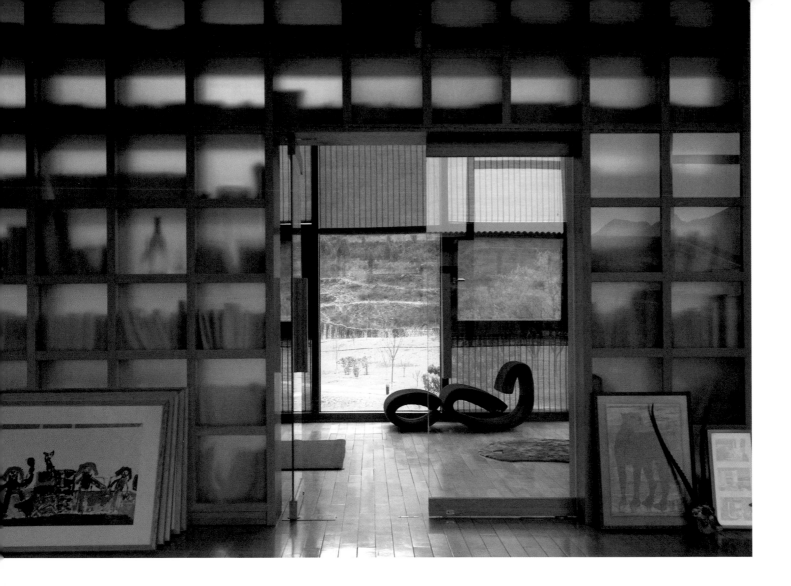

Above Bookshelves against translucent glass create a sculptural wall in the upstairs study. A modern designer chair adds a splash of color to the neutral palette.

Left A set of three painted chests sourced in Tibet stand at the entranceway.

Right Angled skylights allow shafts of light to penetrate the building. The walls are composed of local stone cut into cubes and mortared with concrete.

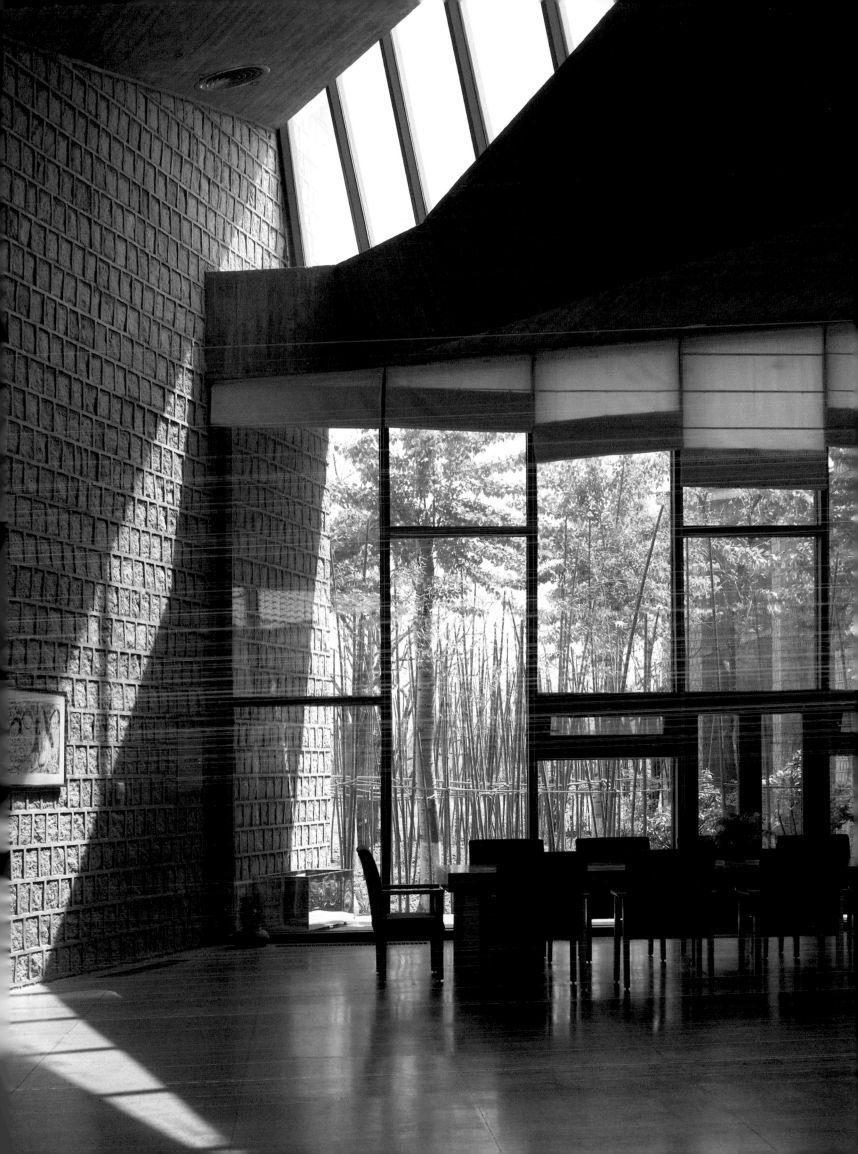

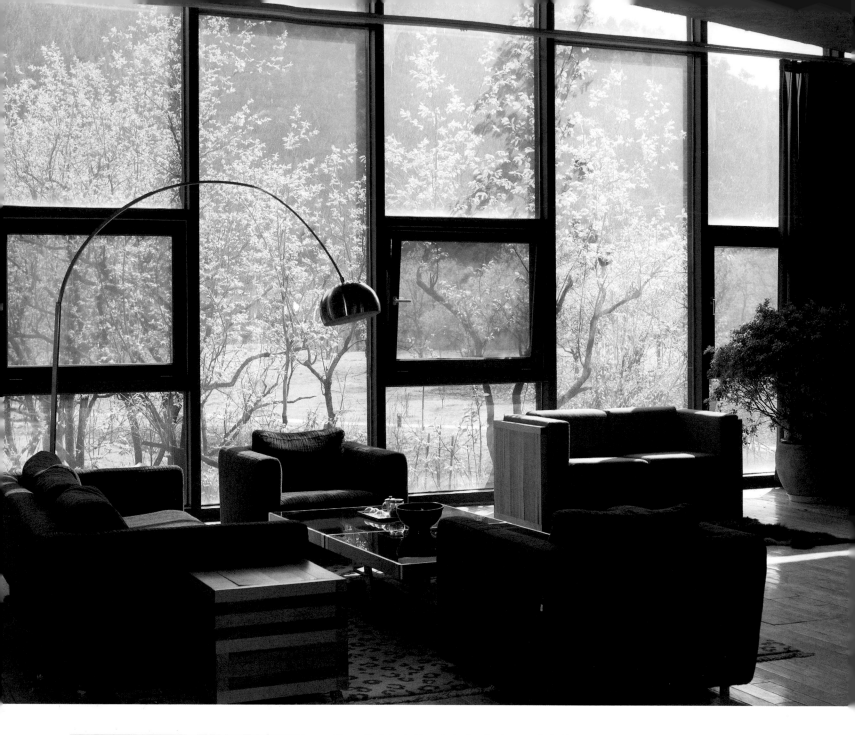

Above Upstairs in the private family wing, comfortable furnishings soften the austere palette. Wooden floors add warmth while the high ceilings and large windows bring the outside world inside.

Left Stacks of freshly-cut logs in the reception room, ready to be thrown onto the fireplace when the temperatures drop.

Right top Upstairs, a Japanese-style wooden tub stands in an open-air glass courtyard adjacent to the master bedroom.

Right bottom The soaring ceiling of the master bedroom allows uninterrupted views of the sky and fruit orchards.

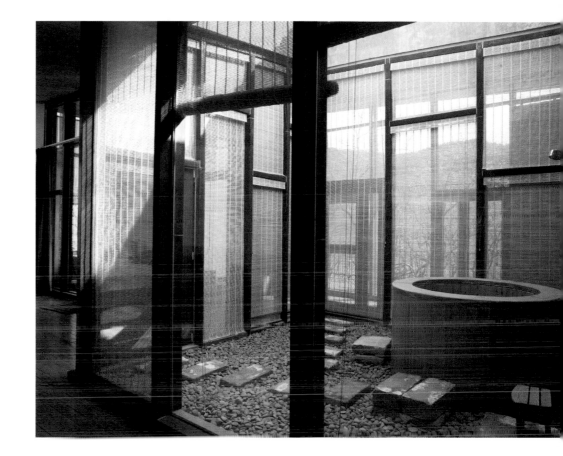

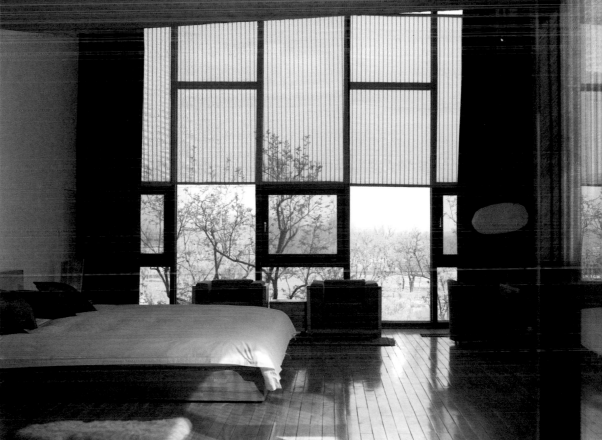

Below Rusted Corten steel is used on the exterior of the building. Corten steel changes over time and the architects wanted to use time like a tool to change the building as it matures—blending even further with its environment.

Opposite top (left to right) Throughout the day, light moves into different parts of the sloping roofs. Corridors are lined with tree-filled courtyards on either side. Upstairs in the family wing, exterior decks connect the rooms. In the foreground is a sculptural custom designed chair made of chopsticks broken into tiny pieces.

Right bottom Afternoon sunlight floods into one of the lounge areas upstairs. To the left is a custom-designed bamboo chair.

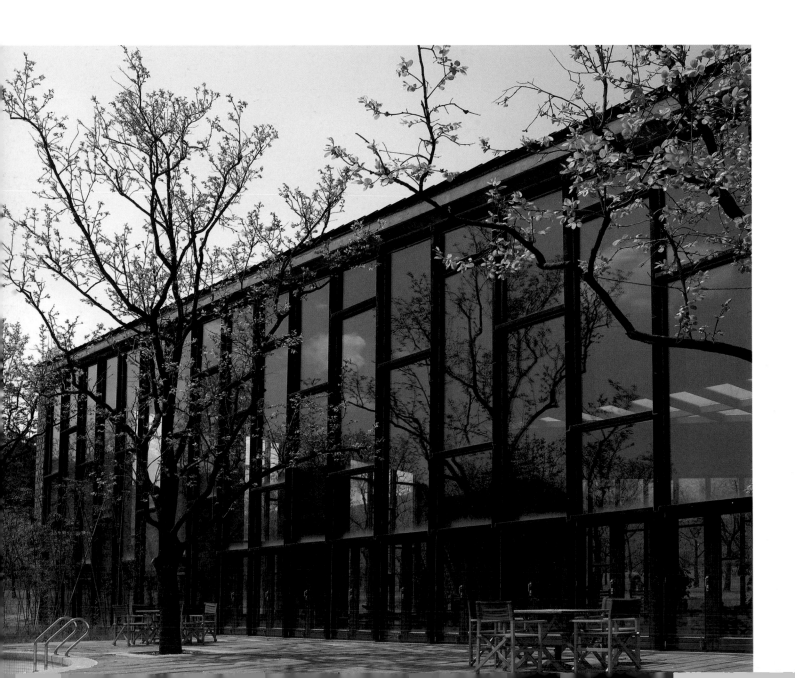

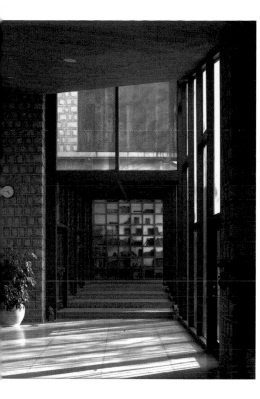

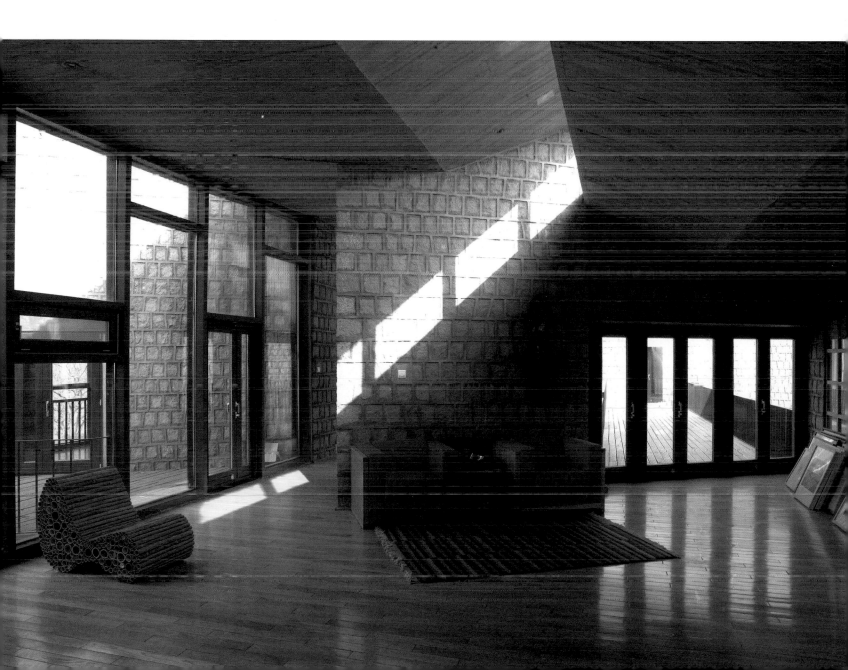

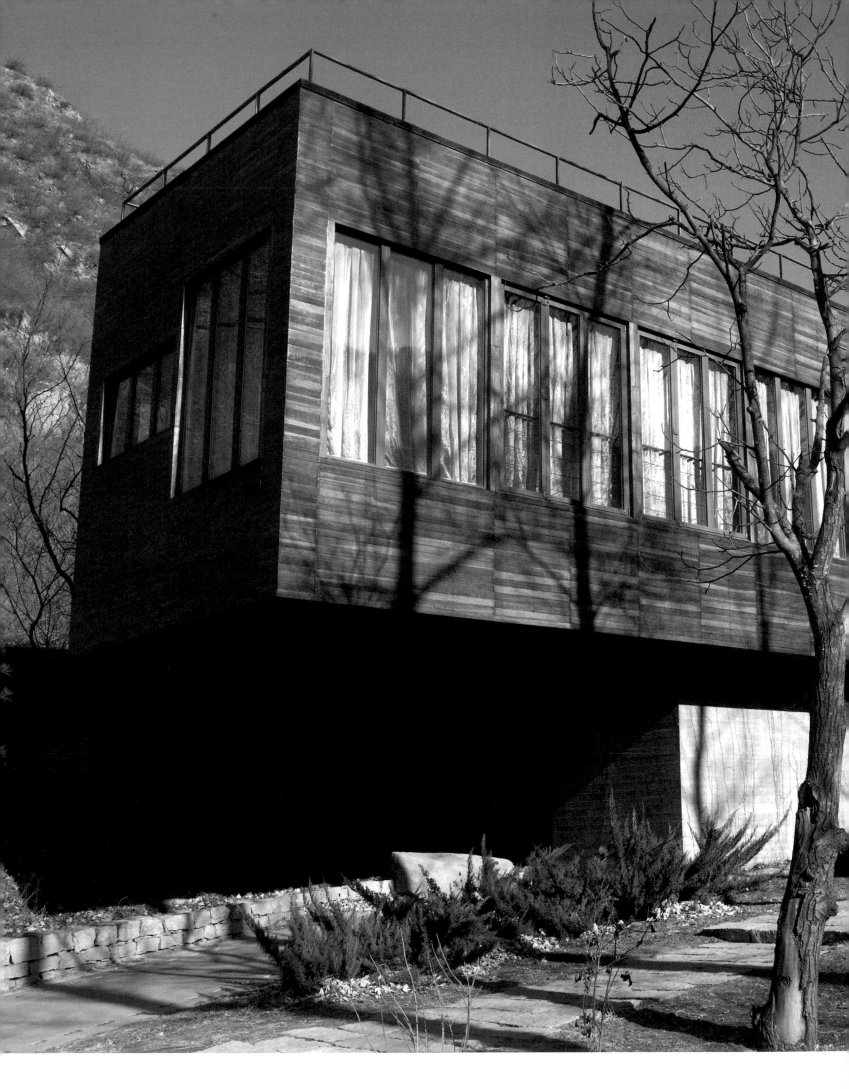

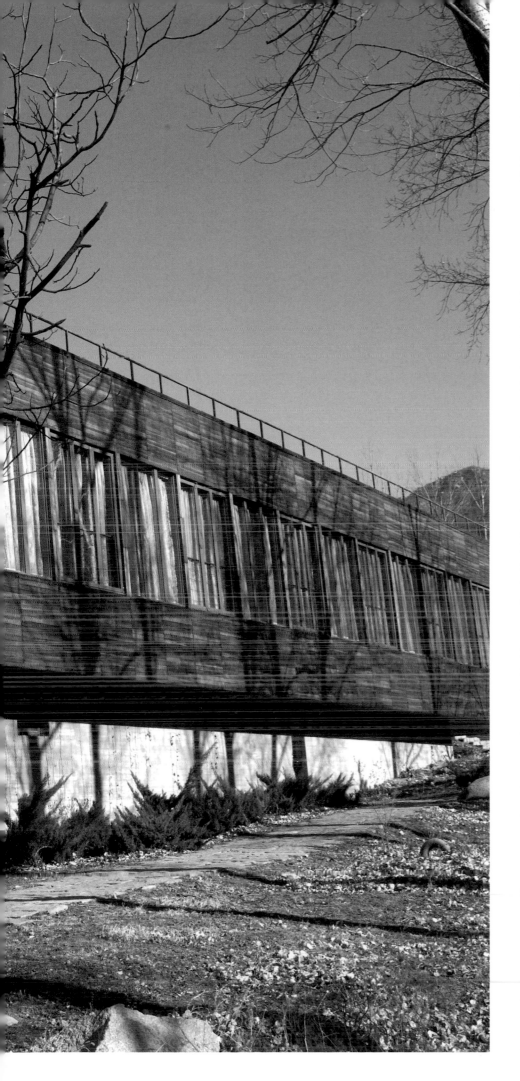

suitcase house
flexibox living

Designer GARY CHANG
Commune by the Great Wall BEIJING

HONG KONG-BASED ARCHITECT Gary Chang of Edge Design Institute designed the Suitcase House to be one of the most playful and innovative villas at the Commune by the Great Wall outside Beijing. A private collection of contemporary architecture by 12 new generation Asian architects, the Commune—located in the Shuiguan Mountains—is a boutique hotel and architectural showcase. Hailed as a "New Architectural Wonder of China" by *Business Week* magazine, the Commune is the brainchild of real estate developer Zhang Xin of Soho China, and is considered an icon of modern Chinese design.

At first glance Chang's cantilevered Suitcase House—which measures nearly 350 square meters (3800 square feet)—looks like a giant timber shoebox with modern furnishings dotted around. However, a series of hidden pneumatic trapdoors can be pulled up to reveal the functional elements of a house below: bedrooms, kitchen, storage space, bathrooms, plus areas for meditation, music, a library, a lounge and a fully equipped sauna.

Chang's guiding concepts are flexibility and spontaneity. In addition to the sunken chambers, a series of sliding panels in the main space can be effortlessly rearranged to allow the free-flowing house to be transformed into different types of spaces, whether intimate or expansive, to suit the user. The design is playful yet practical, allowing endless options for contemporary living. "It is a simple demonstration of the desire for ultimate adaptability," says Chang.

To maximize views of the Great Wall and to ensure maximum solar exposure, the house has been built along a north-south axis. Timber clads both the interior and the exterior, helping to blur the divisions between the house, its interior and its furniture. Furnishings are kept to a minimum, with brightly-colored, transparent modular pieces by designers such as Kaname Okajima and Marc Newson playing an active role in the adaptability of the space.

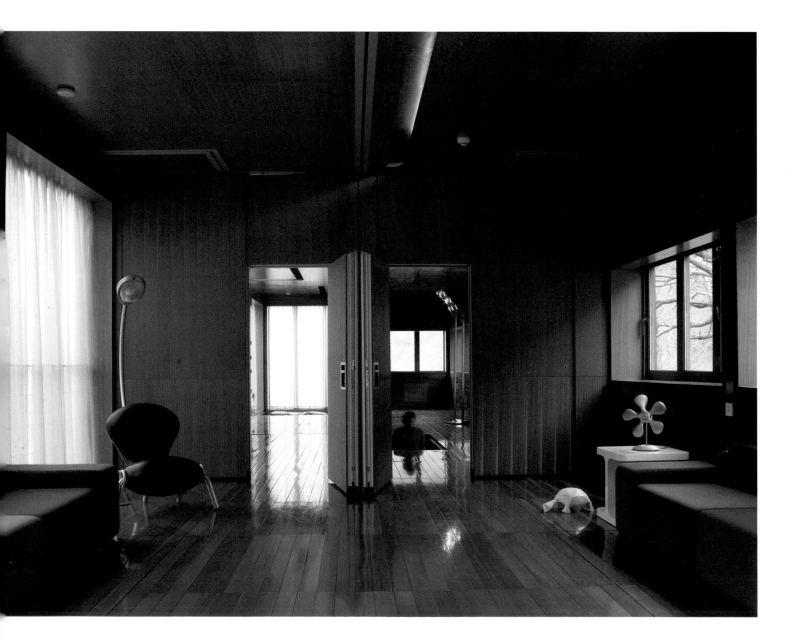

Previous page Looking like a giant shoebox, the Suitcase House soars over the sloping terrain near the entrance to the Commune. Chang conceived the design to offer residents intimacy, privacy, spontaneity and flexibility.

Far left Brightly-colored modular furniture plays an active role in the adaptability of the space.

Left A pneumatic trap door with a padded underside opens to reveal a cozier-than-normal sleeping area.

Left bottom In addition to the trap doors in the floor leading to sunken utility chambers, flexible sliding wall panels allow the house to be transformed from a single open space into a sequence of rooms, according to the needs of the users.

Right The main entrance is at the end of the house. Timber clads the walls both outside and inside.

Below Rooms for specific uses—the kitchen, bathroom, library, lounge and a fully equipped sauna and meditation room—are concealed in a series of sunken chambers.

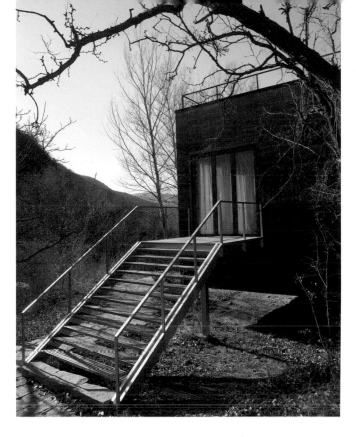

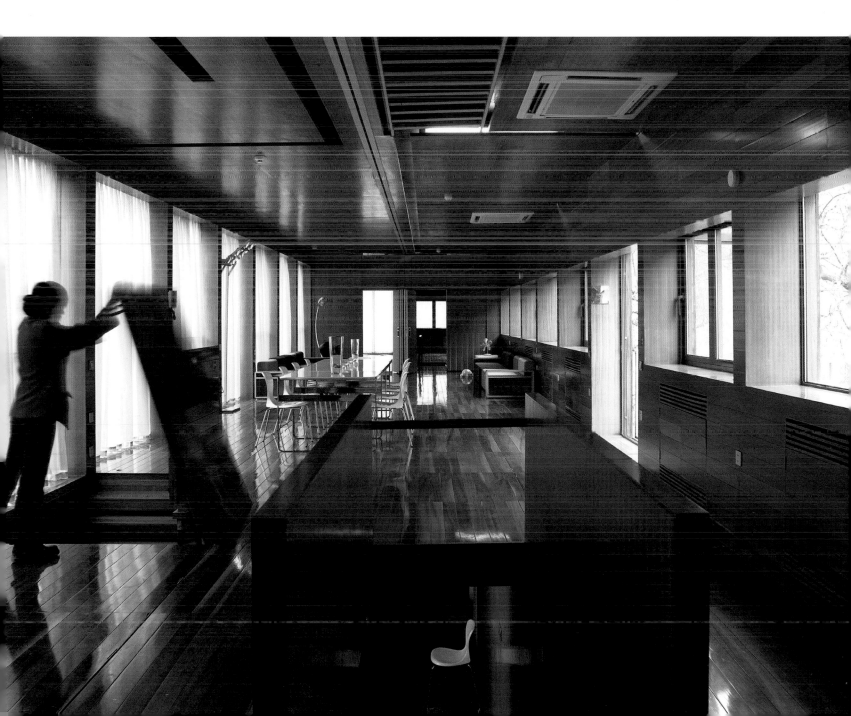

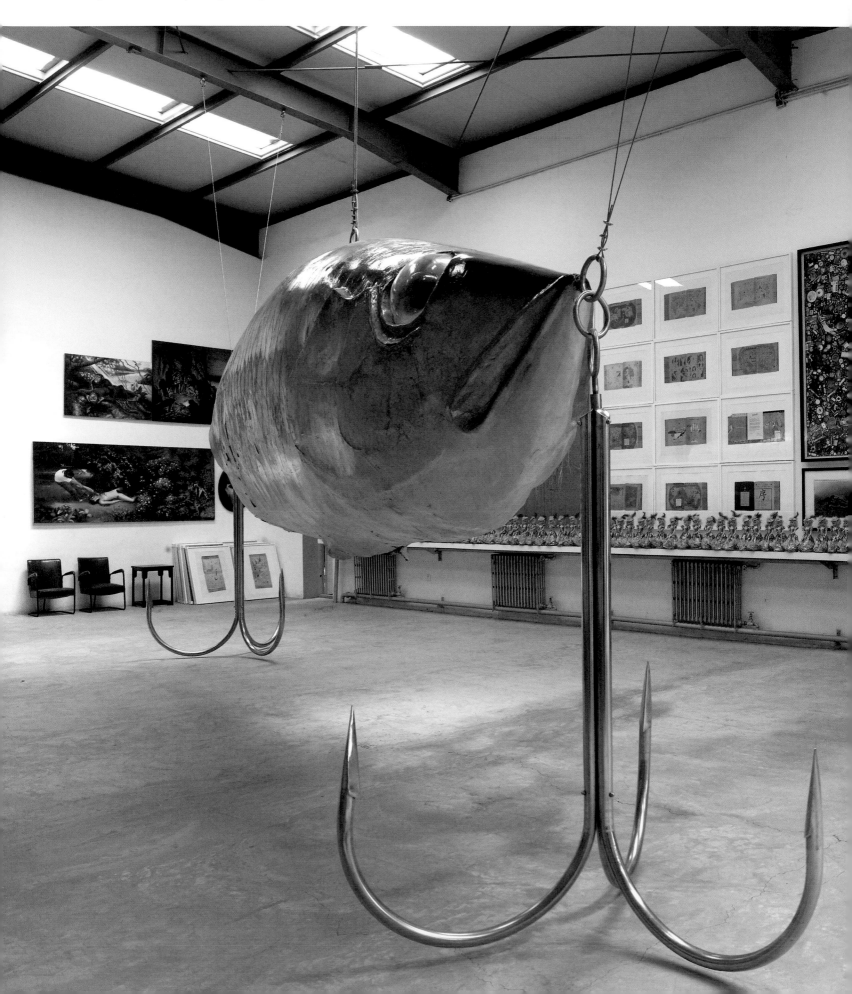

Below Large-scale installations and artworks by leading Chinese contemporary artists fill this aircraft-like hanger in Songzhuang village. Pieces include a giant fiberglass fish installation by Huang Yongping and a collection of dolls by Gu Dexin.

GUAN YI HAS AMASSED one of the largest collections of contemporary Chinese art in China. A huge, aircraft-hanger building near the artists' village of Songzhuang in Beijing's eastern suburbs houses some 200 of his 500 artworks—including paintings, sculptures and large-scale installations by China's leading artists. The scale of the works is staggering; many are so huge that anything smaller than this cavernous warehouse could never house them, let alone display them effectively.

Inside the dramatic space are pieces that, quite simply, take your breath away. A colossal chandelier by Ai Weiwei hangs from the roof; a huge prayer wheel by Huang Yongping balances on the floor; on the walls are paintings by Yan Lei, Liu Wei, Wang Xingwei and Zou Tiehai. Outside is a full-size replica of a wing of an American spy plane grounded in China in 2001, part of Bat Project 2, also by Huang Yongping.

Scale is important here. "Obviously there is a connection between the size of the pieces and the size of the space," Guan Yi explains. "It is important to have somewhere big enough to appreciate the works. The idea is that the space is ever-changing."

A self-taught architect, Guan Yi designed the warehouse and its attached 60-square-meter (650-square-foot) duplex residence himself. Inspired by the works of Mies van der Rohe, his residence is almost monastic in its simplicity. Austere yet tactile materials such as red brick, wood and concrete form the backdrop to furnishings which are mostly Shanghai art deco (downstairs) and Ming dynasty style (upstairs). An interpretation of the traditional courtyard house, the space features a downstairs dining and living room flanked by a bamboo-filled interior hallway and a courtyard. A brick ramp leads from the courtyard to the upper level comprising a master bedroom and open bathroom on the side. Floor-to-ceiling windows facing into the courtyard provide the dominant light source.

Guan Yi began collecting in 2001 before the current explosion in the Chinese art scene. Today he believes it is important to take stock of what is going on in the marketplace. "Some things are happening too quickly and we should think about the longer term and the substance underneath." He devotes his time to education and raising awareness of the contemporary art scene and hopes, one day, to build his own museum of contemporary art. "Reality tells us that everything you think is outrageous is not outrageous in China," he explains.

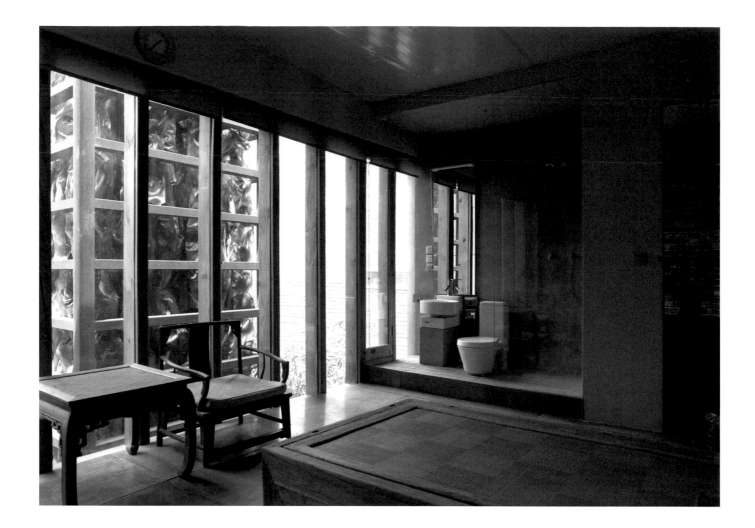

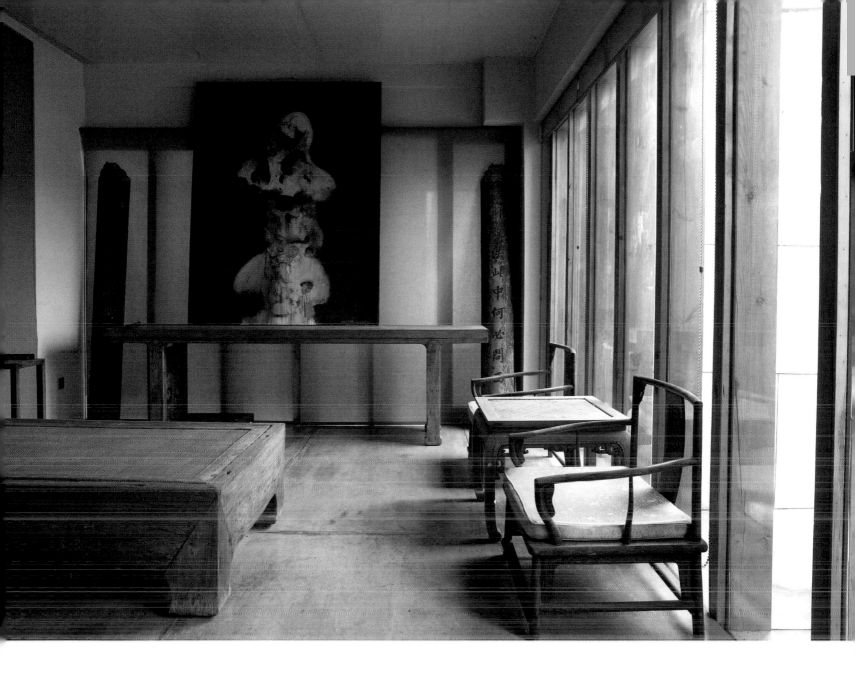

Left top Upstairs, the Mies van der Rohe-inspired residence is almost monastic in its simplicity. Wood and concrete have been used extensively in both structure and furnishings. Floor to ceiling windows allow soft light to enter the serene, minimal space.

Left Outside the warehouse is a concrete car installation by Zhang Huan; next to it is an airplane wing, part of the Bat Project 2 spy plane art piece by Huang Yongping.

Above A Ming bed stands in the center of the bedroom. Above the altar table is a painting by Zhou Chunya; on either side are calligraphy panels that speak of a serene, meditative space, uninterrupted by the outside world.

Right A sculpture by political pop artist Wang Guangyi based on a worker image from the Cultural Revolution.

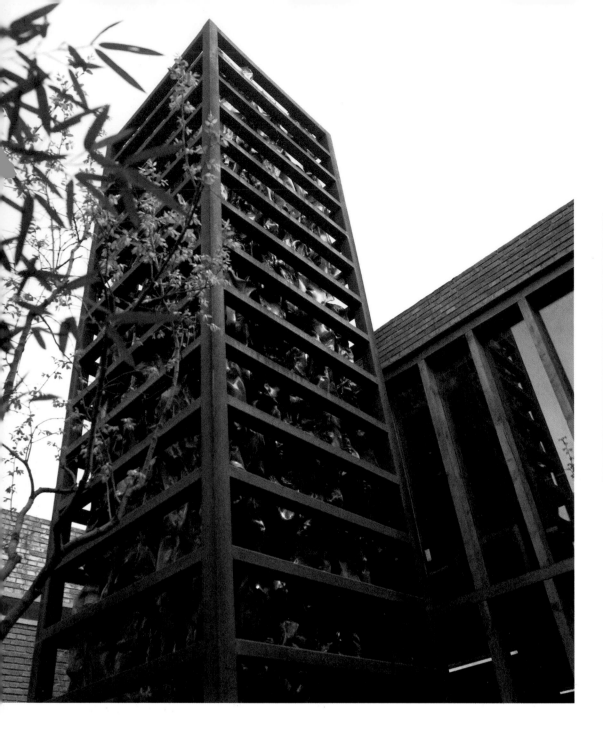

Above and left In the central courtyard stands a commanding 9-meter-high (30-foot) sculpture by Gu Dexin. Encased in an iron cage, the sculpture is formed from melted plastic. Behind (not pictured) is a brick ramp leading to the upper level of the house.

Below Artworks are arranged salon-style in the warehouse. The collections are ever-changing; here they include a set of airplane wheels from Huang Yongping's Bat Project series; a signature Joe Camel painting by Zou Tiehai and a chess set installation by Chen Shaoxiong.

mima café
vanishing act

Designer WANG HUI | Yuanmingyuan Park BEIJING

TUCKED AWAY NEAR THE EAST GATE of Yuanmingyuan Park (the Old Summer Palace) in northwest Beijing is a simple single-story house set in a gravel courtyard filled with walnut trees and bamboo. In the middle of the courtyard stands a 15-square-meter (160-square-foot) stainless steel cube, its shiny surface at once reflecting images of the house and garden yet at the same time itself disappearing into the space.

Yuanmingyuan—the Garden of Perfect Splendor—was a magnificent garden created during the reign of Emperor Qianlong (1736-95). When architect Wang Hui wanted to take over the house and courtyard to build Mima Café he chose the cube as a novel way to introduce contemporary architecture into a traditional template. It is, in part, a response to park authorities who wanted any architectural work here to maintain and reflect the spirit of the past. "Using a stainless steel box allows the structure to disappear and not interfere with the visual impact of the space," Wang explains.

He continues: "The cube is a way to show how to design a new building in the midst of a very old park." The cube is practical too as it contains a small roof terrace offering views of the royal garden, a kitchen (not allowed in the house itself due to fire regulations) and a timber clad bathroom featuring a glass ceiling above which goldfish swim in a roof-top pond. The concept of the inside-outside bathroom is also based on country-side village living.

Inside the house itself, Wang introduced a modern interpretation by removing a false ceiling to expose the structural wooden beams and knocking down dividing walls to allow the space to flow. A huge bar is made of more than 5,000 books in different languages stacked on top of one another in the center of the space. Furniture is kept to a minimum with modern triangular mirrored tables continuing the reflective theme.

Mixing and matching—in terms of cultures, eras and materials—is a key concept in the design approach here. "Mixing elements like these gives a kind of power that can be used in modern life," says Wang. "If you only think about things one way then your approach is limited. I prefer an open viewpoint with no limitations. The feeling comes first, then I like to find ways to use materials and technologies to make a space real."

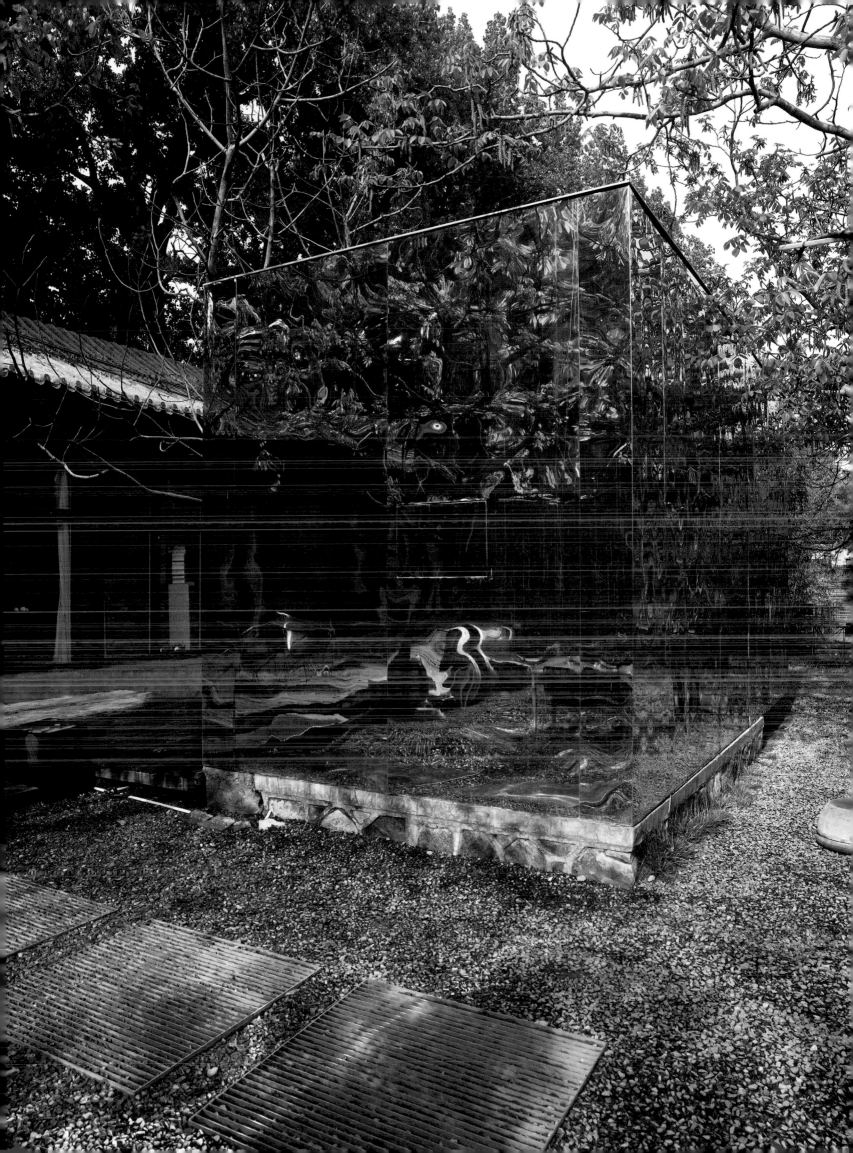

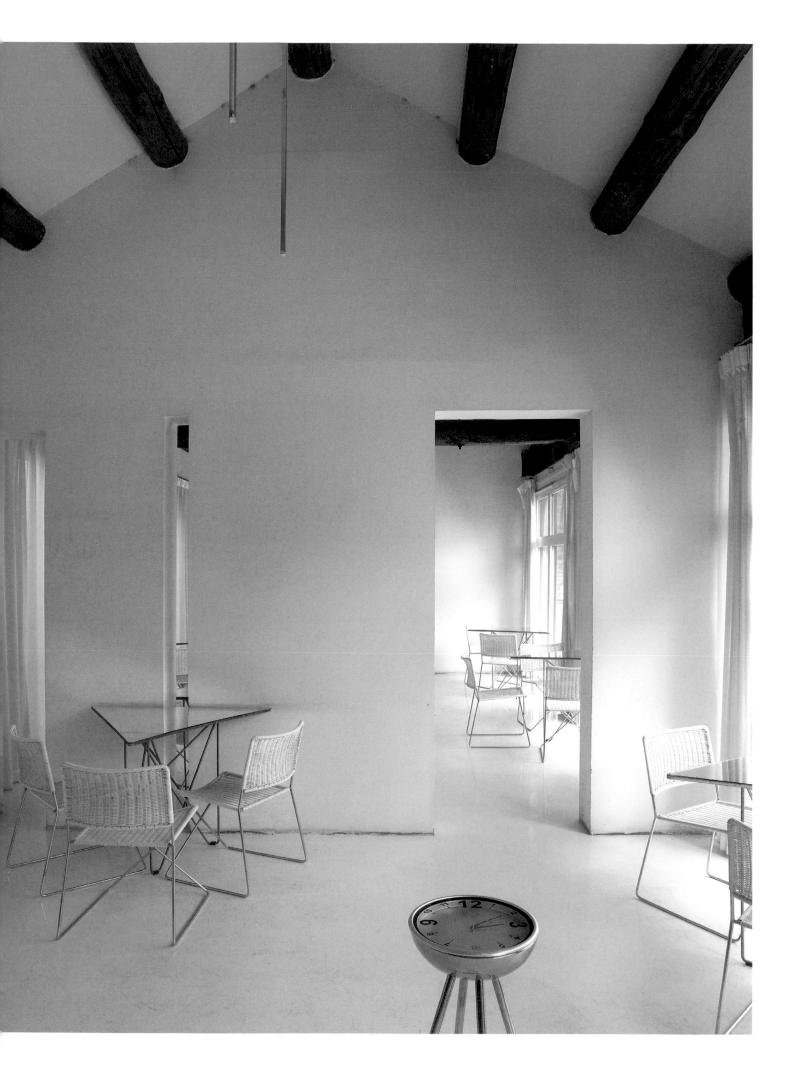

Left Organically shaped tables with mirrored tops continue the reflective theme both inside and outside the restaurant. Beyond the wooden deck is a collection of traditional brick roof ends sourced in Shanxi province.

Below left The bathroom inside the cube is clad in timber from floor to ceiling.

Opposite The old structure has been given a modern edge by removing the false ceiling and exposing the wooden beams. The floor, walls and roof were then all painted white. Dividing walls are kept to a minimum to allow the space to flow.

Below The centerpiece of the space is a large bar composed of over 5,000 books in different languages. Such a structure reflects Wang's belief in the power of cultural exchange.

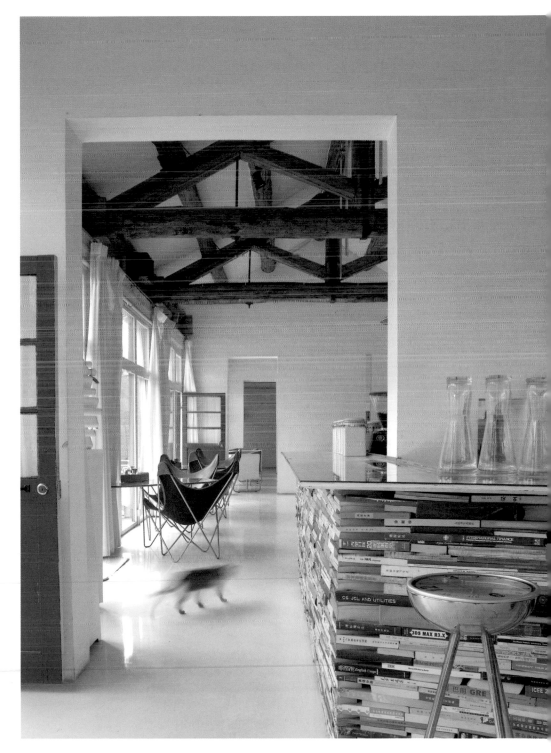

the bridge 8
creative cluster in the heart of Shanghai

Designer LIFESTYLE CENTRE and HMA | Jianguo Zhong Lu SHANGHAI

WHAT WAS ONCE A GROUP of auto part factory buildings on Shanghai's busy Jianguo Zhong Lu is now homebase for a group of like-minded creatives intent on setting new standards of originality in China. The Bridge 8, developed by Tony Wong of Lifestyle Centre (he formerly worked with the Shui On group to create Shanghai's successful Xintiandi entertainment and retail complex which breathed new life into an area of old shikuman houses) comprises offices, restaurants, shops, even a nightclub. All have been specially designed with stylish facilities to lure those in search of different ways of working and living.

A collaboration between Lifestyle Centre and architectural firm HMA, the shells of the buildings were reworked, interiors redesigned and different elements added to tie the disparate structures together. The word "bridge" is a key theme. Exterior skybridges and walkways plus connecting corridors and catwalks allow the space to flow. "We call it The Bridge 8 because we have different types of bridges that link up the buildings for a better connection within the community. It is also symbolic as we want it to be a bridge between foreign and local creativity," says Daker Tsoi, Lifestyle Centre's Vice President of Strategic Planning.

The industrial origins of the building have been emphasized with steel trusses, skylights, glass curtain walls, cantilevered staircases, stainless steel rails and balustrades featured through the space.

Local grey brickwork clads the exteriors and different thicknesses of brick are used to produce a unique pattern on the façade. Exterior spaces between the buildings have been landscaped and offer informal meeting places for tenants who include designers, architects, marketers and advertising types. Such interaction, Wong believes, will allow creative juices to flow freely.

Such sensitive and forward-thinking regeneration of inner city spaces has a key role to play in building a new China. "We consider cultural issues, historical issues, the users' perspectives and the right investment," explains Tsoi. "You should not just demolish and build all new buildings. A city should change gradually rather than suddenly."

Below The revitalized space encourages interaction among a number of creative businesses such as Italian fashion studio Idem.

Opposite The interior corridors allow glimpses into a number of different shops and businesses, from interior design stores to architectural, design and advertising offices.

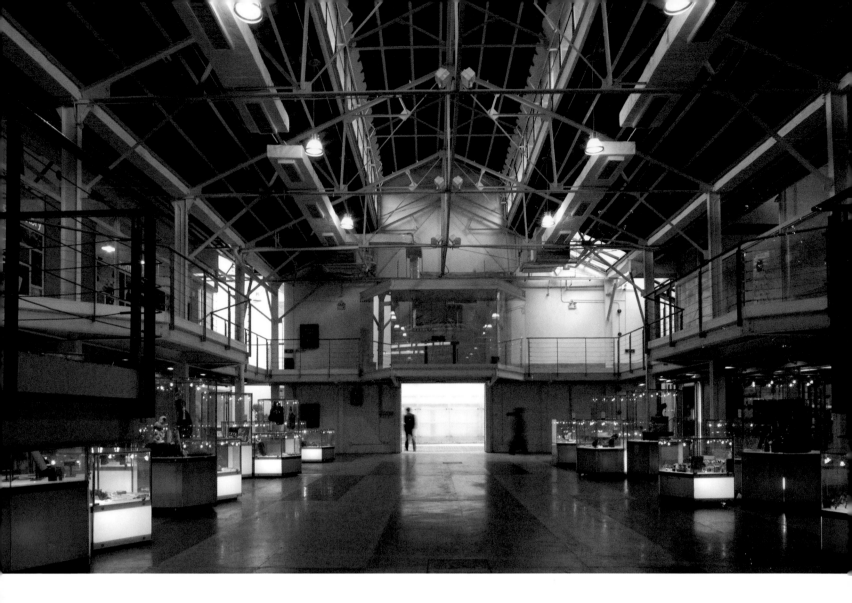

Above This cluster of 1970s auto part factories took on new life when they were redeveloped as office and studio spaces. Here, a cavernous hanger-like space is flexible, used for functions, exhibitions and promotions.

Left The word "bridge" is key; alluding to the skybridges, walkways, corridors and catwalks that connect the buildings. The development also functions as a bridge between past and present and between different cultures.

Top right and top far right The Bridge 8 aims to attract creative businesses in the fields of design, fashion and architecture.

Right The central display and meeting area of the complex also plays host to functions and exhibitions. Curved mezzanines of different sizes and heights create a dynamic, futuristic feeling.

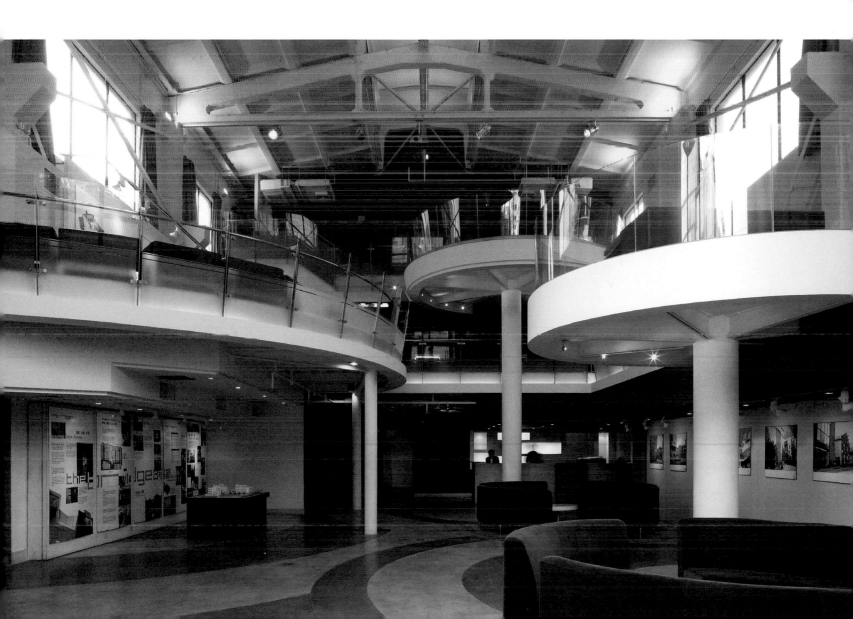

Right and opposite Materials such as concrete, wood, stainless steel and grey brick have been employed as a backdrop to the creative processes fostered at The Bridge 8.

Below Raised wooden walkways connect the offices and studios to allow easy access and intermingling amongst tenants. Restaurants and outdoor seating can be found in the courtyards below.

city glamour

A globalized view of Chinese style is increasingly popular in cosmopolitan cities such as Shanghai and Hong Kong, where a strong sense of multi-cultural cross-fertilization is infusing contemporary designs. With increasing numbers of Chinese architects studying overseas and foreign architects practicing inside the country, both sides benefit from the other's techniques, points of view and ideas. Countless creative currents combine in the interiors shown in this chapter—where spatial purity is often enlivened by touches of rich color and ornate detailing. Such work reveals a diversity of inspiration which perhaps only China can provide and shows how these can all be incorporated within the modern lifestyle. From a large glass pavilion mounted on the roof of a neo-classical building to a low-rise apartment swathed internally in raw brick, steel mesh and sand-blasted aluminum, the range of possibilities is endless.

contemporary chic
a passion for luxe

Designer ANDRE FU | The Peak HONG KONG

INTERIOR ARCHITECT Andre Fu will not be limited to any one style. "I never say I'm trying to interpret Chinese things with Western influence," he explains. Instead he says his designs are open to interpretation and he works to incorporate his clients' vision within his own vocabulary.

In this opulent 280-square-meter (3000-square-feet) residence at the base of The Peak on Hong Kong Island, Fu has created a home which combines spatial purity with ornate elements and rich colors in a bid to blend one family's Hong Kong history with a contemporary architectural approach. "Actually the lines are pretty simple but material-wise it is quite rich," says Fu, gesturing to the Chinese lacquer finishes, rich wood veneers, decorative mirrors and Chinoiserie-style French fabrics.

Fu spatially reconfigured the apartment to adapt it to the owners' requirements. "It needed to create a sense of place as well as to reflect what they have accumulated not just in terms of possessions but in terms of living habits and styles." Hence he devised a large living area with a terrace to one side and a dining room to another. A raised platform with a mirrored rear wall is home to a large grand piano and a long corridor leads into the private area with two master bedrooms and guest rooms for visiting family members. The spaces are interconnected via corridors.

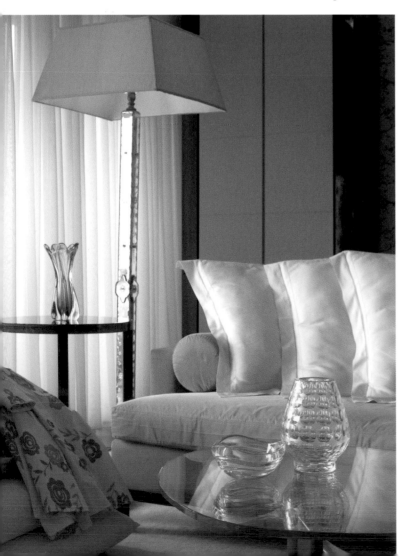

Storage is a priority here and Fu has increased the amount of storage space by installing a series of discreet built-in floor-to-ceiling cupboards with green lacquer façades which function as part of the decorative scheme. "The owners don't need much space-wise, but they do need a lot of storage. This apartment is about how to make storage tucked away and hidden."

Fu designed much of the furniture here himself, mixing it in with classic designs such as a transparent Perspex chair and coffee table both from the 1960s. For a hint of luxe he added lots of mirrors including a decorative mirrored screen and a vintage Venetian mirror plus embroidered fabric wall coverings and a huge chandelier over the dining table. Here old and new, East and West, modern and classic combine to produce an elegant contemporary scheme which is, in many ways, timeless.

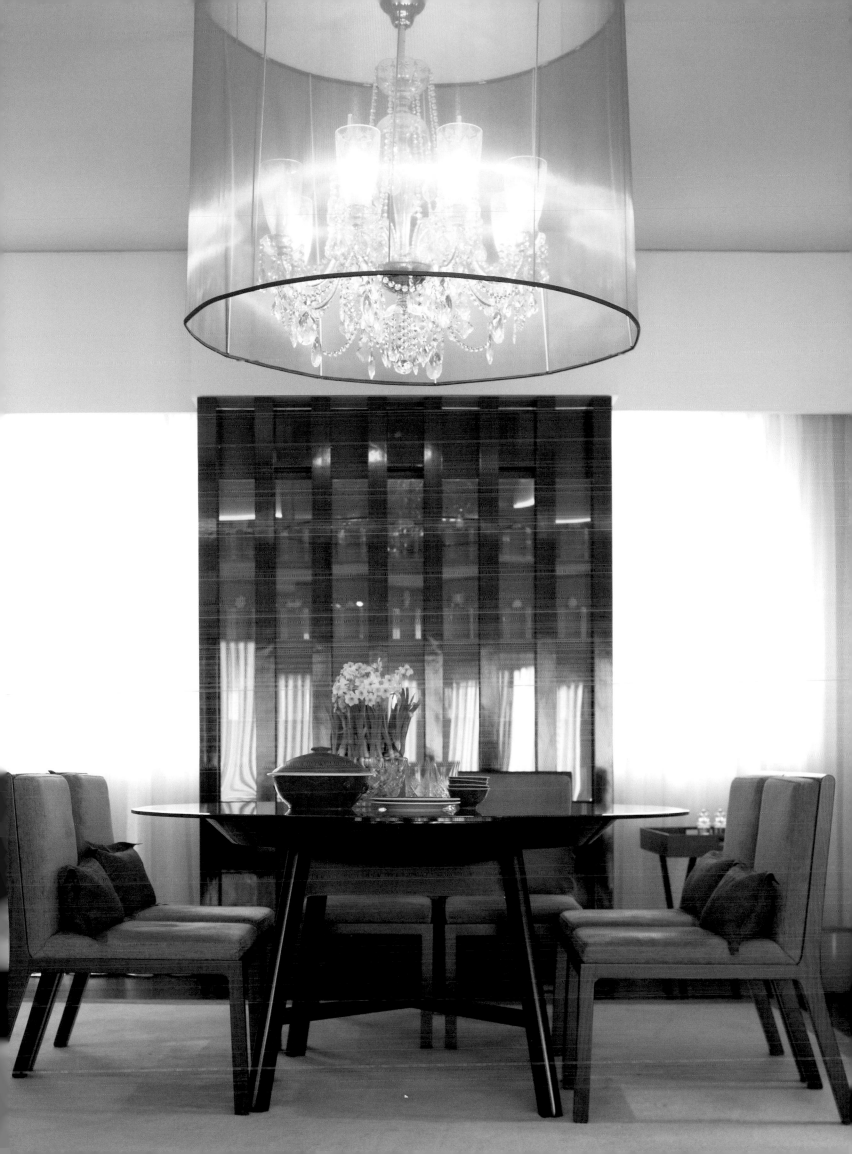

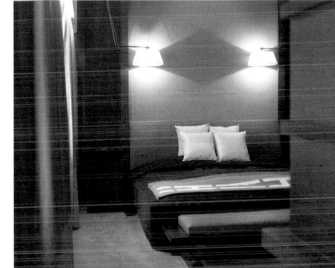

Opposite Spatial purity: looking down the corridor leading into the private area. Fu has utilized lacquer and wood for impact and to create much needed storage space.

Left A modern interpretation of a traditional Chinese cabinet. In the foreground is a gold-painted bamboo chair.

Below A masculine master bedroom is all clean lines and earth tones. At the end of the bed is a Hakabench with a cushioned leather surface, designed by Fu.

Far bottom Curvaceous mirrored screens, Chinoiserie-style French wall coverings and green lacquer panels work with 60s period furnishings in the living room. Bifolding doors to the left lead to a spacious terrace.

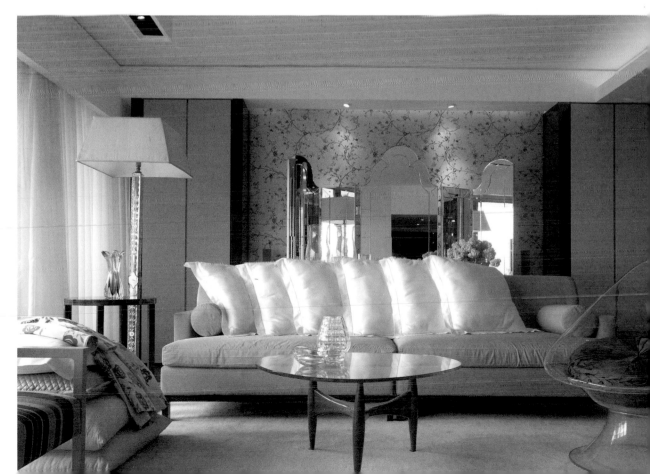

outside-in apartment
the rough and the smooth

Designer KENT LUI | Mid-Levels HONG KONG

AN AMERICAN-BORN Hong Kong resident wanted to recreate a New York feel in his 250-square-meter (2700-square-feet) apartment which hugs the hillside in the Eastern Mid-Levels. His priority was to open the space up to the elements, allowing as much natural air inside as possible to minimize the reliance on air-conditioning during Hong Kong's humid summer months.

Architect Kent Lui came up with a novel solution that blends visual perception and practicality. "To create an outdoor feel I suggested we use external materials as much as possible, in effect recreating the feeling of a building's exterior inside the apartment." Lui chose materials such as corten steel—which is more often used in ships and bridges—plus raw brick, steel mesh and sandblasted aluminum to create a rough, weathered look. The flooring retains an industrial feel too, made of natural, self-sealing unvarnished oak.

The apartment has a long, slim layout, with windows at either end providing the main light sources. "Everything has an external feel. It's like living in an alley between two buildings," says Lui. A concrete-floored corridor runs from the living area (at the front of the apartment) into the rear section which houses the master bedroom, bathroom, kitchen and dressing area-cum-guest room. "We liked the articulation of the corridor, it is a nice transition between the public and private spaces," says Lui. "It is like a gallery space with room for artwork and paintings on the wall."

The master bedroom is expansive. "When we decided to redesign the apartment we gutted everything in this area," says Lui. "We chose to have the bedroom here and an open bathroom because there are lots of green views and lots of light. It enhances the external feel."

Most of the furnishings were purchased to fit the space. Pieces include classic mid-century chairs, contemporary furniture by Italian designers such as Cassina, Minotti and Cappellini and original art deco light fittings from New York. Accessories include a collection of Korean celadon ware and contemporary Chinese works by artists such as Pan Dehai and Russel Wong. The result is carefree, usable and comfortable. Says Liu: "It is very tactile, you want to touch everything in the place."

Right In the entrance foyer, corten steel panels have been used to divide the space. An inset shelf displays a pair of downlit opaque glass vases. The steel contrasts effectively with the concrete floor.

Left The wine rack was designed by Lui using ten-cm (four-inch) galvanized pipes.

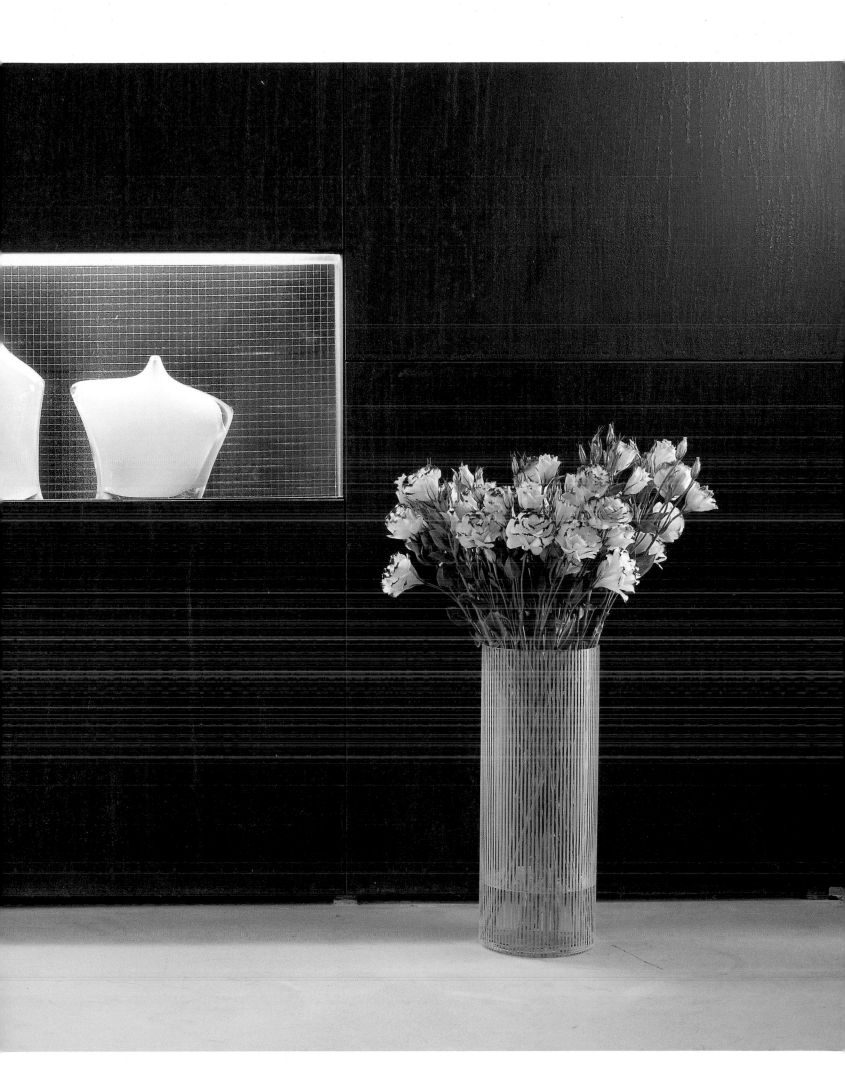

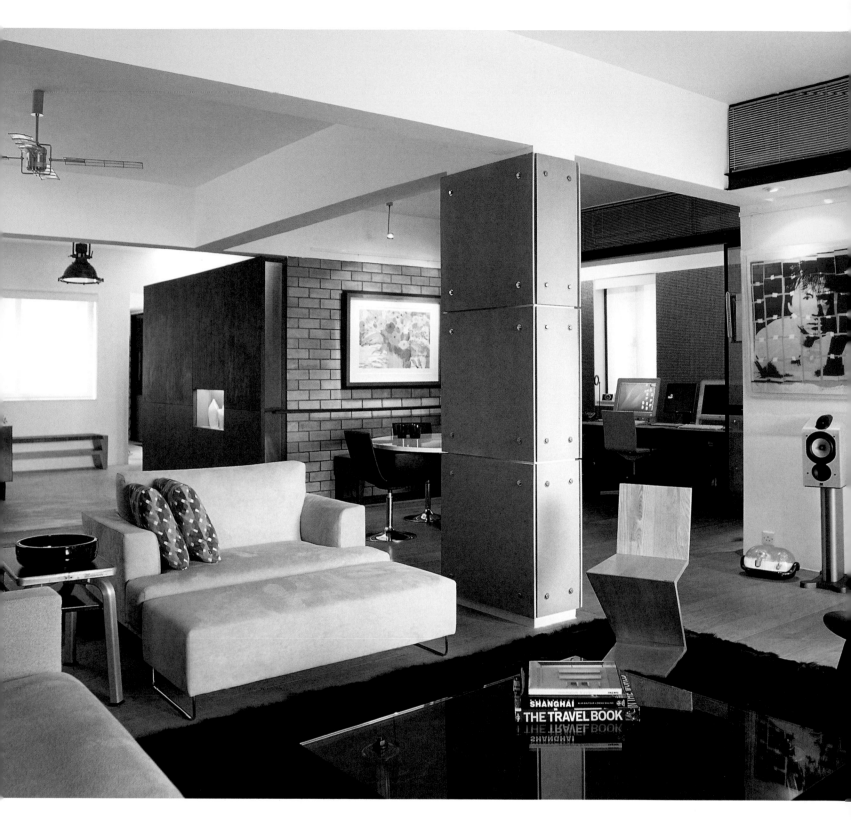

Above The open plan living area has a New York loft feel. Materials used include raw bricks, steel mesh, sandblasted aluminum and unvarnished oak. On the wall is "Jackie Deconstructed" by photographer Russel Wong.

Top right The entrance foyer utilizes exterior materials. An industrial light from the US hangs from the ceiling; a retro cabinet displays the owner's extensive collection of clocks.

Right Raw brickwork clads the living room wall. On a concrete shelf is a collection of celadons from Korea; the painting is by Pan Dehai.

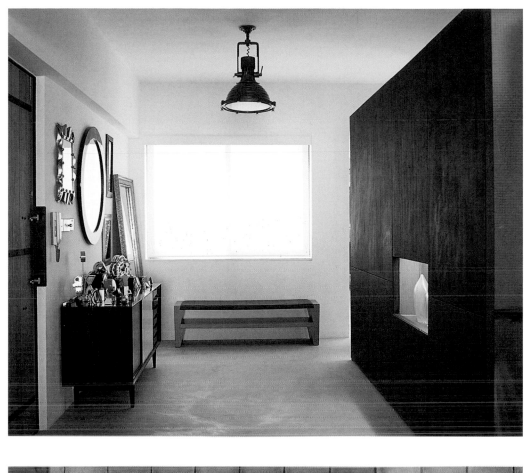

Above A brass headboard in the master bedroom is composed of square panels with raised circles. The recessed shelf is used to display a selection of clocks.

Right The marble and opaque glass bathroom is filled with natural light. A black chandelier provides a decorative touch.

Below Lui situated the bedroom and bathroom at the back of the apartment to make use of the natural light and the green views outside. In the foreground is a dressing area which can be transformed into a guest room via a series of folding doors when needed.

soho living
modern minimalism

Designer ELKE NISSEN | Jianwai Soho BEIJING

THE TALL WHITE TOWERS of Jian Wai SOHO once dominated the skyline at Beijing's busy
Guo Mao intersection in the east of the city. These days, the complex competes for skyline
supremacy in what has become the city's rapidly growing Central Business District. Yet it
remains an eye-catching urban environment both in terms of its distinctive minimalist archi-
tecture as well as in the way it offers Beijingers a range of flexible urban units that can be
used for living or working or both.

Jian Wai SOHO (the name stands for Small Office Home Office) is the brainchild of high-
profile property developers Pan Shiyi and Zhang Xin of SOHO China. Japanese architect
Riken Yamamoto designed the master plan and apartment towers, creating an urban environ-
ment with soaring towers, lower commercial buildings and landscaped open spaces. The towers
are angled to maximize sun exposure and ensure daylight reaches all areas of the complex.

Primarily appealing to small business owners and residents who prefer unadorned, loft-like
spaces, Jian Wai SOHO has created a new kind of urban environment in Beijing. Those who
live here, like Elke Nissen and Andreas Otto, are drawn by the minimalism of the spaces,
with their huge floor-to-ceiling windows spanning
the width of each room, blond timber floors and
stark white decorative scheme. "It is a unique
development; we like the style and the fact that it
is modern and bright," says Nissen.

Nissen has built on the neutral palette of her 160-
square meter (1700-square-foot) home, retaining
a pared-down look whilst adding touches of soft
color (green, purple, yellow, pink) and textures
(sheers, woods, cowskin) to lend personality to
the space. On the walls hang Chinese contempo-
rary paintings sourced from Pan Jia Yuan
(Beijing's biggest flea market) mixed with
artworks from all over the world (Budapest,
Vietnam, Australia).

Her approach combines several eras and cultures.
The sofa is modern Italian and the coffee table
1970s Austrian; on the wall hangs a 200-year-old
Chinese wood carving whilst the Chinese-style
wooden furniture pieces were custom-made in
Beijing. A great fan of antique markets, whether
in Europe or China, Nissen mixes and matches
with flair. "It is good to go with open eyes
through the world. Beijing is very inspiring."

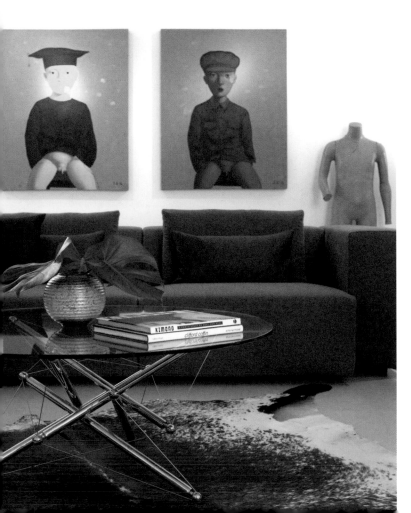

Above Decorative objects from Europe and China enliven the white space and quiet soft furnishings. Above the sofa is a 200-year-old carving from a wealthy Chinese courtyard house.

Right The all-white common areas have a distinctive industrial feel.

Top right Above the dining room table hangs an international gallery of portraits from China, Austria, Hungary and Vietnam.

Right Sculptures, paintings, books and magazines add color to the white-on-white palette in the bedroom.

china deco
design classics

Designer RODERICK MURRAY | Mid-Levels HONG KONG

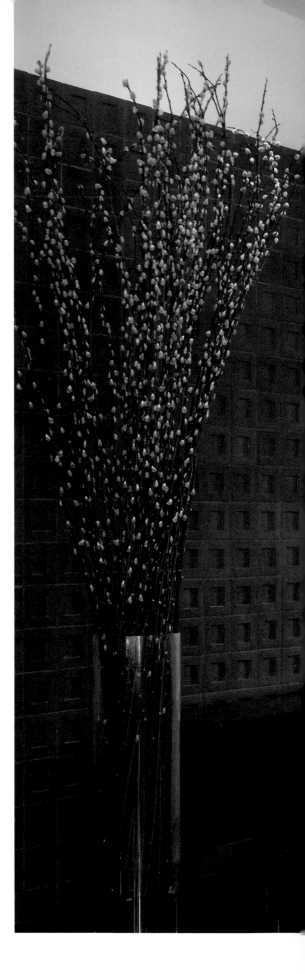

DESIGN CLASSICS, antique Chinese furniture and fashionable decorative elements come together in the home of Hong Kong-based architect Roderick Murray of R J Murray Design. His apartment, a light-filled duplex of 130 square meters (1400 square feet), features a striking steel staircase and a muted palette of black, chocolate brown and white. With its high ceilings, dark oak flooring, decorative wallpaper and handmade wall tiles, it is a serene and comfortable retreat from the city.

When Murray purchased the property, it was composed of lots of small rooms, with long dark corridors and an enclosed stairway. He totally reconfigured the space, stripping everything down to its bare walls. "Only then I could reintroduce pattern and texture," he explains.

Today, the duplex comprises a large open-plan living room and dining room on the lower level, with an open-tread steel staircase (minus balustrade) as the focal point. Upstairs is the master bedroom plus an open study area at the top of the stairs. Throughout the interior, Murray worked to provide a sense of height and length and to maximize the living space as much as possible.

Wallpaper has been used to add layers of texture and pattern to the interior. A series of vertical panels behind the open staircase that runs the height of the duplex have been covered in pearlescent white wallpaper which can be changed as desired. "I can change the look and feel of the space simply by changing the material," says the architect.

Furnishings that would stand the test of time were selected. "I try not to buy high fashion because it's going to date pretty quickly." Instead, the focus is on classic pieces by designers such as Charles and Ray Eames, Arne Jacobsen and Jasper Morrison. "These are modern but very usable and have a quality feel about them." Custom-designed pieces (the bed, a bold Japanese-print chrysanthemum carpet, retro tiles from Thailand) work well alongside Chinese antique furniture and Asian artifacts. The result is a home to be enjoyed: "I feel comfortable and relaxed in this space," says Murray.

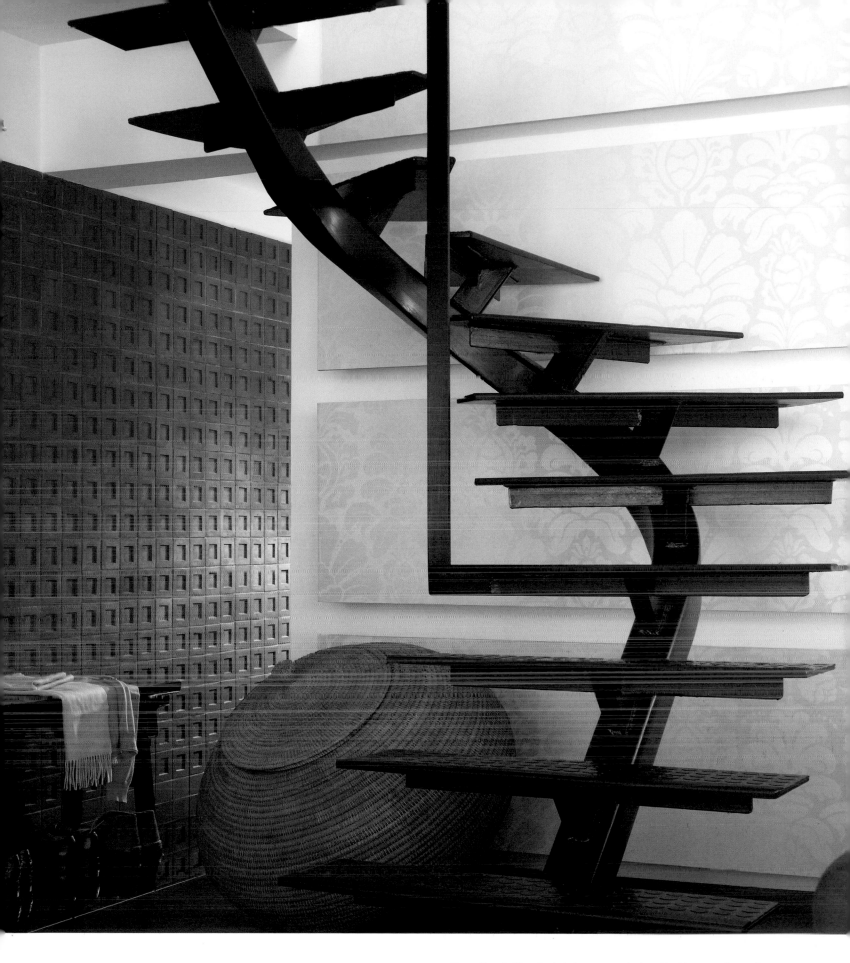

Above The striking steel staircase was designed by Murray and manufactured in sections in Dongguan, China. The antique elmwood bench is from Shaanxi province and the large basket is from Indonesia.
All photos styled by Esther van Wijck.

Opposite Behind a black leather Low Pad chair by Jasper Morrison stands a 13th-century wooden statue of a Burmese acolyte.

Left A low white-lacquer elmwood cabinet runs the length of the living room. A pair of photographs by German photographer Andreas Lutherer hang above a pair of Chinese wooden candleholders.

Right Handmade terracotta tiles clad one wall of the living room. Murray worked with a tile factory in Thailand, updating old tile molds from the 60s and 70s and introducing modern colors and glazes. Black Chinese granite tile flooring extends along the corridor.

Left The open-plan dining area combines Chinese antiques with modern classics. The black lacquer table is from Shaanxi Province; the four DKW chairs are by Charles and Ray Eames. To the rear, mirror-door cabinets provide storage and visually extend the space.

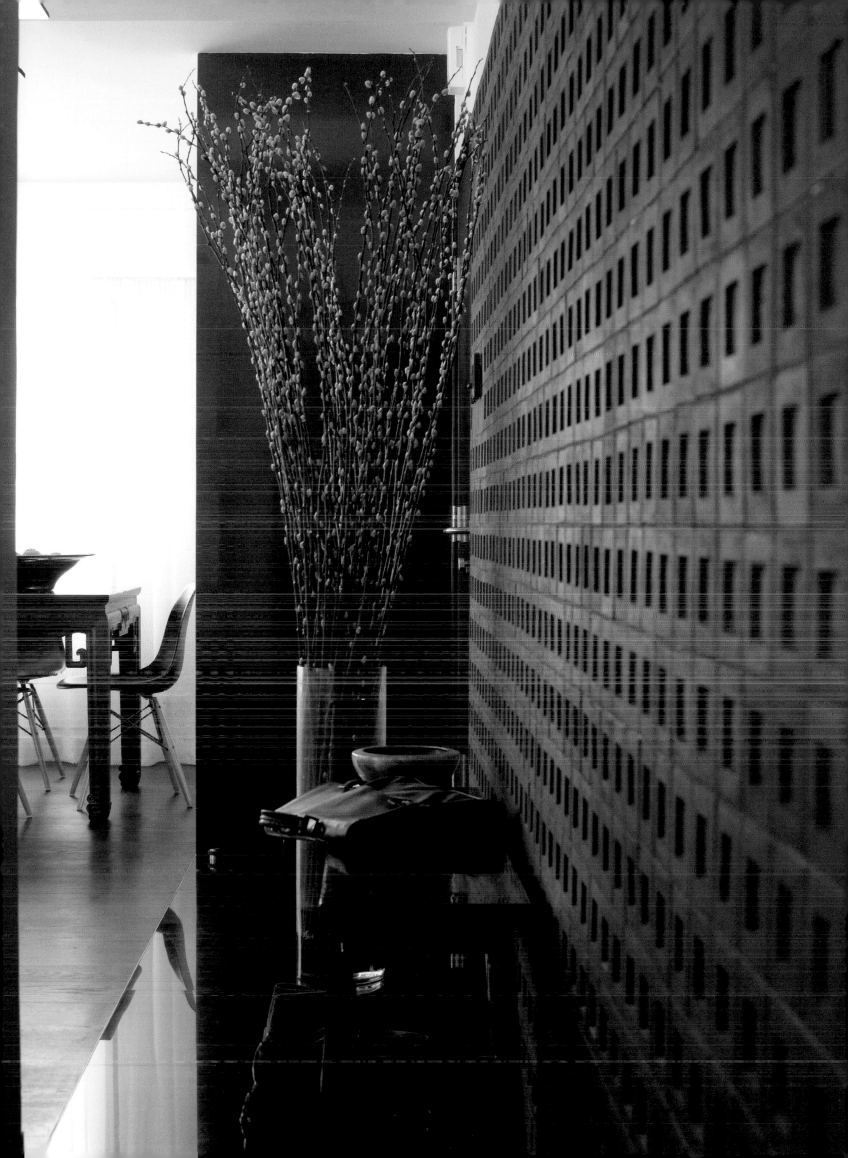

Below In the living room Murray used a bold Japanese chrysanthemum carpet made of New Zealand wool and custom designed by RJMD. A pair of Chinese trunks works both as storage and display space.

Opposite top Seven vertical panels behind the staircase have been covered with pearlescent white-on-white wallpaper. The panels can be changed from time to time. Hanging above them is a Jasper Morrison Glo Ball.

Opposite bottom Flock damask print foil wallpaper covers the bedroom wall. The solid teak bed was designed by RJMD to fit the space; the white curved bedside table is by Kartell.

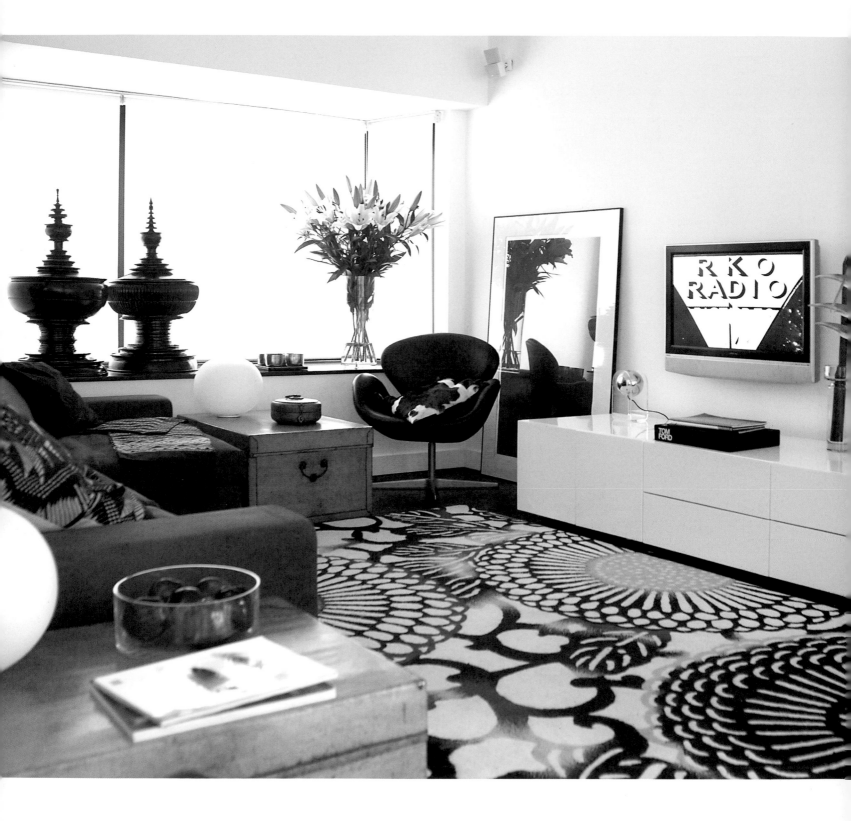

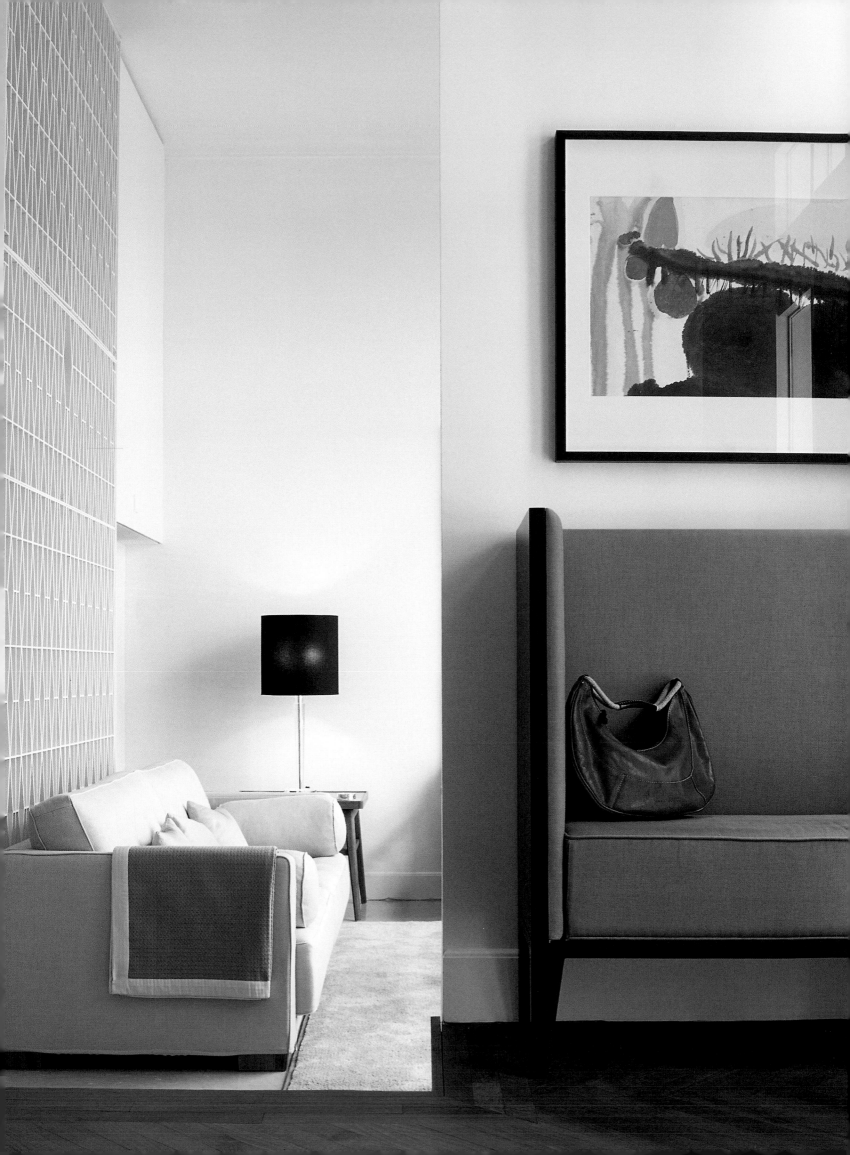

mid-century retro
back to basics

Designer JOHNNY LI | Happy Valley HONG KONG

IN HONG KONG, where high rise apartment blocks with compact shoebox-like layouts comprise the vast majority of housing choices, this 280-square-meter (3000-square-foot) ground floor apartment in a low-rise building, with its four-meter-high (13-foot-high) ceilings and beam and column construction, is a rare gem.

Tucked away in the quiet residential district of Happy Valley, the owners asked architect and designer Johnny Li of Nail Assemblage to create a comfortable, modern vibe whilst retaining the apartment's character. Li reconfigured the floor plan and turned what was a dark, enclosed space into a bright and airy family home, encircled by a private garden. "We tried to tidy up the circulation so that the whole house was more defined and well-designed in terms of circulation and space. The layout had to be straightforward and clear," explains Li.

Adding more light was a priority: "It was very dark but we opened it up to let the light in," says Li. His choice of materials helped to open up the space—Spanish yellow marble, teak and granite flooring, and lots and lots of glass. Access is through an impressive entry hall shielded from the living area beyond by a pair of retro-inspired wrought-iron screens which jut partway out into the space. Says Li: "We replaced the existing walls with the screens both for decorative purposes and to bring more light into the space."

Because the apartment is on the ground floor and is surrounded by a high stone wall, it has an almost total sense of privacy, both inside and out. Li's extensive use of glass windows and doors along the rear of the property—in the dining room and wrapping around the master bedroom—means the space enjoys a relaxed, indoor-outdoor atmosphere.

Inside, the interior palette is muted, natural, and simple, with modern classic furnishings which retain a mid-century feel. Much of the furniture was designed by Nail Assemblage from its furniture collection Yi Line. "Yi means first in Mandarin," explains Li. "With this kind of furniture we are going back to basics, with simple shapes, clean lines and use of solid woods such as walnut and maple. Personally I love mid-century furniture, so classic elements have influenced me. These are pieces you can keep for a long time."

Above Floor-to-ceiling shelving runs along the rear wall of the family room. A sliding ladder allows access to the upper shelves.

Opposite Four-meter-high (13-feet-high) ceilings add a sense of grandeur to the space. A slim, tall-backed seat from Li's Yi Line collection stands in the entrance hall; a step leads down into the sunken formal living room.

Above A pair of 1960s style wrought iron screens designed by Li (one pictured) divides the entrance hall from the family room. Using screens rather than walls enables more light to enter the space. A Tolomeo Mega lamp hangs above a Yi Line wooden cabinet.

Right Looking from the formal living room into the hallway, a mirrored wall along the left side makes the space seem bigger, brighter and lighter.

Far right Steps lead up to a small guest room. The teak parquet enhances the mid-century feel of the space.

Bottom Floor to ceiling windows along one side of the living room afford a light and airy atmosphere. Muted colors and bespoke furniture by Yi Line give a serene quality to the space.

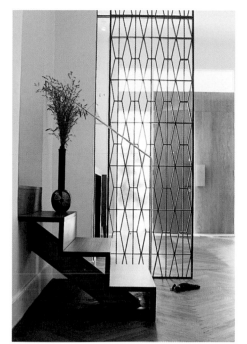

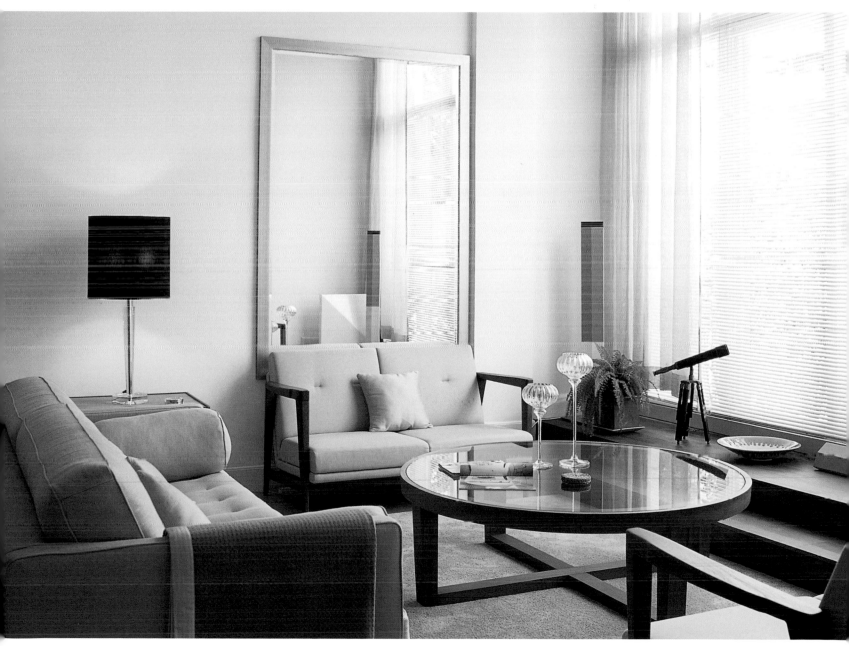

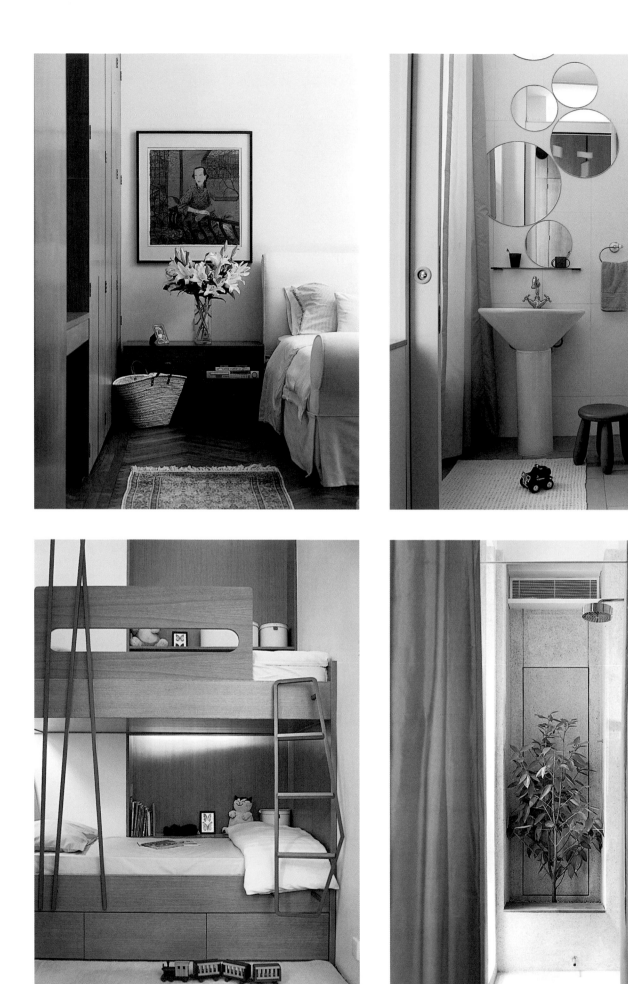

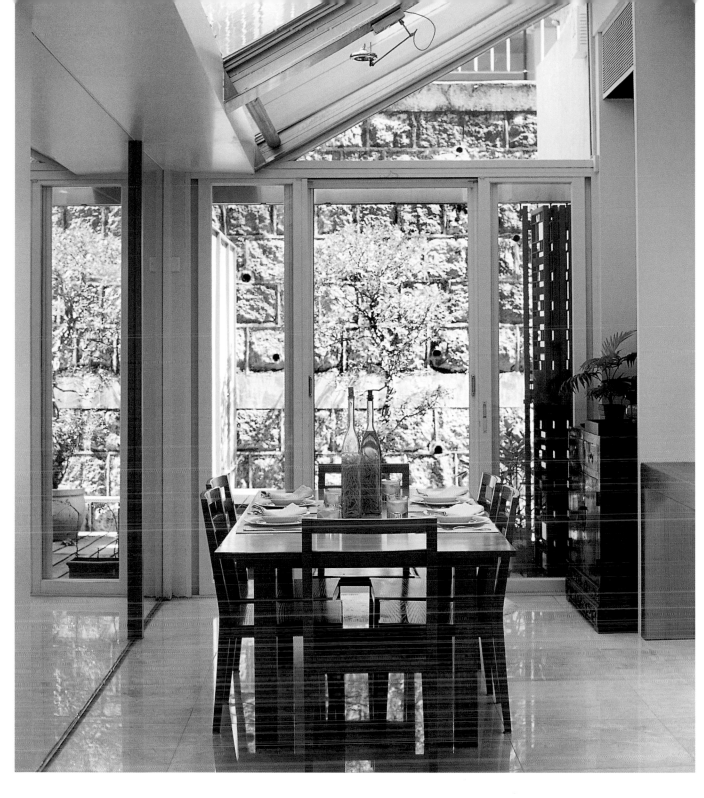

Opposite top left Parquet floors and neutral tones in the bedroom provide an indoor-outdoor atmosphere.

Opposite top right In the children's bathroom, a series of circular mirrors above the sink were designed by Li to simulate bubbles.

Opposite bottom left Li designed bunk beds for the boys, a modern reinterpretation of a classic design. Drawers underneath are used to store toys.

Opposite bottom right Nature is brought into the bathroom by placing a tree behind the shower stall.

Above The dining room has been designed with glass doors and a slanted glass ceiling to make maximum use of the light. Outside, a high stone wall borders the wraparound garden.

Right A family of metal ducks waddle around the patio.

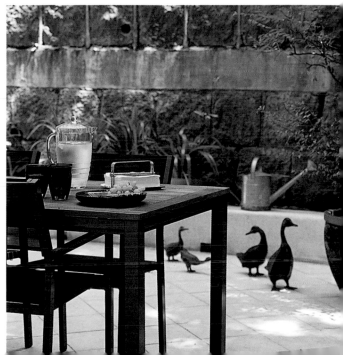

shanghai triplex
a mix of eras and cultures

Designer KENNETH GRANT JENKINS | Hongqiao SHANGHAI

THIS DOWNTOWN TRIPLEX evokes a sense of Shanghai's multi-cultural roots. The look is bold and dramatic, with elongated geometric lines, a soaring internal staircase and use of tactile materials such as hand-beaten brass, Amazonian slate and mosaic tiles. Home to American architect Kenneth Grant Jenkins of JKarQ (China) Limited, the 200-square-meter (2100-square-foot) space is a mix of eras and cultures. "I think there are a lot of different influences here," he explains. "Some are Chinese, some are Japanese, some are 60s influences, with a little bit of 70s modernism thrown in."

Set in a complex surrounded by other less-than-attractive buildings, Jenkins chose to focus on the internal spaces rather than the external views. Thus it was vital to maximize the amount of light that entered. He did this by replacing some of the internal walls—especially those around the central staircase—with glass panels. "The exterior view is not very nice so some of the ideas incorporating the glass and different textures on the glass were used to preserve and enhance the light without seeing the view."

On the lower floor, the space flows from the living room into the dining room, with the staircase separating the two areas. With its clear glass balustrades and glass panels, the staircase rises steeply up three levels. During restoration, Jenkins had to reverse its original position. "It was essential to switch the staircase around as this would enable a connection into the master bedroom and allow a bridge to go over in order to access the bathroom at the top."

From the base of the staircase you can see all the way up to the top floor. "The proportion of the lines are very tall and thin. I was trying to emphasize the verticality and play games with the height," explains Jenkins.

Above Contemporary Chinese art hangs on the landings of the staircase. On the top floor is a work by Liu Xin Gang; below is a pencil study by Sung Yong Hong.

Opposite top right Classic Chinese furniture is used in the dining room. To the right, a pair of Chinese screens flank the kitchen entrance; in between is a glass panel that can be closed when cooking.

Right In the living room, a pair of Wassily chairs by Marcel Breuer flank a coffee table with removable panels designed by Kenneth Grant Jenkins. The painting above the fireplace is by Yue Min Jun.

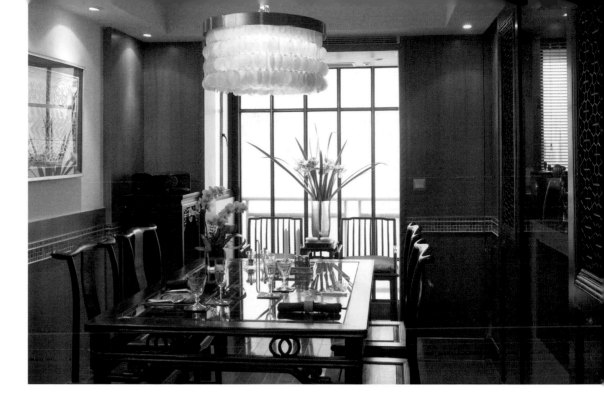

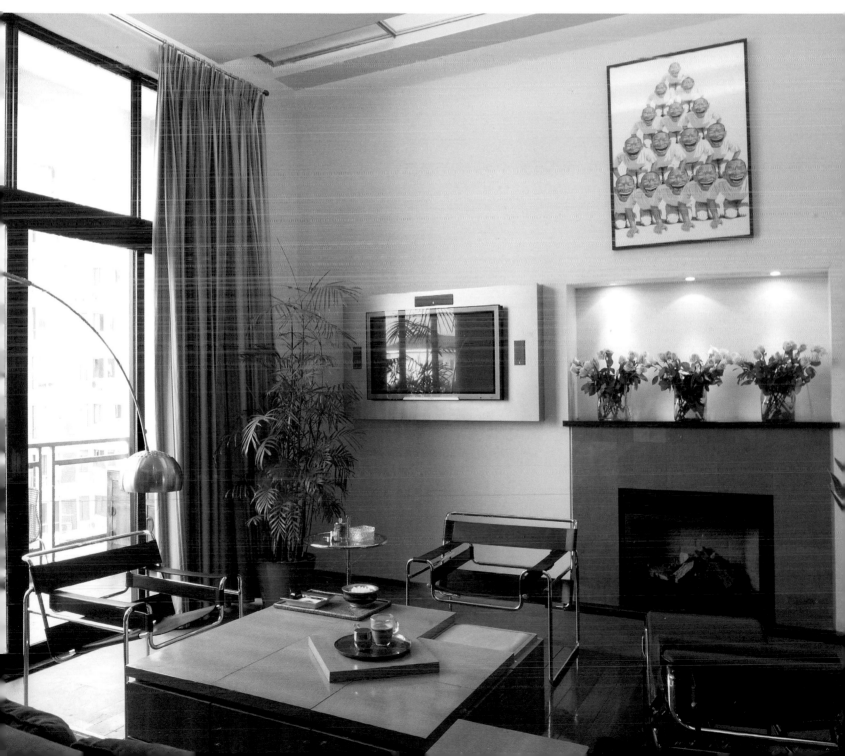

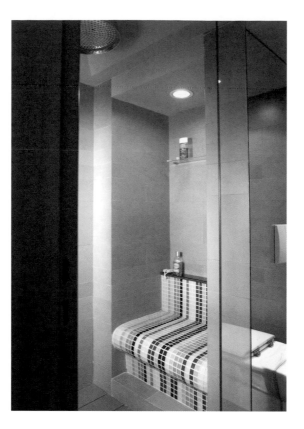

Left A seat in the shower is clad with colorful mosaic tiles arranged in stripes.

Far left At the top of the stairs, Grant Jenkins installed a textured glass wall rather than a solid one to create visual interest and to maximize the light flowing into the stairwell.

Bottom In the bathroom a curvaceous bath is clad with colorful mosaic tiles.

Right top The bedroom cupboards are of red shadow wood. Square brass panels with a raised circular motif add texture and visual interest to the wall above the bed.

Right bottom Looking through the master bedroom into the bathroom (left) and stairwell (right). The soft palette of pale woods and grey-brown furnishings is calm and restful.

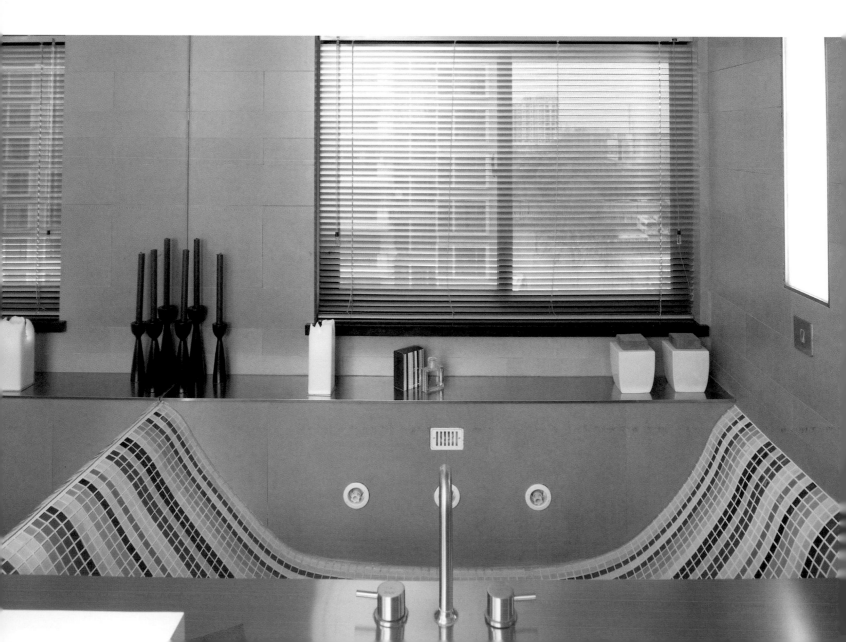

bund 18
the east is red

Designer FILIPPO GABBIANI | The Bund SHANGHAI

FOR HIGH-OCTANE GLAMOUR, Shanghai's party crowd flock to the city's Bund district in search of entertainment. The Bund, a long row of neoclassical highrises built on the curving banks of the Huangpu River, is well known for its grandiose—and visually stunning—art deco buildings which these days draw a distinctly modern crowd.

Bund 18, a former bank headquarters, has become one of the city's most exclusive retail and dining meccas. It was meticulously renovated by Italian firm Kokaistudios under the auspices of architect Filippo Gabbiani. On the roof, however, is something much more modern: a large glass pavilion and terrace, home to Bar Rouge.

Bar Rouge was designed by Gabbiani in collaboration with French designer Imaad Rahmouni. The glamorous space has two focal points—one interior and one exterior.

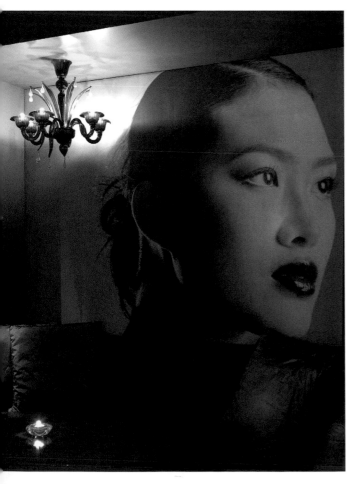

Inside is a large central island bar made of China black marble flanked by acid-carved mirrors and red chandeliers. The crimson palette and large black and white photographs add drama and sensuality to the space. Outside, a large teak-floor terrace draws the crowds at night when the Bund lights up to reveal a panorama of Shanghai's architectural history.

On the floor below, Sens & Bund appeals to those who favor a more restrained venue. Again a collaboration between Gabbiani and Rahmouni, the restaurant aims to reinterpret the eclecticism of the Bund 18 building and integrate classic elements with a distinctly modern style. A lush red carpet, yellow Perspex reception desk, angel hair curtain dividers, transparent chandeliers and strings of red Venetian glass vases, each holding a single white rose, whisper subtle elegance to the cosmopolitan crowd who choose to dine here.

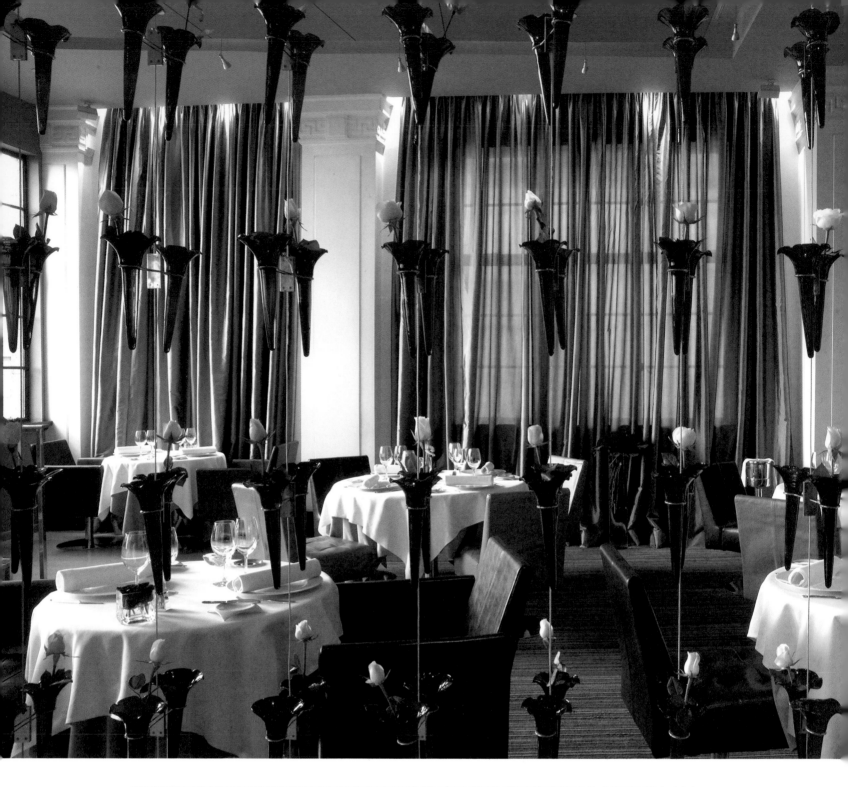

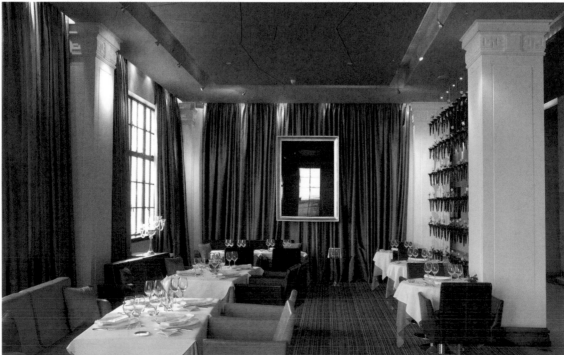

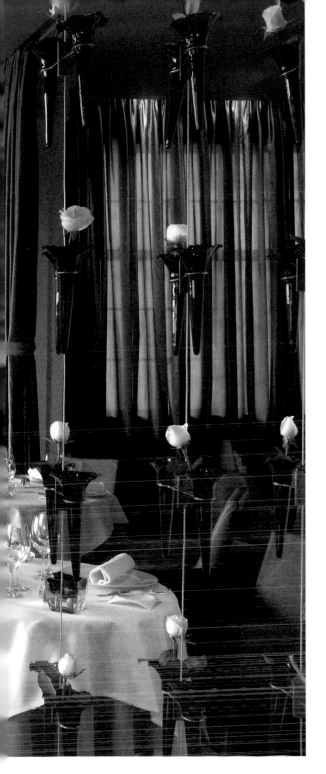

Below The entrance to Bar Rouge. Large, freestanding boxes on wheels house sofas and oversized black and white photographs. As a moveable element, the boxes keep the space fluid and flexible.

Bottom The lighting in Bar Rouge features over 20 red chandeliers designed by Filippo Gabbiani, himself a descendent of an Italian glassmaking family.

Below Modern and sophisticated, the bar at Sens & Bund has subtle lighting, elegant metallic counters and angel hair curtain dividers.

Bottom A yellow Perspex reception stand, a Murano glass chandelier and a long red carpet greet diners.

Above A wall of rose-filled vases attached to steel wires divides the large, open space in the Sens & Bund dining room.

Left The interior of Sens & Bund combines classical architecture with modern elements in a bid to reinterpret and update the diverse roots of the Bund 18 building.

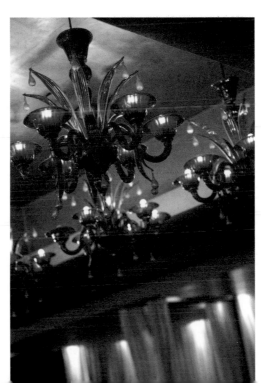

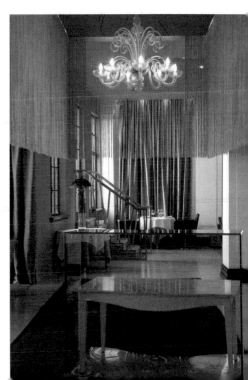

garden of delights
under the arches

Designer ANTONIO OCHOA-PICCARDO | Dongcheng BEIJING

A SIX-METER-HIGH (20-foot-high) vaulted ceiling arches impressively over a former corridor between two buildings near the historic center of Beijing. Designed by architect Antonio Ochoa-Piccardo of Redhouse China, the Garden of Delights serves modern South American cuisine in a dramatic setting.

"I realized the space was empty land so I took over the area. I think the vault was the natural solution to the space," explains the Venezuelan architect, referring to his decision to choose an arch over a flat or apex-style roof. "It is a very simple structure and the proportions are perfect. In my work I like to make a statement in a space. If the space is strong that is the most important thing."

Ochoa-Piccardo has created a sense of drama not just in the soaring wooden ceiling inset with semi-transparent skylights but also in his use of materials within the six-meter-wide (20-foot-wide) space. "I love to use basic materials and industrial elements in other ways." Hence external materials such as Beijing bricks have been used on internal walls; oxidized metal panels run along the base of the roof line; and simple grey PVC pipes form storage units inside a glass-clad wine cellar. He has played with proportion too, installing a line of huge white plant pots along the right side of the space, filled with towering plants.

Decorative inspiration was taken from the painting "Garden of Earthly Delights," a triptych by Dutch painter Hieronymus Bosch (ca. 1450-1516) who created a painted utopia depicting visions of humankind in paradise, in the garden of delights and later in hell. Panels depicting sections from the enigmatic work line the walls on both sides and at either end of the space. This is an interior which manages to be both grand and intimate at the same time. "We wanted to create a place for extreme pleasures," says Ochoa-Piccardo, "to make Garden of Delights a sensual, glamorous experience."

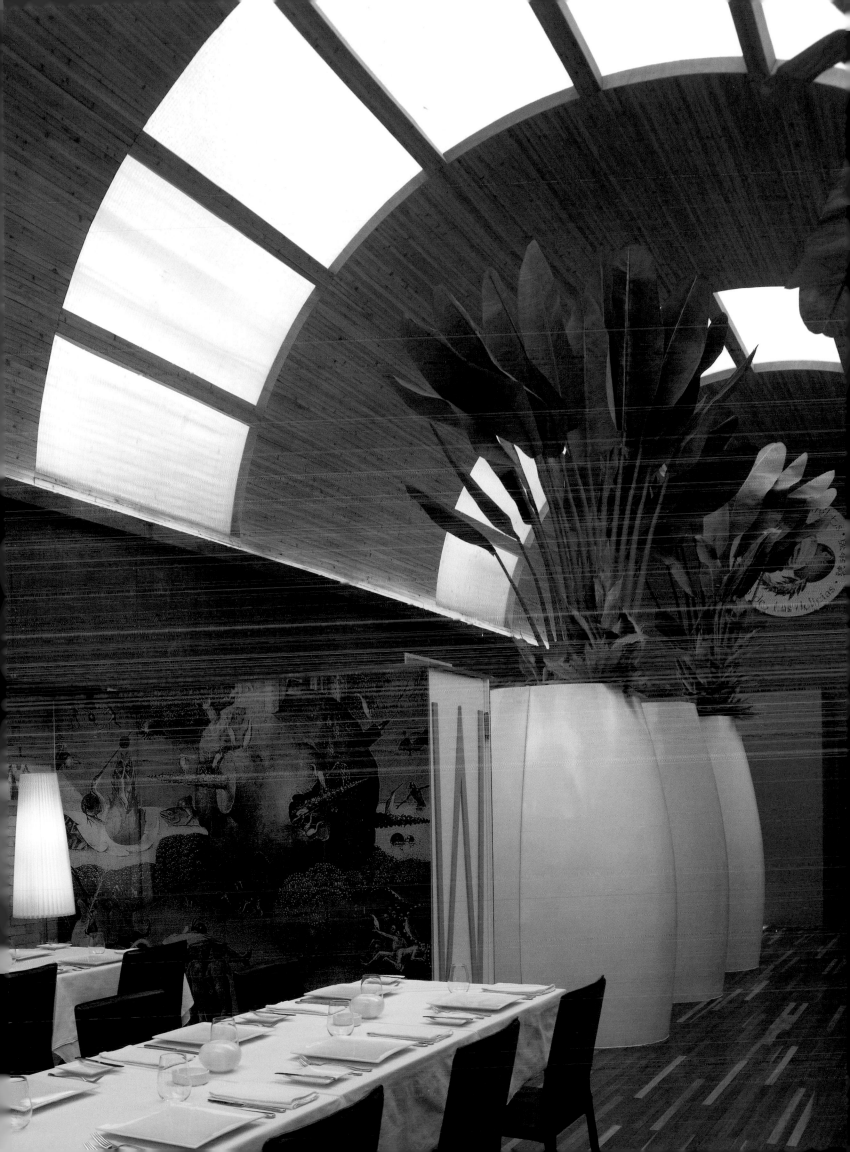

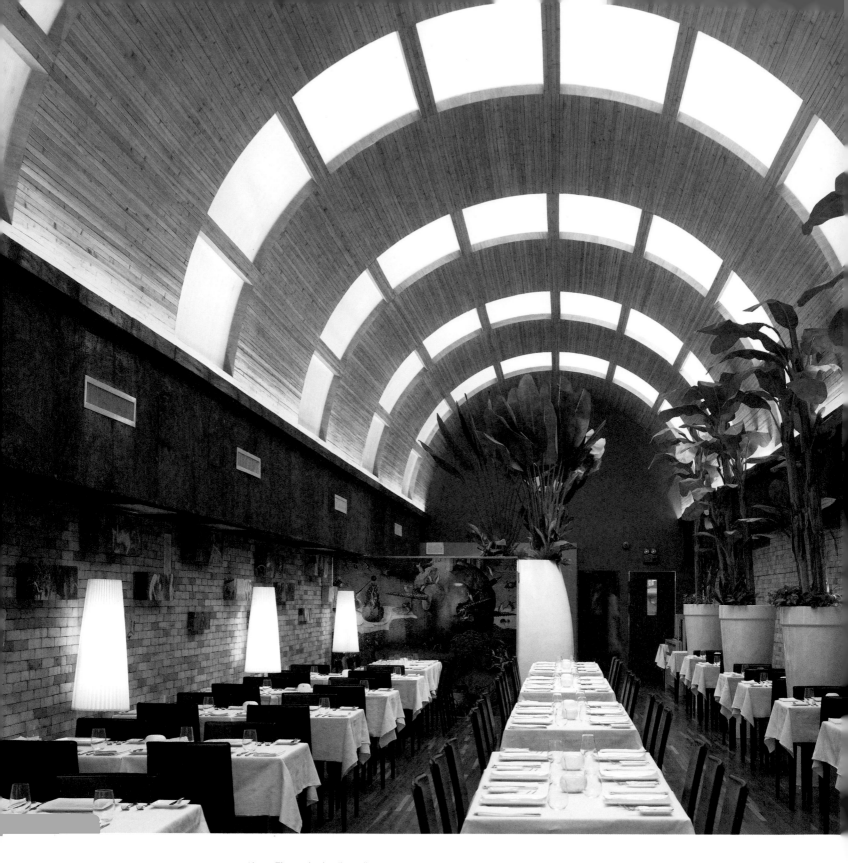

Above The arched ceiling allows the space to be both grand and intimate at the same time. A simple structure and perfect proportions combine to produce a statement-making interior.

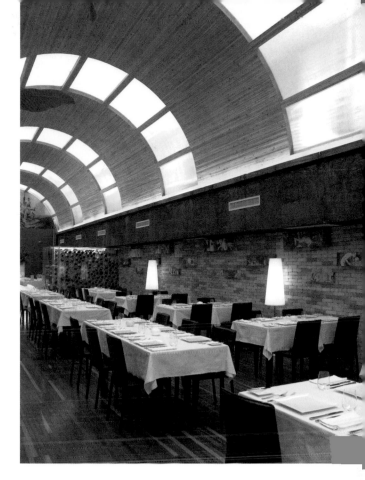

Right Ochoa-Piccardo has used external elements such as Beijing brick, oxidized metal panels and unvarnished timber to lend a sense of urban locality to the space.

Below Dutch painter Hieronymus Bosch's utopian vision called "The Garden of Earthly Delights" proved inspirational in the decoration of the restaurant. Stairs lead upward to a mezzanine office area.

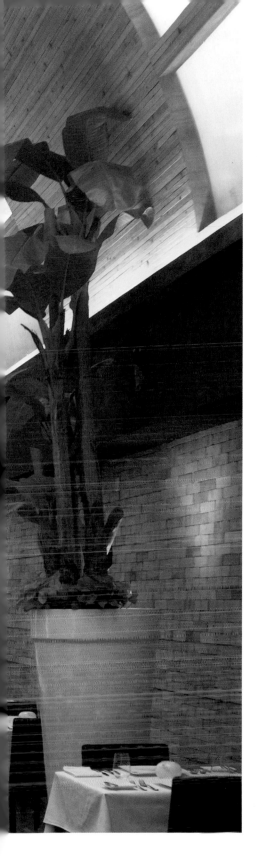

architects and designers

The Bridge 8
No. 8-10 Jian Guo Zhong Lu
Shanghai 200025, China
Tel: 86 21 6415 0789
Email: gracen@lifestylecentre.com
www.bridge8.com

Bund 18
18 Zhongshang Dong Lu
Shanghai 200002, China
Tel 86 21 6323 8099
Email: info@bund18.com
www.bund18.com

Gary Chang
Edge Design Institute Ltd
Suite 1604, Eastern Harbour Centre
28 Hoi Chak Street
Quarry Bay, Hong Kong
Tel: 852 2802 6213
Email: gary@edge.hk.com
www.edgedesign.com.hk

Jean-Marie Charpentier
Arte Charpentier Et Associes
Shanghai-Paris
www.arte-charpentier.com

Clarence Chiang
Team HC
1005-07 China Merchants Building
152-155 Connaught Road
Central, Hong Kong
Tel: 852 2581 2011
email: ccj@teamhc.com
www.teamhc.com

Commune by the Great Wall Kempinski
The Great Wall Exit at Shuiguan
Badaling Highway
Beijing, China
Tel: 86 10 8118 1888
www.commune.com.cn

Contrasts Gallery
Suite 2306-2309 Jardine House
1 Connaught Place
Central, Hong Kong
Tel: 852 2826 9162
Email: info@contrastsgallery.com
www.contrastsgallery.com

Garden of Delights
53 Donganmen Dajie
Dongcheng District
Beijing 100006, China
Tel: 86 10 5138 5688
Email: info@gardenofdelights.com.cn
www.gardenofdelights.com.cn

Pascale Desvaux
p_desvaux@yahoo.com

Andre Fu
AFSO
Unit 2001, Fairmont House
8 Cotton Tree Drive
Central, Hong Kong
Tel: 852 2523 6998
Email: email@afso.net
www.afso.net

Filippo Gabbiani
Kokaistudios
Shanghai Design Studio
3/F Bldg 1, 170 Yueyang Lu
Shanghai, China
Tel: 86 21 6473 0937
Email: info@kokaistudios.com
www.kokaistudios.com

Darryl W Goveas
Pure Creative International Ltd
10/F, 48 Wyndham Street
Central, Hong Kong
Tel: 852 2335 1144
Email: info@purecreativenet.com
www.purecreativenet.com

Green T House
No 6 Gongti Xi Lu
Chaoyang District
Beijing 100027, China
Tel: 86 10 6552 8310
Email: info@greentn-t-house.com
www.green-t-house.com

Green T House Living
318 Cuige Zhuang Xiang Hege Zhuang Cun
Chaoyang District
Beijing 100015, China
Tel: 86 10 6434 2519
Email: info@green-t-house.com
www.green-t-house.com

Guan Yi Contemporary Art Archive
Tel: 86 10 8957 8727
Email: guanyiart@yahoo.com.cn
www.guanyi.org

Huang Rui
PO Box 8503
4 Jiuxianqiao Lu
Beijing 100015, China
Tel: 86 10 6438 2797
Email: huangruistudio@vip.sina.com

Kenneth Grant Jenkins
JKarQ (China) Limited
5th Floor, Hong Jing Business Center
1001 Hong Jing Lu
Chang Ning District
Shanghai 201103, China
Tel: 86 21 6269 0787
kenneth@jkarq.com
www.jkarq.com

James Law
James Law Cybertecture International
413A InnoCentre
72 Tat Chee Avenue
Kowloon Tong, Hong Kong
Tel: 852 2381 9997
Email: james_law@jameslawcybertecture.com
www.jameslawcybertecture.com

Johnny Li
Nail Assemblage International Limited
Rm 409 Yu Yuet Lai Building,
43-55 Wyndham Street
Central, Hong Kong
Tel: 852 2526 8326
Email: nail@netvigator.com

William Lim
CL3 Architects Limited
7/F Hong Kong Arts Centre
2 Harbour Road
Wanchai, Hong Kong
Tel: 852 2527 1931
Email: cl3@cl3.com
www.cl3.com

Kent Lui
Tactics
Tel: 852 9193 7170
tacticskentlui@yahoo.com.hk

Meg Maggio
Pekin Fine Arts
10-124 Qi Jian Yuan
Jianguomenwai Dajie
Beijing 100600, China
Tel: 86 10 8532 2124
mcg@pekinfinearts.com
www.pekinfinearts.com

Odile Marchand
Belle Planete Art + Design
Studio 602, Block 10
Dong Hu Ming Yuan
No 881 Fa Hua Zhen Lu
Shanghai 200052, China
Tel: 86 21 6283 5231
Email: odile@sh163.net

Roderick Murray
RJ Murray Design Ltd
Tel: 852 6103 2073
Email: rjmurray@netvigator.com

Ed Ng
AB Concept Limited
11/F, Tai Sang Commercial Building
24-34 Hennessy Road
Wanchai, Hong Kong
Tel: 852 2525 2428
Email: info@abconcept.com.hk
www.abconcept.com.hk

Antonio Ochoa-Piccardo
Redhouse China
ROOM 905, Building 5
Soho New Town
88 Jianguo Lu
Chaoyang District
Beijing 100022, China
Tel: 86 10 5129 8878
Email: antonio@redhousechina.com
www.redhousechina.com

Deborah Oppenheimer
Deborah Oppenheimer Interior Design Limited
Tel: 852 2592 7415
Email: d_o@deborahoppenheimer.com
www.deborahoppenheimer.com

Jiang Qiong Er
VEP Design & Number D Gallery
CQL Design Centre
Building 2
50 Moganshan Lu
Shanghai 200060, China
Tel: 86 21 6266 2109
Email: jqe@cqlgroup.com
www.numberD.com
www.vepdesign.com

Adam Robarts
Robarts Interiors and Architecture
Ju Fu Dian
Ri Tan Park
North Ri Tan Lu
Chaoyang District
Beijing 100020, China
Tel: 86 10 8563 0088
Email: info@robartsinteriors.com
www.robartsinteriors.com

RongRong & inri
Studio RongRong & inri
100 Cao Chang Di
Chaoyang District
Beijing 100015, China
Email: inri@threeshadows.cn
www.Rongin.com
www.threeshadows.cn

Soho China
Tower B 18-20/F
88 Jianguo Lu
Chaoyang District
Beijing 100022, China
Tel: 86 10 5878 8866
www.sohochina.com

Juan Van Wassenhove
Email: Juan_van_wassenhove@yahoo.com
Email: suite_interdite@yahoo.com

Wang Hui
Tel: 86 13901216699
Email: design2520@yahoo.com

Rocco Yim
Rocco Design Architects Ltd
38/F AIA Tower
183 Electric Road
North Point, Hong Kong
Tel: 852 2528 0128
Email: rdl@roccodesign.com.hk
www.roccodesign.com.hk

Jason Yung and Caroline Ma
Jason Caroline Design Ltd
Room 1401, 39 Wellington Street
Central Hong Kong
Tel: 852 2517 7510
Email: jason@jasoncarolinedesign.com
www.jasoncarolinedesign.com

Yung Ho Chang
Atelier FCJZ
Beijing office:
Yuan Ming Yuan East Gate Nei (inside),
Yard No.1, North Side,
Yuan Ming Yuan Dong Lu
Beijing 100084, China
Tel: 86 10 8262 6123
Email: fcjz@fcjz.com
www.fcjz.com

acknowledgments

The author and the photographer wish to thank all the architects and designers who participated in the project and all the homeowners who allowed us access for photography; without them this book would not have been possible.

Thanks also to Joe Magrath, for his encouragement, enthusiasm and perceptive insights. Thanks to Xie Meng in Beijing and Michael Lucas in Shanghai for their assistance during shooting, which took many forms beyond the photographic, from translation to sweet-talking gatekeepers to hunting out the best Sichuan food in town. Thanks to Wang Xu of *Elle Decoration* China and Rhonda Yung of *Elle Decoration* Hong Kong and their teams for their support. Thanks to Esther van Wijck for styling Roderick Murray's Hong Kong duplex.